Life Drawing

A journey to self-expression

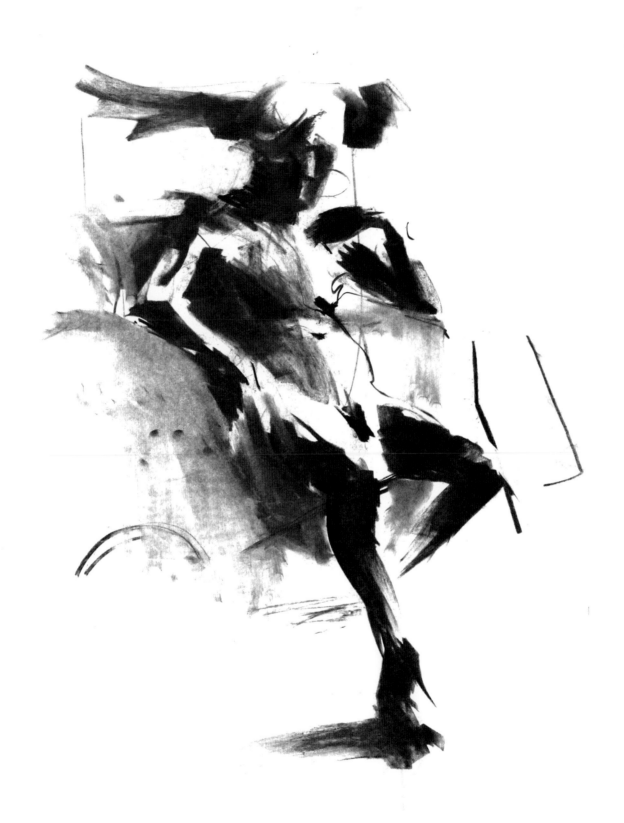

Life Drawing

A journey to self-expression

Bridget Woods

The Crowood Press

First published in 2003 by
The Crowood Press Ltd
Ramsbury, Marlborough
Wiltshire SN8 2HR

www.crowood.com

This impression 2018

British Library Cataloguing-in-Publication Data
A catalogue record for this book is available from the British Library.

ISBN 978 1 86126 598 2

Illustration previous page: *Expressive Tone used for a short pose,
side-lit by sunlight.*

Photographic Acknowledgements
All the photographs in this book were taken by the author, unless
otherwise credited.

All the illustrations in this book are the work of the author, unless
otherwise credited.

Dedication
To Mary Oak-Rhind (née Sewell) and Sam Rabin for their infectious
inspiration and to all the life models I have ever worked with, for their
patience, stamina and creative involvement.

Note: throughout this book, the pronouns 'he,' 'him' and 'his' are
intended to apply both to men and women.

Typefaces used: text, Stone Sans; headings, Frutiger; chapter headings,
Rotis Sans.

Typeset and designed by
D & N Publishing
Lowesden Business Park, Hungerford, Berkshire.

Printed and bound in India by Replika Press Pvt. Ltd.

CONTENTS

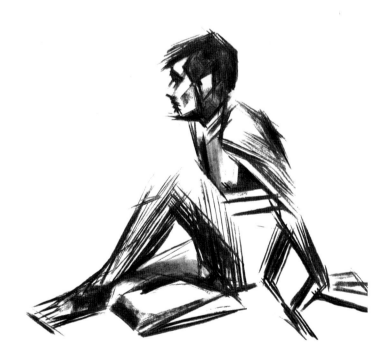

ACKNOWLEDGEMENTS

Many thanks to Chichester College, The Earnley Concourse and West Dean College for providing the fertile ground in which I have thus far developed my teaching ideas and to Rob Newton for a warm sense of affirmation.

To all my life drawing students, past and present, for their open-minded enthusiasm, especially those who generously offered many fine drawings for inclusion in this book, which would have been twice as long to adequately accommodate them all.

To all the models who may or may not recognize themselves in this book and especially to Oliver Dawson, Frank Dunn, Nikki Rose and Jessica Train.

To Martin Davey, Richard Banister and Evan Morgan for respectively launching, maintaining and frequently life-saving me on my journey into 'computer world'.

To John Hill, Carolyn Genders and Julie and Tim Simmons for their ideas, words and energy input and to Ian Aston, Clive Quick and Helen Wyatt for calming advice and help on the photographic front.

To the dance tutors and students of University College, Chichester, who kindly allowed me to draw them while they were rehearsing.

To Graham Pollard for invaluable support and Paul Pridmore for meticulous indexing. To the Crowood Press for encouragement and guidance.

Lastly, for cheering me on, many thanks to my family and other friends, especially Denis Hughes: model, mentor and chum.

INTRODUCTION

Why do we want to draw the human body?

Because we all have a body, and we know the look and feel of it, outside and in, and have an innate interest in other people for our physical and emotional survival, we are 'finely tuned' to its visual shapes and proportions and to the messages that another body conveys. So not only are bodies fascinating to us, but we know instinctively when making a drawing of one, if it looks right and can, therefore, get instant feedback.

Life drawing, far from being the preserve of the professional artist, is a perfect subject for the absolute beginner to *any* kind of drawing, including those who believe – or have been told – that they have no aptitude for drawing. An interesting subject will usually kindle the desire and confidence to discover more.

So why is life drawing so rewarding?

Because of the diversity of poses and shapes a human body can create; the study and collection of them can become quite addictive.

As a visual limbering up, and to keep the eye 'in', life drawing is the ideal complementary activity for practitioners of all two- and three-dimensional studies.

It also acts as a great 'unblocking' process for artists because the model is physically present 'here and now' for a limited period (unlike a still-life arrangement) so there is less time to worry about the outcome, and more of an impulsion to experience *now*.

Therapeutically, life drawing can, in the same way, drag worriers away from past and future concerns, and hold them in the present.

Drawing another human being is an absorbing engagement between artist and model because the dynamics of the process are less about object and subject, and more about mutually active participation.

As a pursuit of individuality, life drawing can be a personal expression of the artist's response to many factors, from the human condition in general, to the model or pose in particular.

Because *everyone* is interesting to draw, our awareness of other people as individuals is enriched, and the yawning gap between standardized 'heroic' statuary and pornographic imagery becomes populated with 'real' people. Students often remark that, after starting to draw from life, they begin to see people differently, appreciating them more as individuals and less in terms of age or sexuality.

Can anyone do it?

Yes, absolutely anyone who wants to, can learn to draw well. Consider the fact that all around the world, almost regardless of age, gender, religion or nationality, people are driving cars. Why? Because they *choose* to. Driving is an extremely complex skill, requiring not only different activities for each foot and hand, but also several modes of looking and thinking. What is more, most cars, most of the time, avoid hitting each other! Driving is neither a talent nor hereditary and, generally, people can choose to drive well with concentration and practice. Drawing, by contrast, is a much easier skill, requiring the co-ordination of eye, brain and hand (or mouth or foot) – and in no way is it physically dangerous!

This book is intended for anyone who is committed to learning to draw, or for those who, already experienced, wish to expand their visual awareness and appreciation of the human body. It can be used as a teaching aid by tutors, as a workshop manual for untutored groups or individual artists, or as a step-by-step course of lessons; with the help of the indexing system at the back of the book it can be used for troubleshooting individual problems, or purely for reference.

The main aims of the book are that it should:

- help overcome students' fears about drawing;
- give them control of their drawing, and the confidence to explore the visual world;
- help them develop an accurate visual awareness of individual models;
- expand their drawing vocabulary of ideas and marks beyond an 'art school look', a rigid path, or solely 'photographic' imagery;
- encourage the artist to make personal choices and develop a unique visual language.

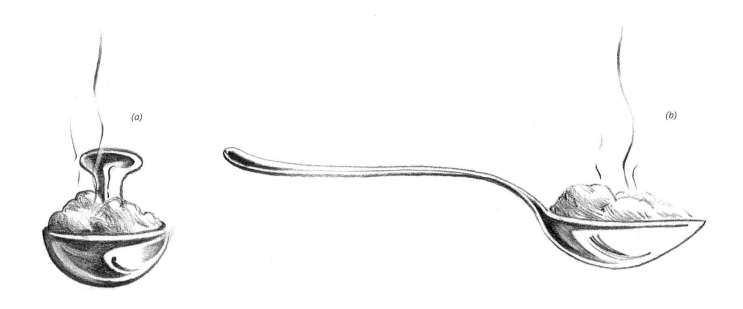

(a)

(b)

OPPOSITE PAGE:

TOP: **(a) The familiar front view, the spoon approaching the mouth. (b) The known, 'fuller' picture.**

BOTTOM: **Is what we see, what we 'know'?**

In short, it is a celebration of the individuality of both artists and models as people!

Different Realities

Why do we tend to draw what we know, and not what we see?

Objective drawing is not a mystery, but depends upon the simpler process of 'knowing what we see' rather than the more sophisticated process, 'knowing what it means'. From the moment that we open our eyes as babies we begin not only to receive visual information (what we see), but also to interpret this visual information into meaning (what we know it is), and we then store that information and its definition for future reference. It is crucial for our survival that we do this, and we quickly become experts.

For example, the front and side view of a spoon are totally different images, but if we have logged and cross-referenced the two images correctly, then we soon know that *a* is another view of *b*. By hiding and shortening, or foreshortening, the real length and shape of the whole spoon, *a* does not tell the whole story, so *b* is logged as a fuller, more definitive meaning of *a*.

If you are fully aware of the speed with which this happens and can speculate on the number of people you have seen since birth, then you will understand why the urge to draw what we know, and not what we see, is so powerful.

Added to this background information is a profound physical knowledge of our own and, often, other bodies, received through our other senses. When any part of our body touches another part (most of the time), we are reaffirming our knowledge of the *real* dimensions of our body. But again, these are not necessarily the dimensions that we see.

All three of the following experiences are very different kinds of truth.

1. WHAT WE KNOW: VISUALIZATION AND MEMORY.
Close your eyes and visualize your own body as you think it looks. Is your image of yourself standing up or sitting down? Are you mentally rustling through photos of yourself, or remembering the person in the mirror?

2. WHAT WE FEEL: PHYSICAL SENSATION.
Close your eyes again, and with your hands, explore the feel of your own body. Feel the textural difference between bone, muscle, fat, skin and hair, and the dimensions and volume of your upper arm, for example, as compared to your thigh, or little finger or heel. Tense and relax a leg muscle, and note the different sensations both internally and externally.

3. WHAT WE SEE: VISUAL SENSATION.
Stand up and look downwards at your body. Look at the size of your feet compared to your chest. How much visible space is there between your chest, knee and foot? Now, bring your hand, turned palm downwards, slowly up towards your face and watch your body 'disappear'. Can these three 'realities' be compared or expressed?

Now, look at the image below: can you see what it is?

It is, of course, seven black lines: a flat image that has only two types of dimension, height and width. If you answered table, top of box, inside of ceiling, square trampoline, you will have some idea of how swift and brilliant is the brain to interpret very little information with split-second zeal and imagination, translating it into a three-dimensional idea that has not only height and width, but also depth. Even complex information is supplied, such as the ratio of the dimensions – square – and the fact that the fourth leg of the 'table' is hidden by the top.

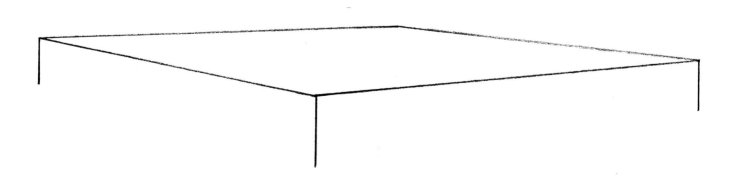

Ten expressive lines.
ARTIST: BONITA BOELLA

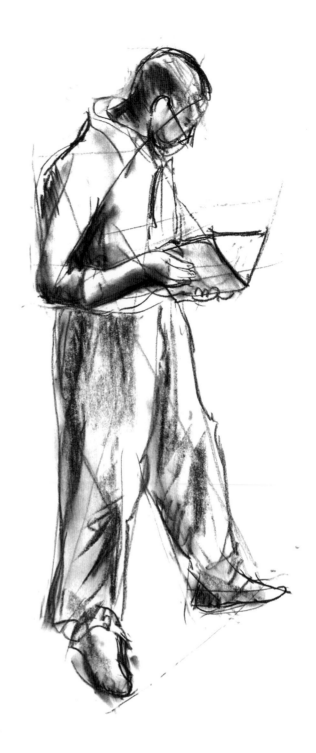

'Life drawing is a safe pastime.' Quick line and tone sketch.
ARTIST: PETER HILL

Life Drawing is not Life-Threatening

Objective drawing means recording reality as the eye sees it, and would be easy if, as beginners, we could simply draw what we see. However, because the eye cannot draw, a hand is needed to make the marks, a hand that is directed not by the eye, but by the brain. Situated so close to the eye, the brain immediately takes the incoming visual information and interprets it into 'known' dimensions – it has a lifetime's memory to refer to, and adds a little prioritizing for good measure. As an example, to the brain, a head is more important than a foot, and so most early life drawings tend to feature large heads and small, or non-existent, lower legs. Moreover it is in no way surprising that the brain should want to do this – after all, as management 'headquarters' it has kept us alive so far with its assessment of road widths, cliff edges and car speeds.

Nor is it surprising that the brain should sense confusion, sometimes humiliation, and often conflict, when our eyes tell us that this fine example of the fuller, more complex picture, with its real, 'life-saving' dimensions, is, as a drawing, 'laughably incorrect'. It is ironic to think that accuracy in objective drawing can be impeded by this brilliant processing system. If you are a beginner you may become conscious of this confusion, or sometimes find your hand wavering uncertainly over the paper. Be reassured that

this is a good sign, signifying that brain–eye negotiations are now under way and that, in a short while, a settlement will be reached in which your brain is satisfied that drawing is not only a rewarding pastime, but a safe one.

The first exercises are specifically designed to help the artist draw what is seen, while staying in harmony with these brain processes, rather than banishing them. This foundation is exceptionally important for the next step, which will explore the artist's personal response to the model, pose, lighting, mood and so on. If a comfortable relationship and dialogue between eye and brain is already in place, then the transition from objective drawing to self-expression and feeling will be a smooth one.

Guidelines for Using This Book

A study of anatomy has been placed, after some consideration, in the middle of the book in order not to interfere with the student's natural perception of individual models by introducing non-visible information too soon. Also a basic understanding of counterbalance and the skills of objective line and tone drawing will already be in place by then for the subtle description of structure and musculature. However, for reference, the anatomy section can be used at any time.

It is suggested that a project be well absorbed in the first part of a drawing session and that, for the remaining time, the artists play with and develop the technique in any way, allowing imagination and individuality to direct the process. During this time different media can be used, and previous exercises, similar or dissimilar, introduced into the 'current' way of looking and drawing. This will simultaneously keep learning and creativity alive.

When a medium is not specified for an exercise, use either pencil or charcoal.

Whenever a question appears in the book, it is hoped that you will consider some answers *before* reading on, in order to develop your imagination and a personal approach.

Do keep all your drawings together, and dated, so you can see how your work develops.

Always, whether you are working in a group or on your own, put your work on the wall or down on the ground after completing a new exercise or several drawings, to compare and discuss your reactions to the experience with each other as a group or with yourself, saying not just which you like, but also why. (Remember when you are admiring other people's work to accept that they are probably looking at yours in the same way.)

Be as objective, practical and positive as you can about your own drawings without focusing *only* on the faults. While being brutal and overcritical of yourself may seem to help progress in the short run, it not only takes the joy out of drawing, but wastes valuable energy, and wearies both you and those around you. It

can also, in the long run, sabotage the confidence of a whole group if it is not balanced by an equal amount of self-admiration and respect for your own work and development. The quickest way forward is to understand *how* you and others have achieved both successes and failures, by sharing your discoveries. Drawing is a non-competitive 'sport', so celebrate your different strengths.

Remember that nobody springs from the womb already able to draw. Drawing enjoyment and success is conceived by the 'idea' of possibility, instigated by choice, and developed by practice, not talent.

I have gained so much in skill simply by looking at other people's drawings, and so much pleasure from the mutual support and encouragement of the group.

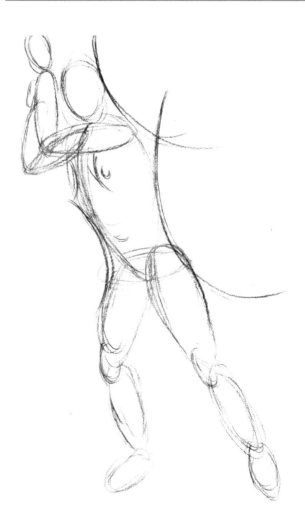

Dynamic use of Circling.
ARTIST: CLAIRE REDGROVE

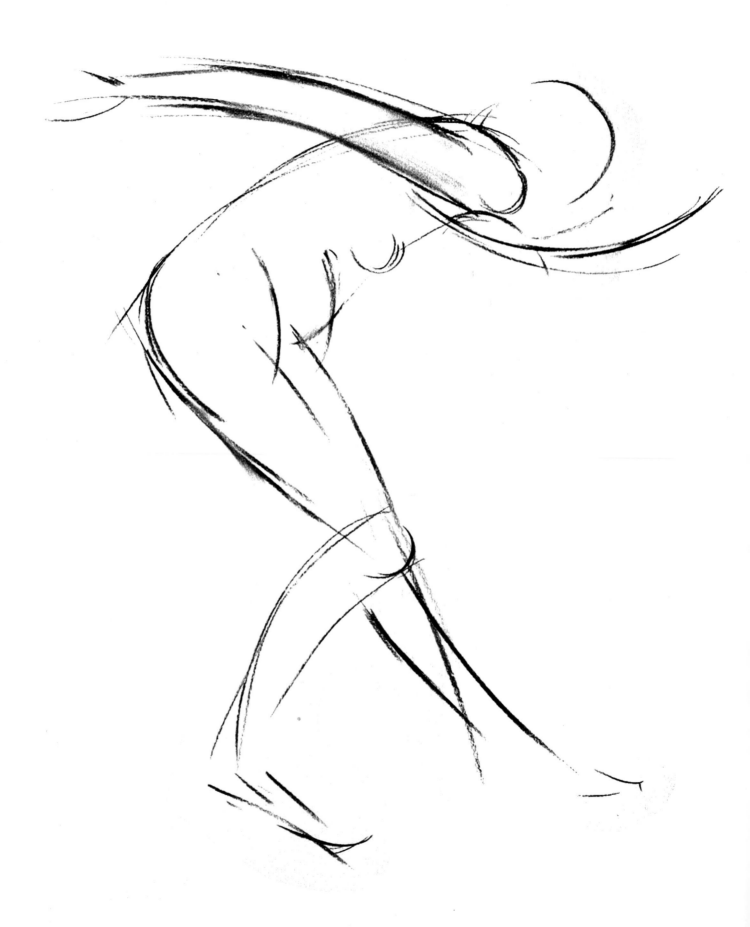

GETTING STARTED

Many people would like to draw from life but are held in check by persisting taboos regarding nudity. However, you can find classes, models and other life-drawing students by contacting the nearest art college, school art department or residential college; and if you already have a group of keen beginners and are looking for models, there is a growing number of life-model registers (for example, RAM-Register of Artists Models: www. modelreg.com). Aim to draw from a wide range of models.

> As an artist, I know when I'm modelling that I'm the centre of attention, the most important thing in the room.
>
> MODEL/ARTIST

Looking after Your Life Model

Life drawing is an activity for two live participants: the model and the artist. Just as drawing what is seen cannot happen without light, life drawing cannot happen without a model. It is,

therefore, very important that your model feels cared for at all times. Hopefully, the days when the model was treated like a servant or a still-life arrangement and left to suffer with numb, blue limbs in a cold and draughty art room are long gone. The best model is a respected one.

While a pose may last from thirty seconds to several weeks, and perhaps even years, a model will usually take a rest after

> Some groups make you feel relaxed and open – then I'll try to give them whatever they want.
>
> MODEL

LEFT: **Economy of line captures the essence of the pose.**
ARTIST: HELEN WYATT

Expressive marks were used for this dynamic pose by an athletic model.

twenty to forty minutes – though poses vary greatly in comfort, and often inexplicably so (an experienced model will know which apparently comfortable reclining pose is a 'killer'!). Different men and women have their own pain threshold and degree of muscular stamina, but one factor is common to all: to know that they *can* have a rest when necessary benefits both models and artists alike. It is far better for a model to have regular rests than to suffer in silence or fidget. If the pose is a long one it can be useful to put chalk marks at significant joint-points on the ground, cloth or chair around the model at the beginning of the pose; then 'slippage' can be easily checked without a riot of differing opinions.

Although the artists may outnumber the model by many, the ambient temperature must suit the *model*, for the simple reason that the artist can take off layers of clothing if necessary. For the sake of good drawing, it is worth ensuring that both parties enjoy a comfortable local temperature and an adequate flow of fresh air (not under-door draughts); to this end a personal cold/hot air fan should be provided for the model.

Ensure that a changing room, or at least a screened area, is available for your model.

Pay is also important: the skill and effort necessary to hold a pose should never be underestimated, and a model should be paid accordingly. Try holding *any* pose without moving for at least ten minutes – then you will really appreciate your models!

I really love the feeling that I'm
part of a creative process.

MODEL

Materials

All media have their own special properties and advantages. Drawing, in the initial stages, is about exploration, discovery, and recording, so for a good adventure you will need tools that will allow you to step forwards tentatively, try several routes, change direction (or your mind) and, finally, affirm the best of your discoveries. Pencil and charcoal both allow for experimental beginnings. On the one hand, pencil requires a greater amount of pressure to make a dark mark and is therefore ideal for making many light 'suggestions', and for strengthening little by little as you feel more certain of your proportions. If the marks become too confusing they can be rubbed out with a plastic eraser.

Charcoal, on the other hand, requires less pressure to make a dark mark, can easily be rubbed away with the hand or a cloth (especially when using smooth paper), and can, therefore,

engender a feeling of boldness in the beginner. You will feel more confident about taking risks if marks can be changed, selected or erased quickly.

A list of materials that might be useful is as follows:

- small range of pencils (B to 6B);
- refillable mechanical pencil (2B leads);
- charcoal, thin and thick (2cm diameter);
- erasers, both plastic and rubber (for different surfaces);
- plenty of inexpensive (not glossy) cartridge/newsprint-type/lining paper from household shops, preferably A1 or A2 size, but not smaller than 420mm × 297mm (A3 size);
- strong, lightweight board;
- 4 × bulldog clips;
- easel, strong enough to take considerable pressure.

The Best Drawing Position

The best position for drawing is to stand with your body facing the model – i.e. not looking over your arm – at an easel that displays your drawing alongside your view of the model. Like this you can:

- at a glance, compare the image to the reality;
- move your whole body, which keeps the muscles relaxed and the blood supply flowing;
- have all the articulation points of spine, shoulder, elbow, wrist and knuckles freely available so you can make with ease any directional mark you wish;
- stand back easily to compare your drawing with reality (this is a golden rule);

An example of materials and their marks.

■ maintain a healthy space between yourself, your drawing, and the model; be aware that the bond between the first two can often shut out the information from the third, particularly if the artist stands or sits too close to the drawing.

Try to avoid hunching over the drawing, which causes muscle strain at the neck and shoulders, and a feeling of tension that can erode confidence. Clutching a pencil in a tight stranglehold near the point can invite bad posture, whereas holding it far from the point, without resting your hand, will give you maximum manoeuvrability with the minimum of effort.

If you do need to sit, lean the board on a low easel, a 'donkey', or the back of a chair, and sit well back without hunching your body or resting your arm or hand on the paper. Above all, make sure that you are comfortable and ready for action.

Preparing to Draw

Line, the Versatile Mark

Where do we draw lines? With a pointed, mark-making tool such as a pencil, a line can be used to describe many aspects of the world around us. In fact, the most familiar uses of line in drawing do not represent a line that is actually visible in reality, and could therefore be called symbolic, like letters or numbers. We take for granted the idea that a line can create a visible description of an object, but – just as a map is not territory and does not look like earth, water, trees and rock – none of the examples in the drawing below would appear to us in the real world as black lines.

This black and white drawing is, like a map, merely an abstract description of perceived edges, boundaries, tone, texture and movement. Two eyes can see edges 'three-dimensionally'

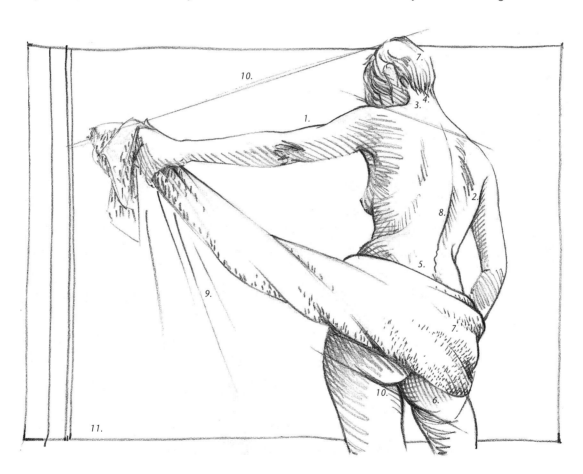

Symbolic or non-visible use of line.

1. where the body edge, as we see it, meets the background or foreground;
2. where the edge of one part of the body meets another;
3. where there is a change of tone (e.g. a shadow);
4. where there is a change of texture;
5. where there is a change of colour;
6. to describe tone, or shadow, by drawing lines close together or overlapping;
7. to describe texture using the same method;
8. to accentuate a visual statement;
9. to convey movement;
10. for linking points to each other (inside or outside the body shape);
11. to create an abstract boundary or decoration.

Examples of visible lines.

1. where two parts of the body overlap or meet and cast a thin shadow;
2. where a part of the body casts an immediate and thin shadow on the ground or another surface;
3. where the skin creases or wrinkles like a narrow crevice where little or no light can reach.

because each one supplies a slightly different image to the brain, informing us not only of height and width, but also of the third dimension, or distance from our eyes. Sometimes we can 'see' an edge that is not actually visible simply by its context, or because, from memory, we *expect* to see an edge.

Line drawn to express *visible* line is less common, simply because there are relatively few conditions that cause narrow, dark, finite marks. Examples of visible lines are shown in the drawing (*above*).

As you can see, line is used far more for imaginative reasons than literal ones.

PREPARATORY EXERCISE: **USE OF LINE**

— POSE: Standing
— TIME: 5min
— MEDIUM: Pencil

Draw the model using lines only to illustrate what you see. Now count, from the lists above, how many different types of description you have used.

The Theory of Relativity

The following exercises explore different uses of line and are intended to loosen up, empower and develop a curiosity in the artist about relative lengths and angles directly as they are seen.

They constitute a basic drawing toolbox, and will help the eye, brain and hand to enjoy working together, and develop good drawing habits.

The secret of successful objective line drawing lies in the practice of assessing and marking relative lengths as they are *seen*, two-dimensionally, as cleverly and accurately as we assess relative lengths as they are *known*, three-dimensionally. The exercises will help by looking at the bigger picture of visual reality and then adding velocity to the equation! First, however, it is important to know a little more about our normal day-to-day processes of looking. How exactly do we use our eyes and brain?

PREPARATORY EXERCISE: **OBSERVING HOW WE SEE**
In order to directly understand more about the way we look at an object, follow this exercise without reading ahead:

— POSE: Standing
— TIME: 10min

Using line, draw the model in a way that feels most natural to you, observing how you are looking and what attracts your eye. As you draw, are you aware of small or large shapes? Are you following an edge? How conscious are you of the edges of the paper?

Now look around you. How do your eyes move? Smoothly, or in jumps? If they jump, what kind of information are they jumping from, and to? Are you aware of large or small areas? The brilliant teamwork of the eye and brain can peripherally and unconsciously scan a scene, and in nanoseconds be concentrating on the detail.

So, because we tend to 'hop' from one specific point to the next (taking the large-scale information for granted), we also tend, at the beginning, to draw in the same way, journeying (usually from the head, of course!) down the body, piecing and tacking together one small area to another. However, if asked to divide a length into sixteen, most of us would not start at one end, travelling hopefully down the length, but would look, firstly, for the middle point, comparing the large lengths and *then* work methodically towards the smaller sections.

■ running out of space, leaving no leg room;
■ heading off in the wrong direction, the drawing looking as if it is 'falling over';
■ a change of scale on the way – big head and shoulders, short legs, tiny feet and hands, 'frayed' at the ends with fingers and toes;
■ running out of time to draw the legs.

Does your drawing suffer from any of these beginner's problems? If it does, do not worry, the next exercises will help to cure them and relax you.

EXERCISE: **RHYTHM AND CURVE**

What will you learn? You will be able to describe the weight, balance and 'intention' of the pose, and thereby achieve better proportions. By rewinding the 'tape' of the visual process to the preliminary scanning stage you will learn to focus on the larger shapes first, and will therefore not be tempted to draw unrelated detail too soon. These exercises also encourage a physical freedom of movement when drawing.

PREPARATORY EXERCISE 1 (NO MODEL)

Take several large sheets of different paper and, without resting your hand or arm on the paper, simply make marks with first pencil, then charcoal. Vary the pressure and feel the difference in friction or 'bite' on the surface. Holding both together, compare their behaviour simultaneously. By swinging your arm in a circular movement, try making 'aeroplane' marks, landing and taking off from the paper as smoothly as possible, approaching the runway from many different directions. Now think of your body as an articulated crane (legs, spine, shoulder, elbow, wrist, knuckles), and see how many subtle manoeuvres and marks you can make.

PREPARATORY EXERCISE 2 (NO MODEL)

This exercise is good for control. Draw two dots approximately 15cm (6in) apart, and very slowly make an aeroplane (not a helicopter!) mark, gently landing on the first dot. As you do so, immediately transfer your gaze to the second dot and, preparing to take off smoothly, leave the paper at that point. Repeat this exercise, drawing in different directions and at greater lengths, remembering not to obscure the view of the second dot.

Now you are ready to start life drawing with a model.

EXERCISE

— POSE: Ask the model to freely swing the arms, bending the body, until an expansive standing pose is found
— TIME: 3min (intentionally short to inhibit dallying with detail!)
— MEDIUM: Pencil

First, assess the general dimensions of the pose, and turn your board accordingly to allow for maximum drawing space. Then scan the pose and, ignoring the detail, look for the longest *single* curve (only bending once) that runs imaginarily through it; it often links the top and bottom, or right and left, of the body. To do this, point your pencil at the model and, swinging your arm, trace across and through the whole shape until you find that curve. It might not follow a body edge continuously, but just touch the bumps; it might cross the body, for example from

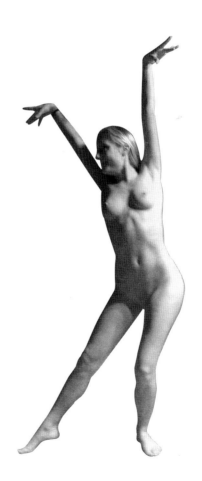

A dynamic pose.

right shoulder to left foot; it might even be a direct link in space between external points. Remember, however, that it must be a single curve, and not an 'S'-shape.

Treat this as a worthwhile game, because the identification of this longest curve usually describes the intention of the whole pose as *you* see it (note that your choice may not be the same as your neighbour's). Now, using 'aeroplane' marks, and still swinging your whole arm, gently and very lightly draw this curve. Concentrate only on length, direction, and whether the curve is concave or convex. If it is not right, draw it again and again until it is, and you are pressing a little harder. Make large, expansive sweeps of the arm, and avoid 'knitting' (making short hesitant marks). Remember, these initial marks do not have to be perfect first time.

Now look for the second longest curve and see how it relates to the first, in both position and length. If the marks are wrong, just press a little harder in the right place but keep moving, swinging your whole arm and stepping back to see the 'big' picture. With a standing pose, ensure at an early stage that the legs are long enough. If the model's feet are apart, draw the arc between them because, while the brain knows that they are on horizontal, flat ground, they may not *visually* be at the same height. Also, if

the arm or leg is bent, establish its general placing as a whole shape, by converting the angle to a curve. Often both arms will make a single curve, running through the shoulders from fingertip to fingertip, and even a circle or oval (which is a continuous single curve). Look out for the spine, or the central surface lines of the torso and head, as these are also important and helpful statements.

> I feel liberated! My drawings suddenly have energy and have come alive!
>
> BEGINNER
>
> Three of these at the beginning of every session really help to get my eye and hand in.
>
> PROFESSIONAL ARTIST

The first curves.

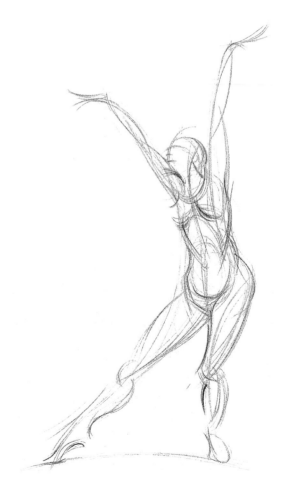

The finished sketch.

TIMING	AN OBJECTIVE EYE
The time limit on quick poses must be respected, as models will feel better inclined to take up more dynamic, strenuous poses if they trust the time-keeper. A 'one-minute-to-go!' signal is very galvanizing.	Stand back/turn around/walk away from your drawing as often as possible in order to re-see it objectively.

Gradually work towards the shorter curves, such as leg and arm muscles, and the curves around the body – the collar bones, abdomen, ribcage and waist – until you reach the smaller curves of face, hands, feet and so on.

What does this drawing convey? A sense of movement and life because the lines are not continuous or sealed, but fade at the ends and, being multiple, give it a breathing, transitory, or 'becoming' feel. Also, all parts of the body usually work together to perform a task or create a pose (such as stretching, reaching, or lying down), and the long curves convey that sense of unifying intention.

Draw several completely different, but equally dynamic, 3min poses, then change to charcoal and note the difference. If the marks are confusing or wrong, simply wipe them away with the hand, feeling your way towards a strong, dynamic, dark line drawing.

If you are working in a group, set up a comfortable pose, then choose and draw your first three curves, and number them in order. Then, with the model still in pose, walk around the room to see what other people have seen. Do you agree with their choices?

THE ADVANTAGES OF RHYTHM AND CURVE

'Rhythm and Curve' is excellent for kick-starting a life-drawing session.

FOR THE ARTIST:

- He/she stops worrying that 'this drawing must be perfect because it's a long pose'.

- There is no time to worry about what their drawing looks like to others.

- The technique loosens up hand/arm/body movement, and opens up eye/brain/hand channels, and because the artist must work at speed, this stops the brain 'correcting' the drawing.

- Short poses can be more dynamic, and therefore visually stimulating.

- The artist gets to know the model's natural body language or idiosyncrasies; longer poses that have to be comfortable do not always express these.

FOR THE MODEL:

- He/she stops worrying that 'this pose must be comfortable because it's for a long time'.

- A new model has no time to worry about what he/she looks like to others.

- Because shorter poses can be more dynamic, muscles can be flexed and so become less exhausted, and the quick changes can exercise the whole body.

- A model can have greater freedom to think of the next pose and express her/himself.

- A new model can 'get to know' the group by facing in different directions in a short space of time.

In short, this is an opportunity for model and artist to engage with each other in the same space.

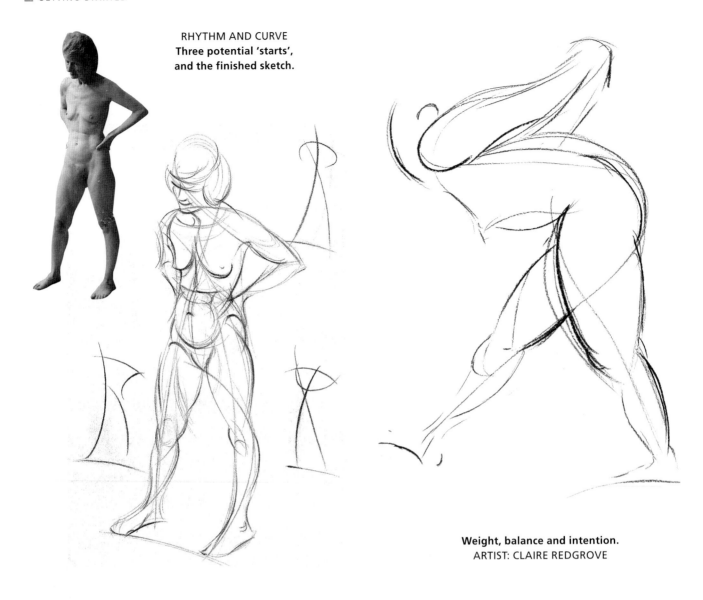

RHYTHM AND CURVE
**Three potential 'starts',
and the finished sketch.**

Weight, balance and intention.
ARTIST: CLAIRE REDGROVE

GROUP EXERCISE: **COMMUNAL RHYTHM AND CURVE**

This exercise is instructive as well as great fun: with a 15sec timer, all move around the room building up communal drawings by adding one line to the next drawing. No erasing of lines this time!

EXERCISE: **CIRCLING**

Circling establishes the relative scale and direction of the body components. Because detail is not required with this method, Circling, like Rhythm and Curve, is particularly useful for comfortably easing the beginner into mark-making, working broadly across the paper and allaying fears of inaccuracy. Scanning general dimensions and angles is the main aim of this enjoyable exercise, which can become almost hypnotic.

What will you learn? You will understand how the body shapes are articulated and relate to each other proportionately, and how to draw shapes that are foreshortened (or tilted towards the viewer, like a bent leg seen from the front). Circling also improves the control of mark-making, and helps the artist to relax while drawing a two-dimensional flat image that the brain knows to be three-dimensional. By simultaneously looking at, understanding and drawing what is seen, this exercise opens up and treads the pathway between eye, brain and hand, which develops their smooth co-ordination.

By asking simple questions and using gentle, exploratory marks before making a final decision, this process allows time for the brain to consult the eye about the larger dimensions and their placement, rather than racing to draw the detail. Also, because pencil-circling continues all the time, even while looking at the model, the brain has less opportunity to instruct the hand to draw what it 'knows' the shape is three-dimensionally, and is obliged to instruct the hand to draw what the eye is actually seeing.

Ask your model to stand symmetrically with arms and legs straight. How many major components make up the human

body? Sixteen, if the neck column is included and the smaller finger and toe joints are not. Ask your model to bend arms, legs and body. Look for the joints and dimensions of the body components between those articulation points. The trunk will sometimes follow one directional intention, but the upper and lower sections of the trunk can turn and bend independently due to the articulation of the spine at the waist between the ribcage and pelvis.

EXERCISE: CIRCLING – SIMPLE SHAPES

This exercise is only concerned with describing these shapes very simply in terms of their general width, length and direction.

— POSE: Standing, with the weight mostly on one leg
— TIME: 5min
— MEDIUM: Soft pencil

Start by swinging your arm in a circling movement, like a pendulum, in order to draw circles, ovals or ellipses. This movement should be continuous, so that the pencil stays on the paper all the time. Now move the pencil, very gently, onto the paper to 'circle' the largest component shape. If the trunk, leg or arm is not bent or twisting, describe it as one shape. While circling very lightly on the paper, look at the model and ask:

- ◼ How big is this shape? (Keep circling.)
- ◼ Where on the paper should it be placed so that all the model will fit in? (Keep moving while feeling your way around the paper before settling the shape.)
- ◼ How high is this shape in relation to its width: narrow and elliptical, or wide and round? (Keep going, and press a little harder.)
- ◼ In what direction is this shape inclining? (Now press hard, but don't stop circling.)
- ◼ Without taking your pencil off the paper, move to another big shape, asking 'where is it, relative to the last shape?'; 'does it overlap?'; 'how large, high, wide, what direction?' and so on.

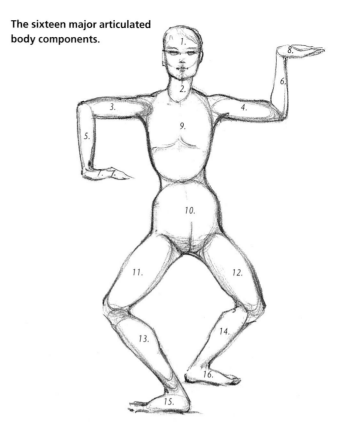

The sixteen major articulated body components.

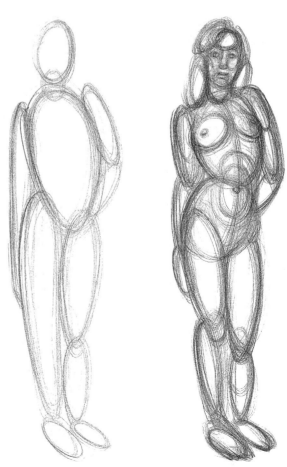

ABOVE: **Identify the largest component shapes.**

RIGHT: **Establishing local and relative dimensions, and the angles of the large shapes.**

FAR RIGHT: **Medium shapes within the large shapes.**

■ Keep circling round all the major body parts, moving from the larger to the smaller shapes until you've drawn the figure. (Don't stop swinging the pencil until the five minutes is over, but circle from shape to shape, refining and perfecting their proportions and angles.)

How does your drawing look? Does the slim model you see before you look like a tyre advert in the drawing? If so, slim down the ellipses in the next drawing. Did you fit all of the body into the paper? The answer is probably yes, but if not, look more carefully at the available space with the next exercise.

EXERCISE: **CIRCLING – COMPLEX SHAPES**

— POSE: Curled-up, compact shape
— TIME: 7min

It may be that the whole pose suggests an ellipse, so start gently with that shape, positioning it comfortably on the paper, and little by little work into the next-largest shapes as before, until you are circling the smaller shapes of the fingers, toes, eyes, ears, muscles, kneecaps and even waves of hair. Introduce external circling for important concave curves. Now take your pencil across the trunk as though you were wrapping thread around it, pressing harder on the 'seen' side in the front, and barely at all on the 'unseen' side behind. Do the same with the other body parts.

Do more of these exercises until you (your brain and your arm) feel mentally and physically comfortable with the idea of looking backwards and forwards to the model while drawing. This is best achieved by relaxing, only considering the simple questions of scale and direction, and not worrying about the outcome. (Many errors can be avoided by not only looking at the model before drawing each mark, but as much as possible *while* drawing.)

What does this method convey? Although the image is puppet-like, this technique produces foreshortened shapes that look convincing, and gives a sense of volume and form to a drawing. Also, because it refines the skill needed to vary pressure, the marks can say 'I'm searching, discovering, just looking, suggesting, whispering, hedging my bets' – or, 'Look! see what I've just discovered', and thereby enlarge the artist's vocabulary for self-expression.

Measuring and Angle-Finding

While Rhythm and Curve and Circling are designed to relax and encourage, the following two methods will put you in control of your drawing and give you more confidence. Together they comprise the key to accuracy because they ensure the correct length (the right relative proportion) and the correct angle (the right direction of mark).

DEALING WITH HIDDEN SHAPES

When circling partially overlapping shapes, draw the whole of the hidden shape very lightly, using the visible information as a guide. Then impose the top shape with a stronger mark on top. This helps to ease the eye/brain relationship by linking, and making sense of, the visible and known realities.

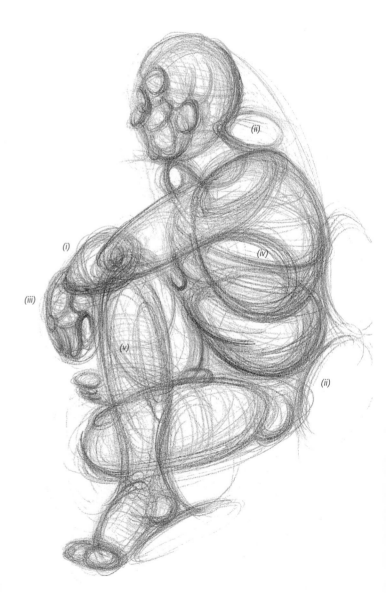

Note **(i)** the foreshortened arm, **(ii)** the external curves, **(iii)** the breakdown of the hand, **(iv)** the line wrapping round the body, and **(v)** the hidden shape overlapped.

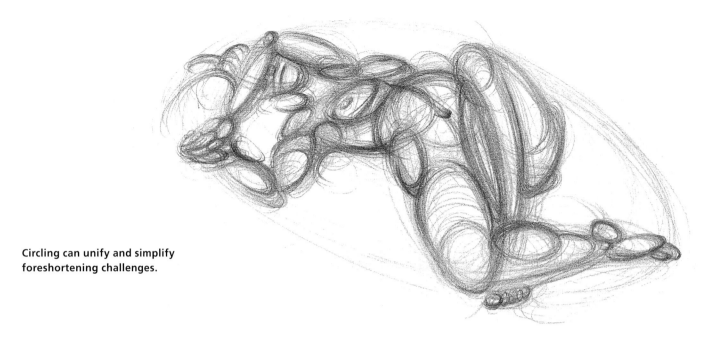

Circling can unify and simplify foreshortening challenges.

EXERCISE: **MEASURING**

Learning how to accurately measure and compare two relative lengths will put the artist in control of proportions, positioning and scale, and prove to the brain that visual and actual relative dimensions are not the same. All you need for this is a long pencil and a reasonably steady hand.

— POSE: Model standing with hands on hips, the body approximately facing the artist who is not less than 5m (16ft) away
— TIME: As long as it takes for both measuring and angle-finding exercises. (Remember to mark the position of the feet with chalk beforehand if the model needs a rest.)

When measuring a length, always hold the pencil or measuring tool at the same distance between the eye and the model for both measurements; at arm's length is consistent. Also, be very careful when measuring a length that, while the pencil may be used at any angle from side to side, it should *never* tilt either backwards or forwards from the eye. Imagine that the pencil is being held against a window, which represents the flat two-dimensional drawing. This can help to resist the urge to follow the length into the three-dimensional distance!

See how the observed length changes if you:

▓ tilt the pencil away from/towards you;
▓ draw the pencil closer;
▓ move backwards or forwards in relation to the model.

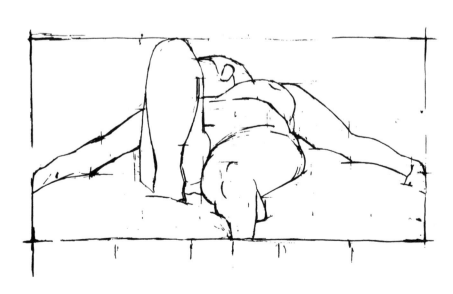

A precise and highly measured drawing of extreme foreshortening.
ARTIST: PIERS OTTEY

The most important question to ask before starting to draw is, how high is the whole shape in relation to its width? If you know which is longer, then at least you will know which way to put the paper and board on the easel. ('Portrait' is the term for an image that is longer vertically, and 'landscape' for an image that is longer horizontally.)

First of all, assess which of the two major dimensions is shorter (in this case, the width across the body from elbow to elbow at their extreme edges). Draw four dots on the paper, which look well placed to describe the extreme width and height. Now guess by eye (no measuring) how many width-lengths there are in the height: 2? 2¼? 2⅓? 2½? To do this, let your eyes 'walk' the distance, scanning slowly across the two lengths, back and forth.

Now close one eye and, holding your pencil by the base, not the point, hold it out at arm's length. (The reason for holding the pencil at the base is that you can immediately draw your discoveries. Also, in the time it takes to turn the pencil around, the brain can seize the opportunity to change the findings!)

Horizontally, line up the tip of the pencil on one model-elbow, and then slide your thumbnail along the pencil to the place where the other model-elbow appears on the top edge of the pencil. This will be used as a basic unit of measurement, as seen at exactly this distance between both your eye and the model. *Do not move your position or thumb on the pencil for the duration of this measuring exercise!*

Now it is possible to measure how many times this unit (in this case, the width) will fit, or 'go', into the height. Keeping your thumbnail in this place on the pencil, turn your hand and pencil to a vertical position and line up the thumbnail with the bottom of the lowest toe that you can see.

See where the tip of the pencil is in relation to the body and, holding your eye on this body-point, move the hand and pencil (the unit) up to a position where the thumbnail is now aligned with that body-point. Because the unit is still within the height, move it up again, and again, if necessary, counting the units as you do. When the top of the head is seen within the unit of measurement, assess what proportion of that unit of measurement it inhabits, for example ¼, ⅓, ½, and so on. Never fail to do this: even when it looks as if it is only 'just a little bit' extra, it can often be a surprise, especially when the 'little bit' is nearer to you!

Now the width-to-height ratio of the pose should be established, for example 1:2⅓ in the case of the illustration, though

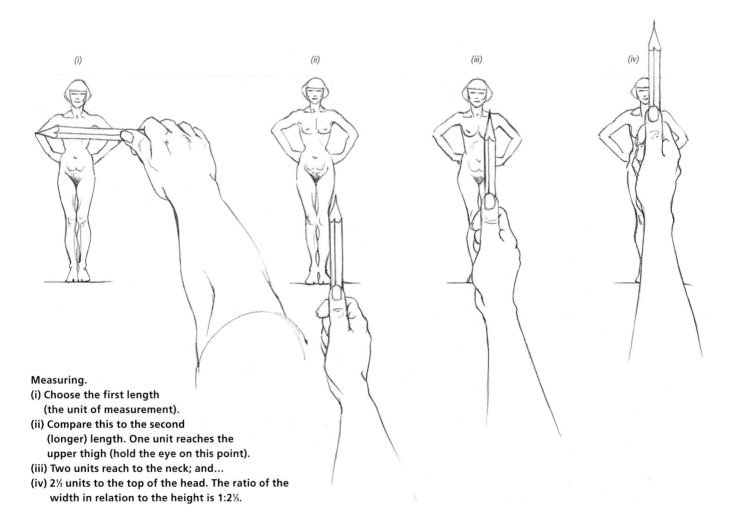

(i) *(ii)* *(iii)* *(iv)*

Measuring.
(i) Choose the first length
 (the unit of measurement).
(ii) Compare this to the second
 (longer) length. One unit reaches the
 upper thigh (hold the eye on this point).
(iii) Two units reach to the neck; and…
(iv) 2⅓ units to the top of the head. The ratio of the
 width in relation to the height is 1:2⅓.

yours may be different. You can now check the ratio of the estimated dimensions that you drew. Lay the pencil on the paper, and measure the distance between the two dots that you originally marked for the width of the pose, by placing the point of the pencil on one dot and sliding your thumb up to the other. (If the pencil is too short, simply stand back in the same direction from the drawing, not to one side, with the pencil at arm's length, until the drawn width can be seen within the pencil length, and stay there for the comparison to the height.)

How many widths fit into the height on the paper? Do your estimated and measured ratios agree? (Remember to celebrate both your successes and discoveries alike!) Adjust the marks if necessary until all four marks represent the accurate ratio and fit comfortably on the paper. Then guess, draw dots, and check some more important measurements: head to elbow, elbow to bottom of foot and so on.

Do not be tempted to draw sight-size – that is, the size of the actual pencil measurement – because this would limit your skill by obliging you to draw either a minute image of a distant model, or a 'too-large-for-the-paper' drawing if the model were very close. Once a ratio is established, an image can be drawn at any chosen size, from miniature to mural.

It is useful to compare a shorter length to a longer one, rather than vice versa, because fractions are generally more difficult to assess on the pencil than the multiplication of one unit. It is also safer to compare lengths that are not extremely dissimilar. If the ratio is 1:7, for example, any small error in the first unit or in misplacing the unit along the longer length will, like a Chinese whisper, multiply the mistake, resulting in a large margin of error.

Standardized information concerning the number of head-lengths there are in the length of a pose can be very misleading and unhelpful for three reasons: adults and children and individual people have different head sizes; the unit is relatively small and may cause inaccuracy if compared to a much longer length; and if the model's pose is bending, sitting or reclining at a foreshortened angle to the artist, this formula will not apply.

Fixed 'rules' like this are fine for the intellect of the armchair artist, but real life is far more exciting and variable. The practising artist knows that the key to successful objective life drawing relies not on applied formulae but on observation, learning and action in the moment. Measuring, however, is useful for checking, for certainty, proportions specific to each situation and as visual proof for your brain. Nevertheless, the best tool that you have at your disposal is your eye. For this reason, it is really important always to use your eye first to compare two lengths, and to draw them before checking by measuring. Treat it as a game – it's no fun if you know the answer before you've placed the bet! Do not put your faith in measuring alone, but continually practise and increase the ability of your brain to trust your *eye*. This way, you will eventually be able to draw perfect proportions without measuring at all.

Relative head size varies with pose, age and individuality.

EXERCISE: **ANGLE-FINDING**

Like measuring, angle-finding should be treated as a checking process after you have drawn a line, so that eventually the brain learns to refer to the eye.

— POSE: Model standing with hands on hips, as before
— TIME: Until the artist feels comfortable about angle-finding

Using only your eye to assess the angle, draw a straight line between two points on the paper, for example elbow to foot. Now, to check it, close one eye, hold the pencil by the base (for the same reason as before), and line up the edge of the model's foot and the elbow, without tilting the pencil away from you, so that these points just 'touch' the edge of the pencil. Bring the pencil closer to your eye, and notice that the angle (unlike a measurement) does not change.

Holding the pencil firmly and still close to the eye, turn your whole body to face the paper (without changing the pencil-angle). Check the angle that you drew by lining it up with an established point – in your case, the dot for the edge of the model's elbow. Hold your eye on the paper further along the edge of the

pencil and, maintaining the same angle, immediately draw a line, representing that angle, on the drawing, down from the elbow dot on the drawing. Remember that, at the moment, this line only represents an angle, not a finite length, so draw it well beyond the point – later you will be certain where it should end.

If the angles of the two lines do not agree, it may simply be that the elbow points are not at the right height, so adjust them, making sure to keep the original overall width–height ratio. Look, draw, and check more angles – with the pencil close to the eye – until the action feels natural.

Holding the pencil close to the eye makes angle-finding and checking a very fast and efficient process, for several reasons. Because the pencil only needs to be between the eye and model, *then* between the eye and paper, the angle can be easily maintained. If, however, the pencil is held out at arm's length (as for measuring), then pulled in and then put down onto the paper this extravagant journey can cause enough arm-swing to completely change the angle on the way and offer the brain yet another chance to draw from the 'memory store'. Likewise, if you are sitting to draw, hold the pencil close to the eye and swing the arm down from the shoulder joint, not the elbow; this is an easy manoeuvre and maintains the same angle. The pencil, if held at arm's length, is often not long enough to encompass the whole angle-length to be checked. Also, when a short or subtle angle is to be assessed, the pencil, if held closer, will act as a visual 'amplifier' or 'megaphone'.

These two processes are wordy to explain but are well worth practising, because once mastered, they are the tools of autonomy and will ensure not only that you can construct an accurate drawing with confidence, but also that you will never need another person to tell you if, where and why your drawing has gone wrong. By checking the larger measurements and angles first you will know the shape and direction of the pose, and will also be in complete control of the scale and placement of the drawing on the paper.

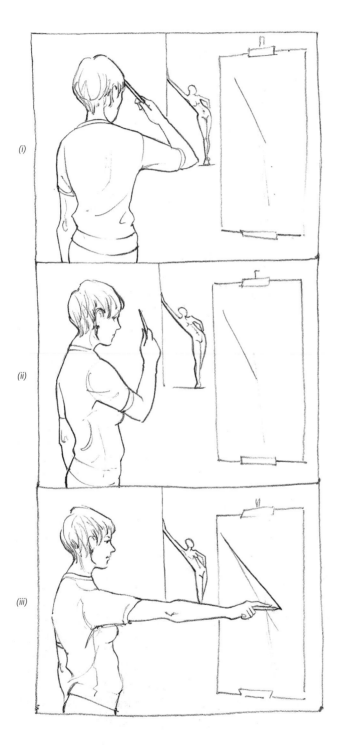

(i)

(ii)

(iii)

Finding and checking the angle on a different, leaning pose: (i) find; (ii) check; (iii) draw.

TACKLING HORIZONTALS THAT 'TILT'

When anything (feet, body or cloth, for example), is lying flat on a horizontal surface, it is extremely tempting to automatically represent the base by drawing a horizontal line, even though the seen angle may not be, simply because the brain interprets and 'knows' the ground to be horizontal in reality. To combat this, first find the angle and then, focusing solely on the pencil, simply ask yourself whether the angle of the pencil is nearer to horizontal, vertical or diagonal. Be prepared for some surprises. Conversely, limbs that are in reality bent or angled may be visually straight if viewed 'head-on' or at the same level.

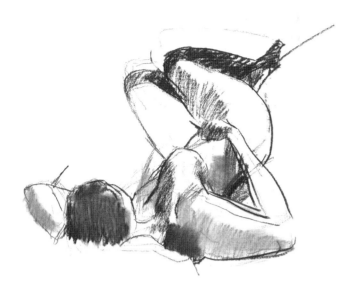

Shoulders, bottom and feet that are horizontal in reality, but not visually (or in the drawing).
ARTIST: BILL STOTE

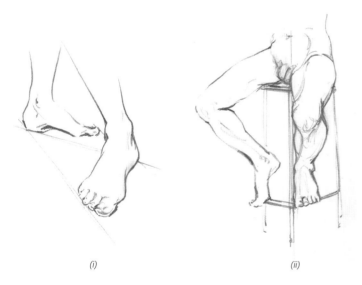

(i) *(ii)*

**(i) Feet on the ground; these are at different levels in the drawing.
(ii) The crotch, knee and foot of the bent leg are aligned as seen, and then drawn.**

EXERCISE: **FIVE-STAR**

This exercise immediately puts into practice these measuring and angle-finding skills, and is invaluable for the accurate planning and layout of a drawing before any commitment to detail. It also enhances the steady progress of harmony between the 'realities' of brain and eye.

What will you learn? You will become instinctively aware of the relationship between the extreme and important points of the pose, which will help to place the drawing where you want it to be on the paper. It also helps to avoid being tricked by the brain into drawing the foreshortened lengths as longer, 'known' lengths.

— POSE: Standing with most of the weight on one leg
— TIME: 10min

Treat this exercise as a game. Look at the model and select just three precise, or 'star' points, those that you consider to be the most useful to mark down to ensure that the whole pose is comfortably placed on the paper. Usually these are found at the extremities of the pose, at the highest, lowest, furthest right and furthest left points. By choosing only three points, and not four, you will become an expert at prioritizing their relative importance. This will help you not to overlook that visually longer, nearer leg, sticking out towards you on the 'flat' ground! You will soon be able to know that an arm, leg, bottom or head may extend the surface area needed for the drawing, often more or less than you think.

If working in a group, take the time now to move around and visit other 'observation sites'; this will help you, the student, to understand and witness the different visual realities of the same pose.

Now, mark the three points with dots, considering their distance from, and the angles between, each other and the edges of the paper. Then lightly draw the angles. It is possible for the angles to be accurate and the dimensions wrong, so check both by measuring and angle-finding.

> For me, the reason, the thrill, the buzz of life drawing, is seeing links across the body.
>
> EXPERIENCED ARTIST

Now choose a fourth 'star' point, and mark, draw and check the angles and distances relating to the others; this may be another extreme point, though in some cases an extreme 'star' point may be both lowest *and* furthest left, for example. In this case, an inside point (for instance the navel or crotch) may be the next most useful because, as it is placed at a similar distance from the others, it will be easy to check them by their interconnection at that more central point.

Finally, choose a fifth 'bonus star point', and again draw and check the angles and dimensions from every point to each other. It is important not to rush this process, because these five points will be the immovable 'constellation' that forms a clear, reliable framework for an accurate drawing.

RIGHT: **Look for the three most important 'star' points: the top and bottom are clear choices, but does the left-hand or the right-hand side qualify for the third 'star' point?**

FAR RIGHT: **The left-hand, rather than the right-hand extreme point was prioritized because it projects a little more from the main body shape. (The question has now alerted the artist to leave adequate space on the right.)**

BELOW: **Five-Star, showing the choice and order of points.**

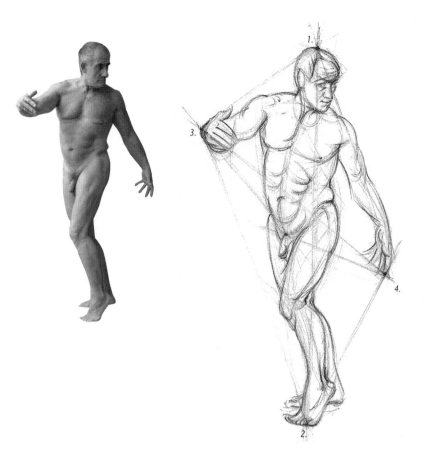

Now you can relax and, using Rhythm and Curve, draw the pose loosely, within this structure, always respecting your five 'star points'. If you have time, draw the finer detail – and again, if you do not, don't rush the big shapes! Of course, you may choose as many 'star points' as you wish, but remember always to prioritize, choosing the most important first.

What does this drawing convey? A good sense of structure, accurate weight distribution, and an awareness of the whole pose, with all the parts of the body interrelating and working to one purpose.

EXERCISE: **THE ELASTIC BAND**

Like Five-Star, this exercise links extreme points and is very useful and empowering for the beginner. It is simply based upon drawing lines between the extreme boundary points of the 'plot' on the paper designated for the drawing of the model.

What will you learn? With practice, this exercise will enable you to instantly assess the nature of the shape of any pose, and the area needed to draw it, without being misled by foreshortened areas (shapes that are tilted towards, or away from, the artist). This avoids running out of space, a scenario that leads either to wasting good drawing time and energy trying to squeeze the pose onto the paper by shrinking, bending, blindly hoping for it to fit, or pretending to ignore the problem. (Both of these are mentally discomforting!)

While knowing the three-dimensional 'story', in following this exercise the artist is obliged to draw the two-dimensional visual experience, and is therefore put in control of positioning and scale on the paper.

— POSE: Sitting on the ground, leaning on one arm
— TIME: 10min

Imagine the model as a flat, two-dimensional shape, like a brooch made from a beaten metal so expensive that, to avoid waste, the shape from which the brooch will be cut must be extremely economical. The shape of the pose within will be revealed by simply cutting the negative shapes between the extreme points (as, for example, a three-dimensional sculpture is 'found' within a block of marble). Then imagine putting an elastic band around this brooch, and draw it, literally joining the extreme points, one by one around the pose. Remember, an elastic band can only stretch directly from one point straight to the next – it cannot bend *inwards*. However, it must follow the convex curve at the edge of the 'brooch', for example the back, head, buttocks.

This process is made easier by pointing, with the tip of the pencil in mid-air, at the model, and travelling very quickly from one extreme point to the next, to note the shape. Do this several times to familiarize your arm with the movement and shape, then immediately draw it onto the paper equally quickly, to avoid interference from the 'three-dimensional brainstore'.

Now check the width–height ratio and the angles between all the points, both adjoining and across the shape. If you want to change the size or position of your drawing, you can easily move or rescale the 'elastic band', which is usually only, at maximum, six lines (this involves far less heartache than erasing and redrawing a precious piece of detailed drawing that just isn't in the right place). You are in control.

Though it is tempting, at this stage, to fill in or cut out the shapes, one by one, the dangers of scale-changing en route, and limbs jutting out of the elastic band, are far too great. A broader, looser approach such as Rhythm and Curve or Circling is called for initially, because these concentrate on the large shapes first. If a toe or finger juts out from the leg- or arm-line, it is wise to draw *from* those points in order to stay in the band. When drawing long-shaped poses, an identifiable point in the middle area is worth marking and measuring to avoid the very common 'long body/short leg' syndrome. Be sure to trust, and stay inside, your 'elastic band' (remember, you did check its dimensions and angles, therefore it was constructed from the visual truth and should be treated as sacrosanct).

By now, any proportional problems that you may have with the drawing should only be local ones of fine tuning. Remember that feet and hands are usually larger, in real dimensions, than we think. (As an experiment, put your wrist knuckles together in opposite directions and see how your hand length

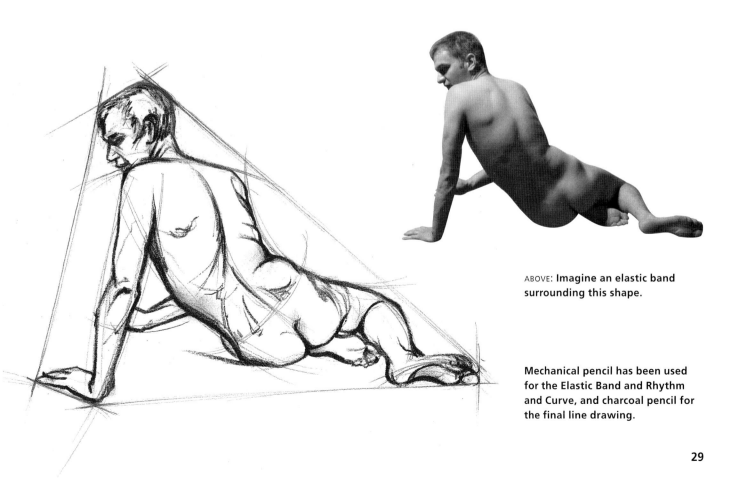

ABOVE: **Imagine an elastic band surrounding this shape.**

Mechanical pencil has been used for the Elastic Band and Rhythm and Curve, and charcoal pencil for the final line drawing.

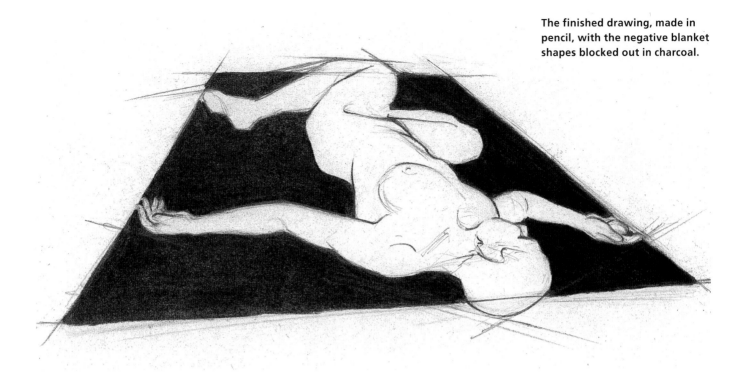

The finished drawing, made in pencil, with the negative blanket shapes blocked out in charcoal.

compares to the forearm. Similarly, put one foot alongside the other leg from ankle to calf. The hand is usually as long as the face, and the foot is usually longer than the head.)

EXERCISE: **NEGATIVE SHAPES**

— POSE: Lying sprawled in an asymmetric star shape on the ground on a plain, square cloth that contrasts with the model
— TIME: 30min
— ARTISTS: Positioned at the head or foot end of the pose, to give a foreshortened view

The aim here is, by first accurately drawing the blanket, then using the Elastic Band method, to eventually block out in black, on your drawing, the 'negative' shapes between the blanket and the body, just as you see them. Resist the strong natural urge to draw the 'known' – in this case, the aerial view. The body should appear to be truly lying down, not propped or sitting up. Does your drawing look convincing upside-down?

What does this method convey? It produces drawings that integrate all the interdependent units as one whole working body. It also gives a good three-dimensional feeling for the 'spread' of the pose in its space.

EXERCISE: **ZIG-ZAGGING**
This exercise is a natural progression from Five-Star but, after such strenuous concentration, is more relaxing. It involves relating

single points of interest, scanning from point to point right across the body, and therefore obliges the attention to stay for some length of time in the pre-detail stage of looking, before describing continuous contour and detail. The brain, itching to interpret, may at first feel held back, but the eye has a field day! At last it is being valued for, and given time to do the job it does so well (and, normally, at lightning speed), which is to search for important key moments and their relative placing and distance.

What will you learn? Zig-Zagging develops an instinctive identification of important points on the pose, by consciously looking for them, marking their relationship to each other, and repeatedly finding different journeys and connecting routes between them (instead of individually tacking one piece of body to the next). Important points are to be found wherever there is a notable visible change – of angle, tone, texture, and so on. These may be intersections, corners, tips, inlets, or at the fullest, thinnest, darkest or lightest point on an edge. By looking continuously from model to paper and drawing quickly, the brain will begin to relax and trust the eye in directing the hand.

— POSE: Any shape or position
— TIME: 10min, with a '2min-to-go' alert
— MEDIUM: Pencil, to begin with

Pressing very lightly, but without taking your pencil off the paper, zig-zag in straight lines directly from one extreme point to another in order to place the model on the paper, only thinking 'what angle, and how far?' Travel at your own speed to begin with, but don't stop for too long at any 'station'. Choose

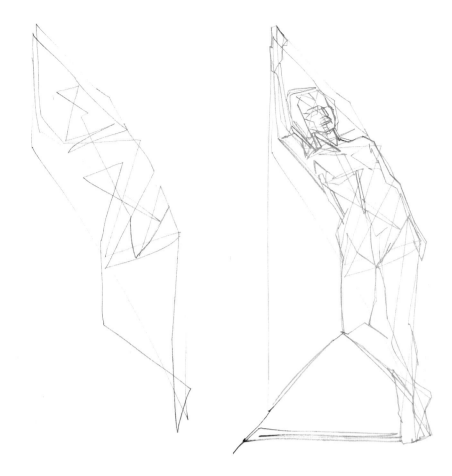

ABOVE LEFT: **A leaning pose.**

ABOVE: **First visit extreme destination points, then internal junctions that catch the eye.**

ABOVE RIGHT: **More exploration, and some edges are drawn.**

LEFT: **More discovery, correction with a stronger line, and finally the edges are drawn.**

any significant point to travel to next – it doesn't matter which – but don't follow the edges. To avoid travelling only to the nearest stop, swing your eye far across the pose to, for example, an ear, the narrowest point of the waist, toe, nipple, or the widest part of the buttock or elbow.

Revisit points over and over again, and to occupy your brain, change the routes each time like a switchback, revising distances and angles as you go. Relax, don't worry if the first marks aren't right – you'll travel this way again, but maybe arriving from a different station – just keep moving! If you feel lost in the 'maze', travel out to the extremities again and use them, like satellite signals, to find your bearings.

Gradually speed up and apply more pressure to make darker marks, especially on the body edges and inside shapes, until the

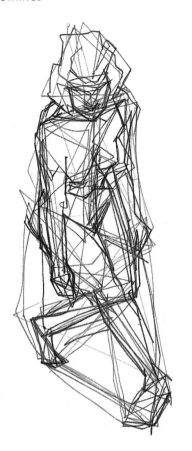

Zig-Zagging is ideal for a pose with subtle foreshortening and overlapping limbs.

BELOW LEFT: **A compact but intricate pose.**

BELOW MIDDLE: **This method creates a sound underlying armature for a longer pose.**

BELOW RIGHT: **Zig-Zagging is equally good for quickly grasping the structure and dynamics of short poses.**

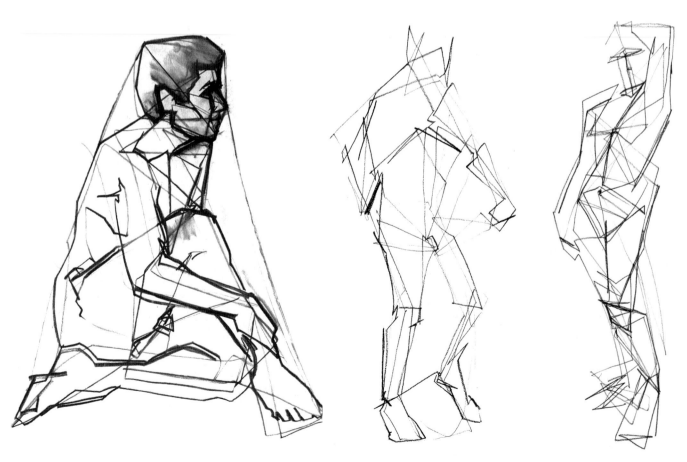

model appears on the paper 'wrapped' in pencil threads. At the 2min warning, draw along the edges of the body with straight lines, still keeping the pencil on the paper (lightly skimming to a new edge when you come to a cul-de-sac).

What does this method convey? A sound, external, three-dimensional structure, with an architectural feeling, as though the model is housed within a wire frame or armature.

> This is so much fun – it's like being on a fairground ride – I felt quite dizzy afterwards, but when I stood back, the model was on the paper!

Conclusion

These preliminary exercises take a more direct approach to drawing what is seen. While perspective, foreshortening and balance are automatically inherent in any pose, the exercises in the following chapter will focus specifically on personal viewpoint (in the literal sense) and gravity.

Selected dark shapes heighten the structural power of this Rhythm and Curve drawing.
ARTIST: JO GIBSON

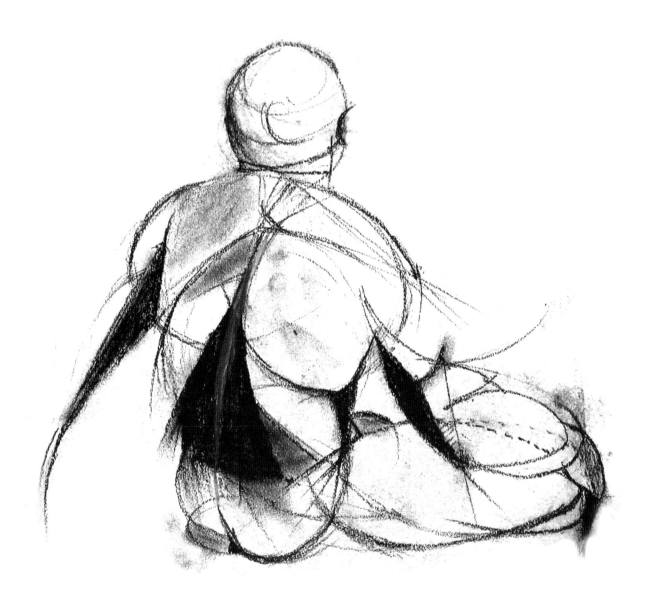

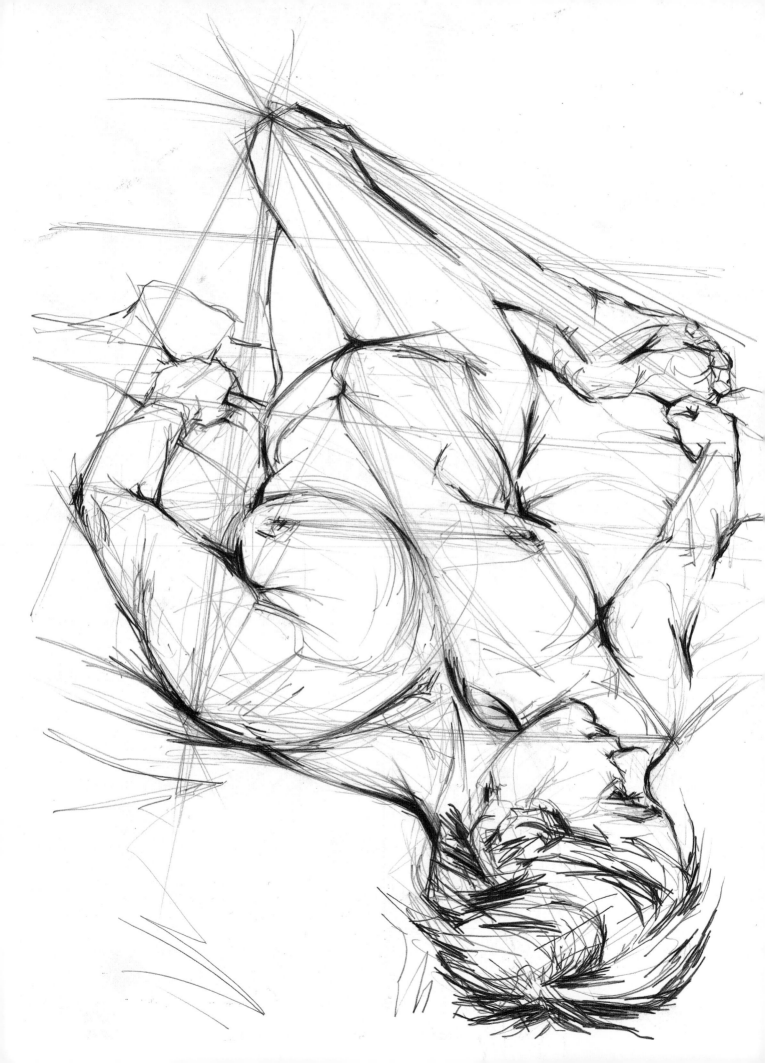

PERSPECTIVE AND COUNTERBALANCE

The fact that we can objectively measure the lengths, heights and distances of our surroundings and experience the force of gravity is something that we all share and take for granted. However, the concepts of perspective and balance are especially interesting for the life artist, as the first is concerned with our own eye-view of the world, and the second with the world's gravitational effect upon us, and how we individually choose to physically respond and move our bodies in relation to this powerful attraction to the earth.

The first group of exercises concentrates on accurately drawing two visually real but nevertheless subjective perceptions: perspective and foreshortening.

Perspective and Foreshortening

Perspective is the process of representing on a plane, such as a piece of paper, the space-relationship of objects as they appear to the eye of the viewer – or, quite simply, drawing things as you see them. Though the relationship of the objects can exist independently, perspective cannot exist without a viewer. Therefore, if you have an eye (or a mind's eye), then that perspective exists (even in dreams) and is the visual reality of the individual not an event that can happen either in isolation from a viewer, or identically to two people simultaneously. Move, even by inches, and your perspective will change. Many people feel that perspective can only be successfully drawn if the 'rules' (out there) are accessed and learned first. In fact it all depends upon you, your

LEFT: **This drawing was constructed using the techniques of Rhythm and Curve, Triangles, Joints and Pairs, and the Centre Line.**

position, your observation, here, right now! However, while the visual facts are specifically unique to the viewer, two facts *are* immutable:

- Visual information is larger when nearer to the eye, and smaller when further away.
- This differential of visual information is much greater nearer to the eye, and gradually lessens further away from the eye. (To observe this, measure the relative sizes of three identical objects placed in a row receding away from your eye, at equal distances from each other and compare the ratios. Remember to hold your pencil at arm's length.)

Foreshortening describes the visual shortening of a length when it is tilted towards or away from the viewer. (To observe this, measure, from the same distance, the relative lengths of one plane of an object firstly not tilted, then tilted away from you.) The best tool you have to assess these facts is your own eye.

EXERCISE: **JOINTS AND PAIRS**
While this exercise is the twin to Zig-Zagging, it is by no means identical, as it specifically leads on to the study of perspective by looking at the relationship of corresponding pair-points across the body.

What will you learn? This exercise will develop an awareness of both the *actual* symmetry of the human body, and the enlarging and diminishing effects of *observed* perspective. The perspective of the body, larger when nearer and smaller when further away, will be as evident when drawing the relative angles and lengths between symmetrical points as it is when drawing a building. With practice, the initial sense of challenge that is felt by the brain (when drawing shapes that are totally different to the 'known' shape) gives way to a tangible *enjoyment* of the 'extraordinary'.

— POSE: Model sitting with feet apart, absolutely symmetrically, on a plain chair or stool
— TIME: 30min, with a 15min alert
— ARTISTS: Standing or sitting within a 3m (10ft) distance from the model, at any angle to the model, except directly in front or in profile
— MEDIUM: Pencil

Firstly, walk around the model, and just look for as many identifiable surface points that are truly symmetrical – for example, two big toenails, kneecaps, nipples, elbows, eyes, joints and so on – and study the angles and distances between the points of these pairs. Choose a 'sample' pair, and find the angle that the two points make. Then check the changes in that angle when you move closer, stand, sit, or lie on the floor. (Remember, when angle-finding, to hold the pencil close to the eye, and not to tilt it away from, or towards you.) You will see that, on the model, the pairs run in a transverse direction – that is, across the body. You will also become aware of some interesting and very important facts which, in the diagram below, are written in the first-

person because perspective is a personal experience. This applies to any situation where the symmetrical model or object, such as a box or house, is positioned at right-angles to gravity. (Incidentally, this is not automatically at right-angles to the ground; imagine the angle of a house or person standing on the side of a hill.)

Now choose a viewpoint, and, using the Zig-Zagging method, draw visible pairs of points, joining them by merely skimming the surface of the paper when travelling between sets of pairs, and pressing a little harder between the points. As before, start with extreme and large points of information to give the drawing a comfortable placing on the paper; for example, shoulders, top and bottom points of chair legs, kneecaps, feet.

Start by measuring the height-to-width ratio of the pose, including the chair, making sure not to tilt the pencil away from, or towards you. Then use the Five-Star method to 'place' the model comfortably on the paper and establish, by measuring, an *identifiable* point that is approximately central to the whole pose. Check the distances between pairs as well as those between the points. Where a matching pair is hidden, simply guess where it might be (as though the model were transparent). Do this for 15min and

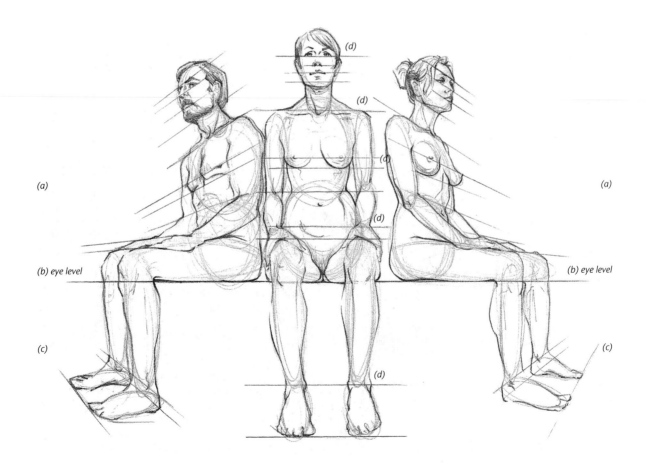

(a) When the points are *above* my eye-level, the angle between them comes *up* towards me.
(b) When the points are *on* my eye level, they are horizontal.
(c) When the points are *below* my eye level, the angle between them comes *down* towards me.
(d) When the points are at the same distance from me – neither angled away from, nor towards me – they are horizontal.

ABOVE: **A close, aerial view.**

RIGHT: **The process alone of identifying and relating twin points enriches the awareness of body structure and perspective.**

FAR RIGHT: **The framework provides the basis for circling in the body shapes and final contour drawing.**

then, in the remaining 15min, check the angles and proportions and draw in the model and chair.

EXERCISE: **CROSSING PAIRS**

— POSE: Symmetrical, lying flat on the back, on the ground or a low horizontal surface, arms slightly away from the body
— TIME: 30min, with a 15min alert
— ARTISTS: No further than 3m away, viewing the model from either the feet or the head end, but not in profile, nor head on to the body

It is also an interesting and useful alternative to choose matching crossing pairs that are visible: for instance, right hip–left knee, left hip–right knee, nipple–shoulder, foot–wrist, and so on. Try to have no preconceptions beforehand, as visual truth can often be stranger than 'fiction'.

ABOVE RIGHT: **'Cat's cradle' construction.**

RIGHT: **More connecting links are added, and after Circling, charcoal pencil is used for the drawing.**

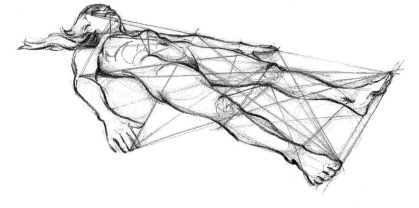

TAKE THE TIME TO TRUST A HUNCH

Whenever a mark looks or 'feels' uncomfortable or inaccurate, don't ignore the message (saying 'Maybe I'll get lucky *next* time'), or turn over the page and start again (this often repeats and, worse, *affirms* the same mistake) – but stop! Relax, stand back and check out the large dimensions and angles first. Sometimes the mark in question is right, and other inaccurate surrounding or large-scale information is making it 'look' wrong. A look at the 'big picture' usually solves the problem. This is not a waste of time, because every time that you do this, another 'golden nugget' goes into the 'reference pot'!

Be patient with yourself. Every time that you draw what you see (not think), accurate drawing will become easier because, as the link between eye and hand becomes closer, so the response will become faster.

EXERCISE: **ASYMMETRIC PAIRS**

— POSE: Model holding any asymmetric pose
— TIME: 30min, with a 10min alert

Using the same method, link reciprocal matching points of the body, which may, this time, be less obvious: for instance, the jutting points of the pelvic bone, shoulder blades, collar bones, ribcage, and so on. Take note, by moving your own shoulders and hips that, while the hip joints and pelvis are fixed and cannot be independently moved, the shoulders, by contrast, can move independently of both the ribcage and each other (*see* Anatomy, p.94).

What does this method convey? The well-observed perspective will give a strong sense of three dimensions and a clear internal structure that is quite architectural.

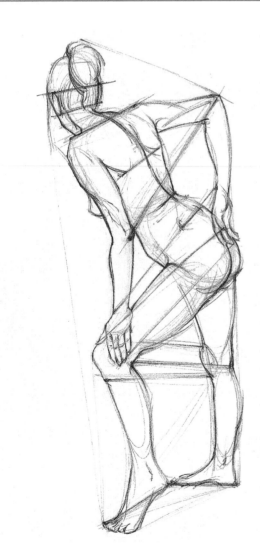

Asymmetric pairs. Note the pairs that are independent, and those that are fixed.

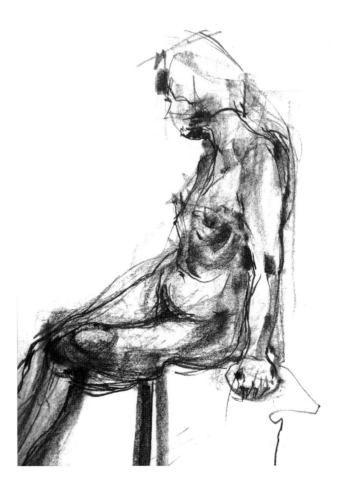

An awareness of transverse Joints and Pairs gives this pose its subtle lean. ARTIST: MILLIE GORTON

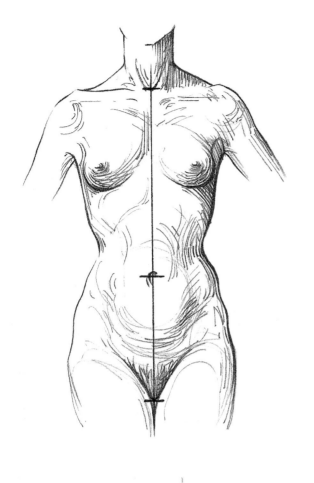

The Centre Line

EXERCISE: **THE CENTRE LINE – TORSO**

The centre line, although not visible as an actual line, is where the longitudinal centre front and centre back of the surface of the body can be discerned (sometimes more, sometimes less). It is very useful in life drawing as a key point of reference, and if placed and surrounded accurately, will give even a line drawing a sense of weight and volume.

Running from the neck down through the centre of the chest and the abdomen to the crotch, the key points of the centre line on the front of the body are:

- the suprasternal notch (the indent at the base of the neck between the collar bones);
- the navel;
- the centre of the crotch.

On the back of the body, the centre line follows the spine and the key points are:

- the centre of the neck, at the top of the shoulders (the vertebrae are fairly visible under the surface);
- the small of the back (the most concave point at waist level);
- the base of the central division of the buttocks.

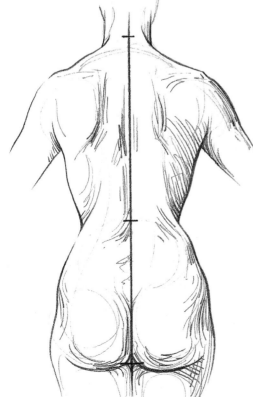

LEFT: **The centre line of the torso, front and back.**

BELOW: **An overhead view showing the difference in size of the two sides of the body, as seen by the eye.**

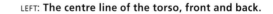

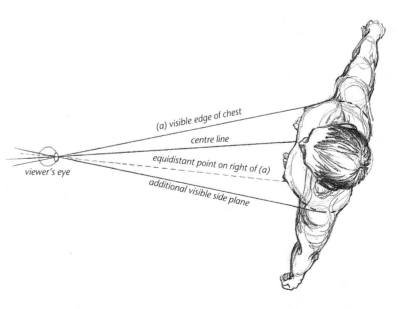

(a) visible edge of chest

centre line

equidistant point on right of (a)

additional visible side plane

viewer's eye

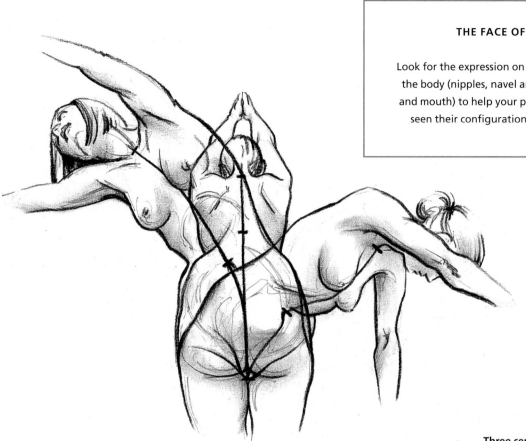

THE FACE OF THE BODY

Look for the expression on the 'face' of the front of the body (nipples, navel and crotch for eyes, nose and mouth) to help your proportions. Once you've seen their configuration, you can't go wrong!

Note the variation in length and angle of the centre line.

Three centre lines of different character.

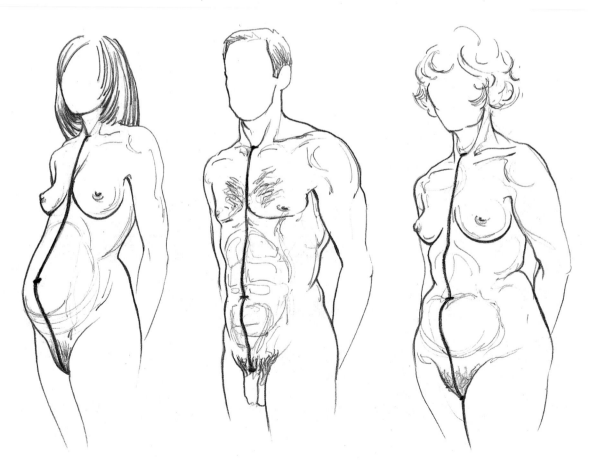

Although the brain *knows* that the body is symmetrical, right and left, unless you are looking at it from the centre front or back, then its two sides will not be visually identical in size. Because the side nearer to you, the artist, appears bigger, the reply to the question 'Which side is larger?' is almost always 'This side' (except where flesh is squashed or narrowed asymmetrically, or when looking at shoulders, which can be moved independently to narrow or widen the visible distance to the centre line: hunch one shoulder and see the effect in the mirror).

Not only is the nearer side visually larger, but more of the side plane of the body is visible.

Accurately placed, the centre line describes three important visual facts:

■ Your position relative to the model, e.g. at a three-quarter, two-third, one-third, side, front, back angle to the model (by correctly apportioning the body right and left of the centre line).
■ The direction of the bend or twist of the pose (by the angles and lengths within the centre line).
■ The character of this individual body (by the relative projection of one point of the centre line to another).

What will you learn? To accurately place the centre line and thereby achieve not only a convincing sense of volume, weight and balance in your life drawings, but also the subtle character of the pose and individual body.

— POSE: Standing, with a slight twist in the torso and arms away from the body, e.g. hands resting on two low chair backs/easels. Be sure to mark the model's feet and hand position; and the model should note the direction of gaze, in case a rest is needed
— TIME: 30min

This will be a drawing of the torso only, so turn the paper to the 'portrait' position (longer vertically). Looking carefully at the angle, draw only the top and bottom points of the centre line (assessing, by eye, the amount of room that will be necessary later for the body edges to the right and the left), and join them with a straight, but very light, line. Check the angle (remember, pencil close to the eye). Then draw the middle point, looking carefully at its angles and distances relative to the first two points, and lightly draw straight lines between them. Now draw the curve between the points to establish the centre line.

Next, compare the width of the shoulders to the height of the centre line, and mark the extreme points of the shoulders, checking their relative distances to the suprasternal notch, measuring first the short length, then comparing it to the longer length. Check the hip and waist widths, then draw the edges of the body, checking as you go and paying attention to the fullest

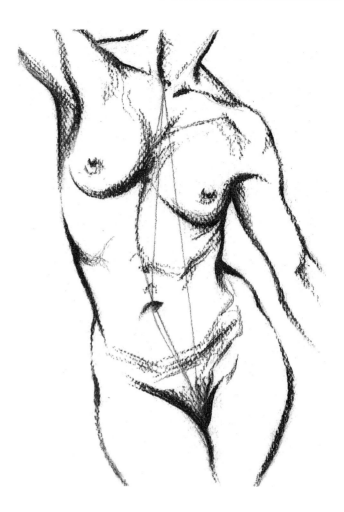

Drawing in charcoal on watercolour paper, showing preliminary construction in pencil.

point of the chest or back. Our brains are very keen for us to draw the symmetry that we know is there, so the difference between the two sides of the body is usually far greater than we think. Always be prepared for a shock, and be ready to check lengths 'honestly' and, if necessary, several times. This way, you will avoid one of the most common of all life (and portraiture) problems: centre-line slippage.

EXERCISE: **THE CENTRE LINE – HEAD**
The head also has a centre line, which is more discernible on the facial plane than the back of the head. Running from the centre of the hairline on the forehead down to the chin (excluding the nose), the key points to look for are:

■ the centre point between the eyebrows (where they would meet if they did);

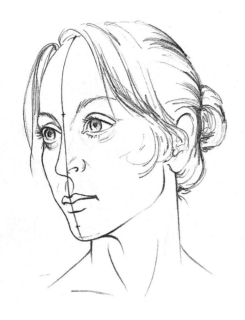

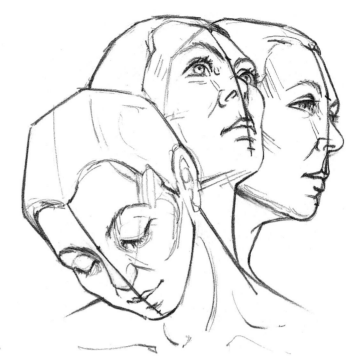

ABOVE: **The centre line of the head at three-quarter viewpoint.**

RIGHT: **Different head axes and viewpoints.**

BELOW: **Three different centre-line configurations.**

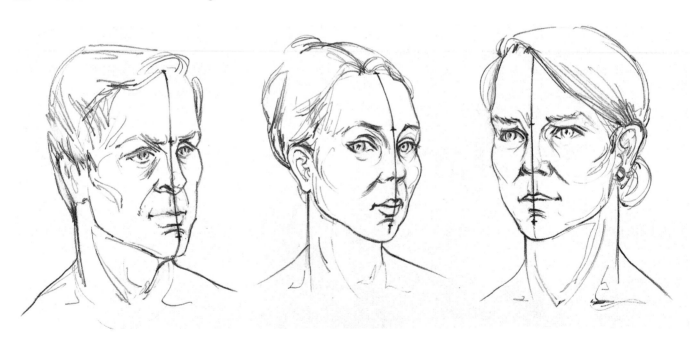

ENJOY THE SURPRISES

Learn to celebrate your discoveries as well as your successes, and to look forward to unanticipated surprises. After all, this drawing process is not meant to be a familiar holiday, but an adventure.

■ the centre of the top lip (you may choose the bottom lip if it projects more than the top);

■ the centre of the fullest part of the chin.

As it does for the drawing of the torso, this centre line, accurately placed, will describe: the relationship of the model to the artist (where you are standing/sitting); the axis of the head (inclination or tilt); and the character of major areas of the face in terms of their relative projection (e.g. jutting, or receding, chin, brow, and so on).

— POSE: Model sitting with head erect
— TIME: 20min
— ARTISTS: Facing the front plane of the model's head, but not the centre front or profile

This time the approach to drawing the centre line will be different. Firstly, using circling or rhythm and curve, lightly draw the head shape, and check the ratio of width to height, seeing where the highest and widest 'star points' occur. Position the neck and shoulders, looking carefully at the relationship of the base of the neck to the chin. The head doesn't come out from the top plane of the shoulders, like a lollipop, because the base of the neck column is angled forward, high at the back (neck vertebrae) and lower at the front (suprasternal notch). Also take note of the surprising difference in size between the near and far shoulders to the centre neck.

First, assess the level of the centre eyebrow point, gauging by eye, not brain, the ratio between this point and both the top and bottom of the head (this point is lower than one thinks). Now draw a light line for the centre eyebrow line and check it, adjusting if necessary. Then do the same to place this centre point in relation to the left and right of the head. Then draw a light vertical line, and check it. Where the two points intersect is a good starting mark for the centre line, because the head is usually widest at this point. (Bigger dimensions are easier to assess at a distance.)

As before, an initial statement of the top and bottom centre-line points will establish the tilt and something of the character of the head, so draw a light line directly down from the eyebrow point to the centre of the chin. Then, after drawing the centre top-lip point, the nose can be comfortably projected from this basic framework by checking the relative angles and lengths between brow and chin. Then you can, with confidence, construct the rest of the features. However, be careful not to confuse the edge of the nose, at the bridge, with the centre eyebrow point. Be vigilant! Don't let the centre line drift this way – they rarely drift *that* way.

After drawing several full body-and-head poses with different twists and tilts, you will be able to choose whether to start with the centre line and 'clothe' it, working outwards, or place it in a light framework, accurately apportioning the body and head on either side. One aspect is assured: your drawings will never look

flat. Most poses have not only an inclination or tilt between the head and the upper and lower parts of the torso (thorax and pelvis) but also a twist, due to the flexibility of the spine. Keen observation of the centre line can describe even the slightest nuance, and explain the rhythm and counterpoise of the pose.

What does this drawing convey? A visual sense of three-dimensional volume. With an accurate centre line, a line drawing can appear to 'project' from the paper.

In constructing a drawing, one can appreciate the importance of the centre line, not just for giving an academic accuracy to the structure, but also for conveying the intrinsic character of the individual model. Whether it is visible in the final work or used as a preliminary guideline, the idiosyncratic body language and bone structure are encrypted within this subtle surface evidence.

EXERCISE: TRIANGLES

In this exercise the whole body is translated into a composition of triangular shapes.

What will you learn? This project helps the artist to identify and relate points of interest, to trust the eye, and take the time to rewind the visual process 'tape' and scan any points in relation to each other. You will become subconsciously aware, when drawing any part of the model, not only of its local dimensions as widest or narrowest points, but also of its links to the visual surroundings as they are seen, whether near or far.

— POSE: Any pose
— TIME: 6min
— MEDIUM: Pencil

Treat this as a game. By linking three points, find the largest triangle you can on the model – for example, top of head, toe and toe – and draw it gently several times until you're reassured that it has the right angles and dimensions, and that it occupies the right amount of space on the paper to allow enough room for the whole drawing.

Now look for, and draw, the slightly smaller triangles that make up the pose, looking carefully at their relative size. These may overlap each other, or even be external to the body on one side. They may be equal-sided, asymmetric, long and narrow, or short and wide. Look for the relative distance of 'equivalent' body shapes either side of the centre lines.

As you work gradually towards the smaller triangles and feel surer of your proportions, press a little harder, especially for key triangles, or simply because you like the look of their juxtaposed shapes.

If, at any time, you feel a triangle doesn't have the right dimensions or angles, be prepared to check and, if necessary, redraw earlier statements. Don't just squeeze in a triangle for show or to 'fill in' when your eye is shouting 'It's not right/won't fit!' Square and rectangular shapes may be translated as two

BELOW: **A complex pose that can be untangled with triangles.**

RIGHT: **Initial large-scale triangles.**

BOTTOM LEFT: **Development of internal triangles. Note the difference in shape and scale of triangles on each side of the centre lines of both the body and head.**

BOTTOM RIGHT: **The smallest triangles are found last.**

44

triangles, and curves must be described, very simply, in terms of their widest and narrowest points. Be as inventive as possible about your choice of triangulation points.

EXERCISE: **MONUMENTAL PLANES**

— POSE: Sitting or standing with some limbs bent or projecting
— TIME: 10min

By looking at the relationship of triangulation points on the body to each other you will become aware of their planes or facets, and the spaces around the model. With this in mind, and still using triangles, also mark out planes, like cloth stretched or hanging between the points that project from the model: for example, navel to nipples, temples to tip of nose; elbow–buttock–shoulder; foot–foot–shoulder.

Then, selectively erase some earlier construction triangles of the body inside this structure. Alternatively, the selected external triangles may be drawn in with a much stronger line or charcoal, so

that the model appears to be inside a personal transparent 'web', or opaque tent or caging of inhabited space.

EXERCISE: **ENVIRONMENTAL FACET-FINDING**
This progression from triangles is particularly designed to develop an awareness of the relative scale between model and environment.

— POSE: Any pose, but with some visual information surrounding the model, such as easels, tables, people
— TIME: 20min

Follow the same process as before, then look for triangle links between the model and the seen environment. These may be objects, people, or the spaces between them (negative shapes). Choose shapes that won't move too much, though it is fun to put in other artists. Stay constantly focused on the idea of linking these external shapes to the model, rather than drawing them in isolation; otherwise their relative size will tend to

Two preliminary drawings.

**The same drawings with selected planes
screening the inner drawing.**

assume 'known', not observed, dimensions; this is particularly common when drawing people in the background. Note their reduced scale in relation to the model.

Initially, translating actual rounded forms into triangles is a challenge, and can feel like an unnatural shock after more rhythmic, curving processes; but after two or three drawings, the game aspect of this exercise becomes very enjoyable, even addictive.

A square, a rectangle, or any geometric shape can be used as the key shape instead of a triangle. Also, two shapes can be chosen for one drawing, or can be inter-related with Circling or Rhythm and Curve.

What does this method convey? The image, constructed as it is of facets, resembles a metal-plated robot, a computer-generated, aero-spatial design drawing, or a character from science fiction. Dealing only in general dimensions, and with no concession to soft flesh and subtle musculature, these drawings have a mechanical, ergonomic feeling. While this abstracted effect may not be 'romantic', it represents the very purpose of the exercise: for the artist to become more aware of the space area that the model (and we ourselves) inhabits in any given position, and the spatial relationship to other objects.

LEFT: **This faceted drawing links the model to slowly drawn furniture and quickly drawn artists!**

A combination of rectangles and triangles for an 'architectural' pose.

Here, triangles have been selected and drawn in charcoal to create an exciting design of diagonal tension.
ARTIST: CHRIS ALLWOOD

Counterbalance

The centre line describes the *visual* proportioning of shapes (perspective). However, the entire bodyweight is continually subject to the down-pulling force of gravity, and needs both balance and/or muscle power to maintain a position or prevent it from falling over.

EXERCISE: **COUNTERPOISE**

The exact distribution of weight over the base of the pose is crucial to balance.

What will you learn? To be aware of this finely tuned balance and achieve 'comfortable', natural-looking drawings.

Try, now, standing on one leg, and you will realize immediately how vital it is to exactly balance the rest of the body over the standing foot. Now try to lean your upper body forwards, sideways or backwards without falling over. Leg and foot muscles start to strain – but if you extend a limb on the opposite side to the lean, which acts as a counterweight, it is possible to stay upright, or counterpoised.

With your model, try as many variations of this counterbalancing system as possible, standing, sitting or reclining, feeling the moment when muscles start to pull. Like a stack of boxes or bricks, we have many counterweighting choices available to us. In fact, the choices we make, as individuals, represent one of our most recognizable personal features. Can you identify the personal 'vocabulary' of various models?

— POSES: Several, extremely counterbalanced over the basepoint, which could be one, or a combination of foot/feet, hand(s), knee(s), shoulders, elbow(s), buttock(s), or even, if your model can do it, head!

— TIME: Between 30sec and 5min. It is incumbent upon the artists to work at the model's speed!

Draw the Elastic Band or Five-Stars very quickly, if possible without looking at the paper, and check the points and angles. Consider and find the centre of gravity of the body at the bottom of the pose (it may sometimes be necessary to ask the model where that point is), and the topmost point which is directly over it, by holding a pencil vertically over that base point.

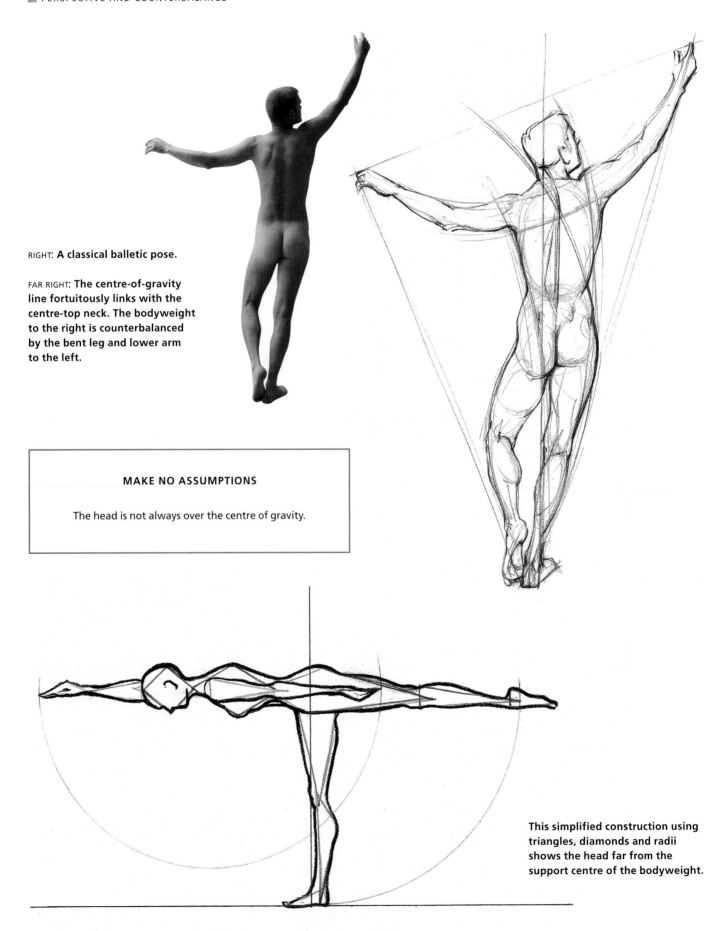

RIGHT: **A classical balletic pose.**

FAR RIGHT: **The centre-of-gravity line fortuitously links with the centre-top neck. The bodyweight to the right is counterbalanced by the bent leg and lower arm to the left.**

MAKE NO ASSUMPTIONS

The head is not always over the centre of gravity.

This simplified construction using triangles, diamonds and radii shows the head far from the support centre of the bodyweight.

Observe the *visible* body distribution on each side of this vertical by looking at the size of shapes and the angles between their extremities. Then draw a line that may be vertical to that base point, or at an angle from it, which links with a distinguishable edge or feature – for example the neck, nose or finger.

Now, working very fast, and using Rhythm and Curve, Circling or Triangles, draw from the largest to the smallest shapes. Remember that a whole torso – leg, arm or grouping of body shapes – may initially be drawn as one shape or line. Refer to your 'significant' angle or to the centre-of-gravity line ('plumb'-line) as frequently, on your drawing, as the model does, in reality, in order to hold the pose!

What does this drawing convey? A sense of energy and balance, which can be quite paradoxical. Like a child's balancing puzzle, the image, with its 'dangerous' stacking of the weights, stimulates and excites the eye and brain. Yet the final resolution of weight, perfectly balanced over the centre of gravity, is as satisfying as the happy ending of a thriller movie!

When a leg is bearing most of the bodyweight, instead of looking vertical in profile, it looks uncannily angled forward at the hip, for two reasons. First, although the bones of the leg may be locked vertically, the muscle is fairly evenly distributed around the thigh bone (femur), and very unevenly distributed around the lower leg bones (tibia and fibula). The shin muscle on the front is fine and narrow, while the calf muscle at the back is much larger. Second, the bodyweight is usually distributed over the whole foot area, not only on the heel, which causes a slight forward inclination.

The leg on the left shows the bodyweight over the centre of the foot. The leg on the right, though straight, looks about to fall backwards.

Conclusion

We know that peripheral scanning is an unconscious part of our survival, and that the translation into three-dimensional 'known' information is so fast that to draw the seen image that first lands on the retina takes a readjustment and rewinding of the looking process. If you have followed the exercises so far, you will by now, with first-hand experience and practice, be more consciously aware of the two-dimensional image. Yet for exactly the same reasons, scanning the 'seen' is probably now a *subconscious* part of your drawing process, an assessment of weight and balance, an automatic event. With these skills of peripheral large-scale awareness in place, the transition can now be made to focus on, and enjoy the subtlety of surface contour while keeping the large-scale proportions intact.

Quick scanning and a confident line balance the weight in this short pose.
ARTIST: MARY GILL

CONTOUR: THE SPECIFIC OUTLINE

Now that you are skilled at automatically scanning and assessing large-scale dimensions, it is time to study the smaller-scale shapes of the body. Along an edge or contour profile we are aware of musculature, changing texture, wrinkles, evidence of bones, even veins, which don't begin and end at the edge but start somewhere inside the visible edge and continue to exist around the surface and out of our view to the unseen area behind. The following exercises are designed to shift the attention from scanning the large shapes, the 'mid-air' activity between spatial planes and the extremes of body-reach, and to focus on the more tangible areas of surface form.

EXERCISE: JOURNEY A–Z

This exercise involves the simplification of complex curves: identifying and drawing major points, directions and the distances between them. Using the analogy of a journey, it is wise to establish the overall departure and destination points *before* deciding where to stay overnight, along the way. Various diversions can then be planned into the journey, either to see the sights or visit friends en route.

What will you learn? How to give your drawings a good sense of weight, gravity, balance and precision, especially in counter-poised poses where the bodyweight distribution is counterbalanced right and left of the centre. This method provides the antidote to sloppy drawing or wandering hopefully with a 'knitted' line, inch by inch, down the edge of the body which, though producing accurate local drawing, has less idea of its destination and can take you way off track. It also helps the artist to simplify and understand long, subtle or complex curves.

— POSE: Standing with the weight mostly on one foot, with a counter tilt of hips and shoulders and the head facing to one side. (Mark the position of the feet, and the model should note his/her eye direction.)
— TIME: 30min, with a '5min-to-go' alert

Firstly, with a fine pencil, make a straight-line construction of the pose using 'Five Star', the Elastic Band, and Joints and Pairs methods, particularly checking that the head-to-foot relationship and height-to-width ratio is perfect. By doing this you are marking the major departure and destination points, and the distances and most direct routes between them. Never worry if a line wobbles on the way to its destination; it is much more important that it starts and ends in the right places. Then, still using straight lines, mark the major points within them: for instance shoulders, waist, hips, crotch, ankle, elbow and knee (if bent), or the narrowest points. Also mark the centre line, using straight lines between the key points.

When an external curve between points bulges dramatically in or out, do not be distracted, but keep your eye on a direct line between the major points, A and Z. Then, looking at the fullest or narrowest points within these, and still using straight lines, construct the finer detail. Eventually you will be able to savour drawing the curving contours with a prior knowledge of their subtle proportions.

What does this drawing convey? Even as a construction drawing of straight lines, this image looks clean, decisive and dynamic, with sturdy musculature and a convincing feeling of weight and balance. The exercise also develops a habitual way of looking, which helps the artist to express the subtlety of body curves.

LEFT: **Passionate line – a subjective interpretation of selected edges.**

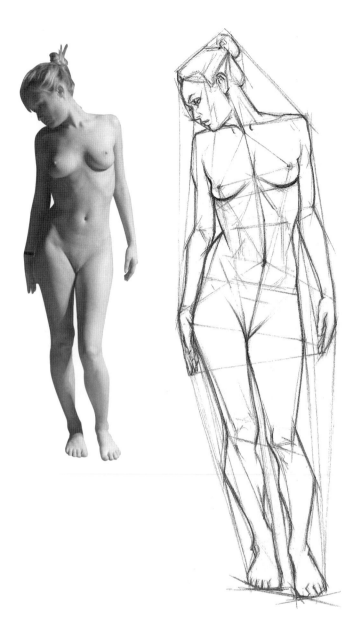

LEFT: **This subtly counterbalanced pose is comprised of equally subtle angles and curves.**

RIGHT: **Transverse links (Joints and Pairs) help to contain this long, narrow, flowing shape.**

EXERCISE: **ARMADILLO**

As its title suggests, this invaluable exercise involves representing the model as interlocking body plates or panels.

What will you learn? This process is excellent for helping the artist to draw body shapes and negative shapes, not three-dimensionally as they are known, but as they are actually seen; it is the antidote to foreshortening problems. With a little practice

you will be able to 'click' back and forth between a three- and a two-dimensional way of looking. Once you can do the 3-D to, 2-D 'click', it is easy to check your drawing quickly and objectively; this is especially helpful when you find you are too subjectively involved, and 'can't see for looking'!

'Armadillo' also enriches the experience of life drawing because, by drawing the shapes individually and concentrating on the unique character of each one, you will develop an awareness and enjoyment of the shapes not just for the three-dimensional 'message' they convey, but for their own sake, as flat, two-dimensional shapes.

— POSE: Ask the model to choose, and settle into, a comfortable pose before drawing begins, to avoid movement
— TIME: 40min
— MEDIUM: Mechanical pencil (2B lead) and thin charcoal (optional)

First use the fine pencil to draw, very lightly and loosely, the large-scale proportions, using the method that you find most helpful for this (Five Star, Rhythm and Curve, Elastic Band, Zig-Zagging). It is crucial that the overall dimensions are accurately established before embarking on the inside shapes and detail. So, take as long as is necessary to check the width, height and angles of the major shapes. *If you take care of the big shapes, the little shapes will take care of themselves.* Now you are ready to start.

The aim is to explore and draw each shape as though it were an island or body-plate, entire and isolated from all others and worthy of your total concentration. It is for this reason that the construction drawing, while simple, should be correct in its large-scale information, because it is quite possible to draw an island that is perfect in shape, but wrong in scale or placing. The drawn island's coastline *must* be complete. It may consist of body edges, overlapping limbs, creases, shadow edges or a change of texture; however, it might not, in reality, be completely surrounded by a visible edge – for instance, the top edge of the shoulder to the armpit, when describing the chest or 'breastplate' shape. In these situations, draw around any shadow shape, however subtle, or simply draw straight across, to *make* a continuous edge. Also, the shape may be a negative one – for instance the space-shape, or hole, between the body and the arm when it is bent.

Next, take the charcoal (or continue with pencil, making stronger marks) and start by choosing a large, chunky shape – the trunk, upper body, or the outer edges of both thighs, or arms – as one single shape. Using your preliminary construction drawing as a guide, draw firmly and slowly, with an even line, around the island, following, very precisely, the character of its edge on the model, studying the lengths of curves, concave and convex, in relation to each other. Continually look across the shape for its wider and narrower places until you have travelled all the way round and back to your starting point.

The following tip will help you see the shape as flat and compare it to your drawn shape. Make a circle with your thumb and index finger and, holding it up to the eye, look at the armadillo shape through the hole, blocking off all the surrounding shapes by moving the 'finger lens' in or out. Look at the nature of the shape: does it look like India, a banana, a shoe, a leaf, boat, axe, rectangle? Use any associated geometric shape or imaginative terminology to help you. You are now asking your brain to go to the 'flat shape' section of its reference library, when it knows that the shape is really three-dimensional (don't be surprised if, initially, it feels a little insulted at having its complex interpretation skills overlooked in favour of what may seem to be silly, childlike descriptions!). By drawing round the island several times, and using the eraser if necessary, refine the first shape until it looks perfect.

Now choose another large shape and draw it, comparing its size to the first one you have drawn, and also its distance from it. If it adjoins the first, don't just add it on, but draw it in its entirety, refining the connecting edge, if necessary, and viewing this shape through the 'finger lens' from time to time.

Continue until all the major elements of the body are pieced together like an armadillo shell or jigsaw puzzle. At all times be prepared to re-draw and erase, however messy the paper becomes: this practice is more about getting into good 'looking' habits, rather than producing a pretty picture. Also, overlapping shapes leave interesting negative shapes to draw, so enjoy these for their own sake, and don't struggle to make sense of them.

Now within these shapes, look for the smaller shapes – for example, the two sections of the torso, using the centre line as a new edge, but still travelling the existing coastline areas again in order to focus your attention on this whole new shape. Remember, centre lines always want to slip this way, so check the relative size of the near and far shapes. Working from the large to the small, and including chosen shapes between model and background, take the time to solve problems – and relish the magic moments when pieces fit together perfectly.

When the drawing is finished, it is interesting to play with the shapes by trying several options. Trace the original drawing, and develop the pattern of the space-shapes by erasing some lines or adding fine detail, the selection of which is not dependent on

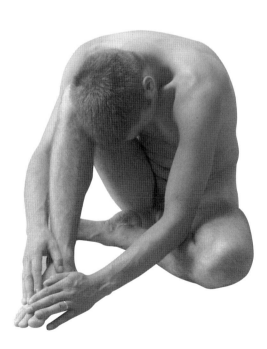

ABOVE: **This complex pose offers a great variety of Armadillo 'plates' both in scale and shape.**

RIGHT: **The large-scale shapes are drawn.**

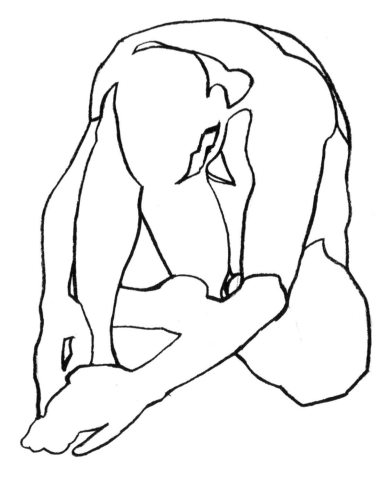

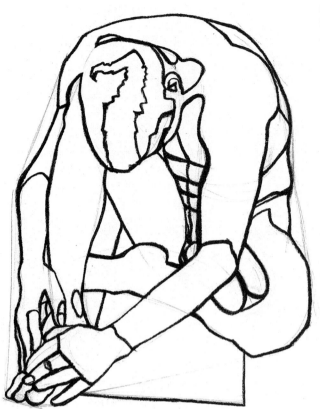

LEFT: **Armadillo not only conquers foreshortening problems but also invites shape discovery and interpretation, for example knee, hair and chest-plates.**

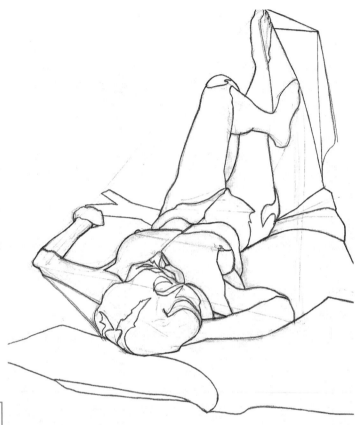

Here, **cloth shapes are integrated into the drawing with a similar emphasis to the body shapes.**

...Scales really have lifted from my eyes. Now I can *choose* whether I 'feel' the foreshortening as a form, or see it as a shape. I hardly measure any more.

- -

...One moment I was thinking 'How on earth do I draw that thigh jutting out towards me?' and suddenly, I saw an upside-down horseshoe – and I thought, 'I've got it!'.

factual logic, but on the creation of dynamic variation between busy and quiet areas of the drawing. Fill in some, or all, of the shapes with different blocks of pattern or flat tone (not necessarily related to observed tone, and so on: this will come later). This process also exercises compositional design skills, and can create powerful imagery.

Drawing lying-down poses, or working from close-range viewpoints (making sure that you maintain exactly the same eye position), is highly recommended for demonstrating the efficacy of the Armadillo for tackling and enjoying foreshortened shapes.

What does this method convey? The drawing will look somewhat like a stained glass window, and the effect is curiously paradoxical. The strong, even line, used here as a device for 'territory marking', doesn't exist in visual reality. Its effect is, certainly, to flatten the image – and yet the fastidious observation of two-dimensional information, and the brain's instinct to interpret it, can make the drawing look intriguingly 'full'. Because there is little concession to form, the image – graphic and mechanistic in execution (drawing piece by piece) – may, initially, feel quite unemotive and dispassionate. However, this exercise can awaken a passionate awareness of the picture surface as a playground for the enjoyment of negative and positive shapes.

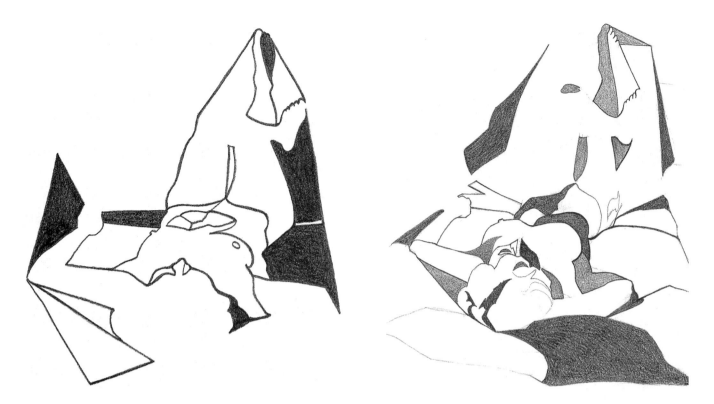

ABOVE: **With selected shapes erased or blocked in, the same pose has a 'cathedral'-like feel.**

ABOVE RIGHT: **This accent of shapes is more open and meanders downwards, like a river.**

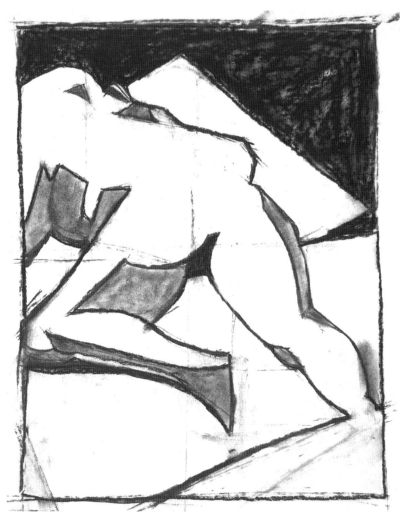

Dynamic Armadillo design.
ARTIST: JO GIBSON

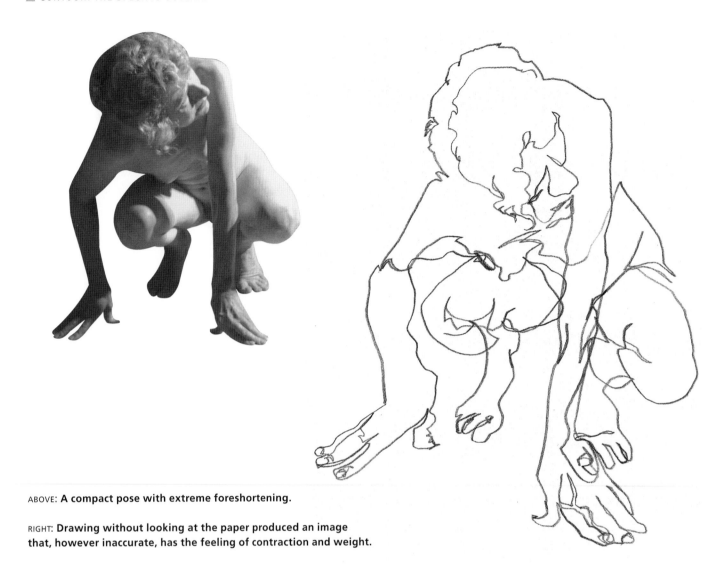

ABOVE: **A compact pose with extreme foreshortening.**

RIGHT: **Drawing without looking at the paper produced an image that, however inaccurate, has the feeling of contraction and weight.**

EXERCISE: **EYE-TRUST**

This useful exercise involves drawing without looking at the paper, and should be treated as fun and for limbering up the eye/brain/hand co-ordination (or for quietening an over-bossy brain!). It is a great leveller, because the only way to do this exercise well is by relaxing and putting your faith in your eye – it requires absolutely *no* previous experience. A beginner, with no expectations, may indeed have more success than a professional. However, it is the process that is the main achievement factor, not the outcome.

What will you learn? To trust your eye. When drawing without looking at the paper, the brain has little opportunity either to oversee and criticize the drawing, or to contradict messages that are received direct from visual reality through the eye. So the brain has to learn to 'let go', enjoy looking, and instruct the hand using messages received here, now, and in the present, instead of referring to previously logged messages from the past!

Note that very many drawings, initially correct, are put *wrong* by the 'brain-in-charge', which persuades you to draw when there is less, or no, looking at the model, and even when the model is not there. 'I changed it because I didn't think it was right,' is a common cry. The operative word – and action – in these cases, is 'think'. Meanwhile the original, perfectly accurate construction lines can still be faintly seen underneath, erased or ignored.

Nevertheless, with this method, judgement of distances cannot be guaranteed, so prepare to be amused by the results, at least initially. Here, however, are some helpful tips.

1) Draw at a consistent speed and without lifting the pencil off the paper, as this gives a reassuring sense of the ratio of time to ground covered: not too fast, because it is important to savour

and describe every detail on the way; and not too slowly, otherwise you will forget where you are. Because it is important to keep the brain occupied (it will be anxiously longing to take control when you start), ask it to remember which parts of the model have been drawn, and which have not.

2) Try this exercise: first, outstretch your arms to the sides. Now close your eyes, and try to bring your middle fingers to join together in front of you. If they miss each other, they were probably very close. Usually, each hand knows where the other is, so if you put a finger or thumb from your non-drawing hand somewhere useful on the paper before starting – for example, halfway down the edge – then subconsciously you will know whether you are drawing high or low on the paper.

3) Stand slightly in front of your drawing with the easel on your working-arm side, to avoid the temptation of looking at the paper. If you are sitting, put the paper on your lap, or the easel to one side, or mask your view with paper.

4) It is very important not to rest your hand on the paper, especially if using charcoal.

Your 'control mind' may feel uncomfortable at first, but 'let go' and prepare to sally forth on an enjoyable, meandering journey. Relax! This isn't gold leaf and parchment, only pencil and paper!

— POSES: Six varied poses
— TIME: As long as necessary, usually 3–5min for each one

Start the drawing at any place, though first you should gauge, by looking, where on the paper this point should be, to ensure plenty of space to wander. Now look at the model, and, never lifting the pencil off the paper, ramble down an edge, savouring every nuance, curve and detail on the way. Relax and take in the sights: eyes, toenails, fingers, bracelets and so on – no detail is too insignificant to draw. When you arrive at a junction or crossroads, take any turning. If you find yourself in a cul-de-sac, lightly, but not lifting your pencil, skim across the paper to another edge. Don't be tempted to look – this is about the experience, remember, not the picture.

Continue your journey, wandering around, through and across the body via any edge that presents itself – it doesn't matter if you travel some paths twice, or even more – and enjoy discoveries as they appear, until your 'brain-on-guard' tells you that you have drawn all the information, including the detail. Then – and only then – take your pencil off the paper, stand back and look.

When the giggling subsides, see if there is an area that you would like to redraw. Placing a finger from your other hand at the estimated destination point on the drawing, redraw towards it, on top of your drawing, again *without* looking at the paper.

Immediately start another, completely different pose, until six have been drawn. Later, fewer drawings will be necessary for simply limbering-up eye/brain/hand co-ordination, but initially it usually takes three for the brain to 'let go' and relax. After a short time, this method of drawing becomes so stress free that it is even possible to talk at the same time!

What does this method convey? Eye-Trust drawings capture a certain feeling or *essence* of the pose, together with a humorous quality of caricature. This is caused by the bizarre combination of occasional inaccuracies of scale or position on 'long journeys' with, by contrast, a stunning honesty and accuracy of contour on 'short journeys'. Because in local terms the hand is able to draw exactly what the eye sees, with little or no interference from the brain, it is easy with Eye-Trust to draw the most apparently complex foreshortening – feet turn, hands grip, fingers curve, even portraits are often surprisingly recognizable. As a method of fast recording, it is extremely useful for drawing from the television, at the theatre, in stations, restaurants, bars and so on; furthermore it has the following advantages:

- no one need know that you are drawing;
- it is possible to draw by 'Eye-Trust' while thinking about something else, or talking;
- the real 'spirit' of your subjects will be captured, even if a little inaccurately;
- no one, not even you, needs to see the drawings;
- every time that you Eye-Trust, your brain will become more reassured that drawing by eye is not life-threatening, and as a result, the eye–brain–hand path will become smoother.

ALIGNING TWO SIDES OF A NARROW POSE

When drawing a long, narrow pose, whether the model is standing or reclining in profile, wander across the body via, for example, the navel, shoulder blades, breasts, crotch and so on, so as to avoid two very long sides misaligning, and in order to maintain a feeling for the width-height ratio. (This is as much to alleviate the sense of 'feeling lost', which could spoil the pleasure of the journey, as it is for the look of the drawing.)

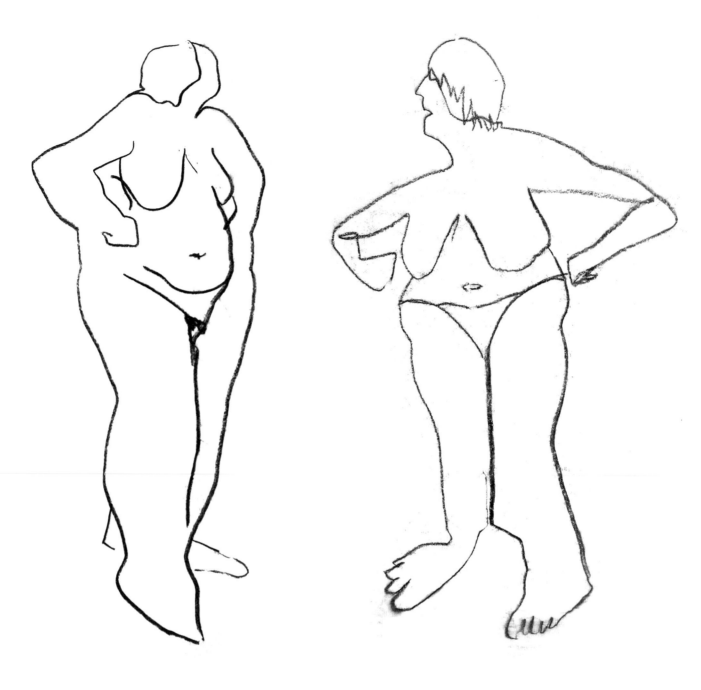

Drawn without looking at the paper, this line nevertheless conveys volume and stability.
ARTIST: HELEN WYATT

Enjoy the body 'face' – imagine the monologue! Drawn while looking only at the model.
ARTIST: KATE CAMERON

EXERCISE: **EYE-TRUST USING THE OTHER HAND**

Now try the same exercise for several poses, but this time using the non-drawing hand for an even more direct response. Unless you are ambidextrous, the brain has even less of a control habit, and the drawing can be even more 'honest'. Again, it will feel unfamiliar to begin with, for both these reasons; so persevere until you feel comfortable with this process.

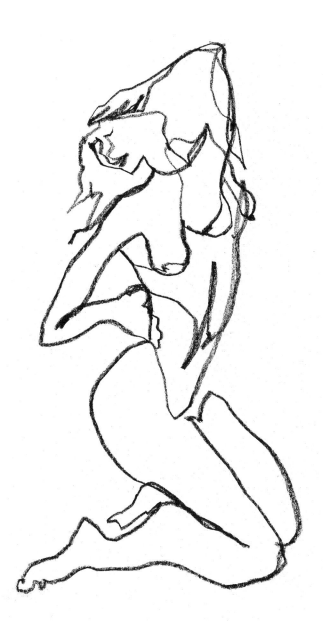

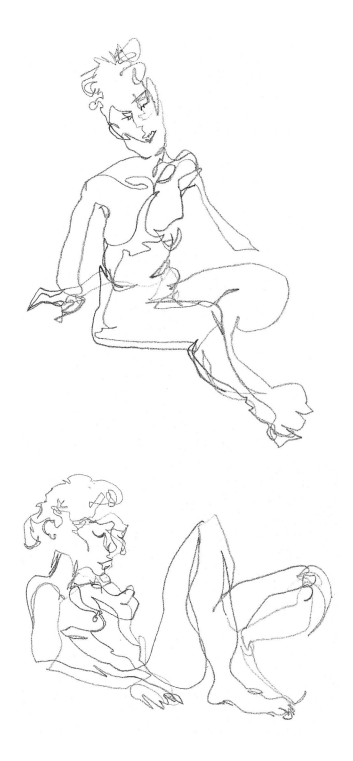

Drawing with the non-dominant hand and looking only at the model has exaggerated the attitude of this 'glamour pose'.

EXERCISE: **EYE-TRUST USING BOTH HANDS**

Finally, try Eye-Trust with both hands simultaneously. With a pencil drawing each side of the body or limb, you are obliged to scan back and forth across the body. Don't look at the paper between drawing body portions. A sense of the volume between the edges of the body or of the limbs is not only 'felt' in the moment, but also shows in the finished work.

TOP: **Using both hands simultaneously and not looking at the drawing directs the attention to the intervening space between edges and eases the flow between the eye and the hand. Despite inaccuracies, the twist, tilt and enigmatic smile of the pose are there!**

BOTTOM: **Though scribbly, this Two-Hand Eye-Trust drawing has an air of 'somnolent slump'.**

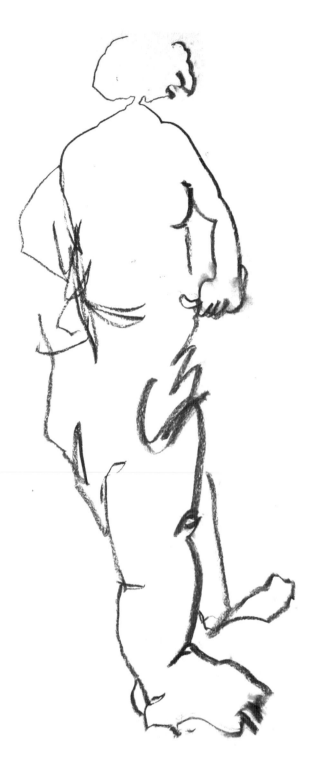

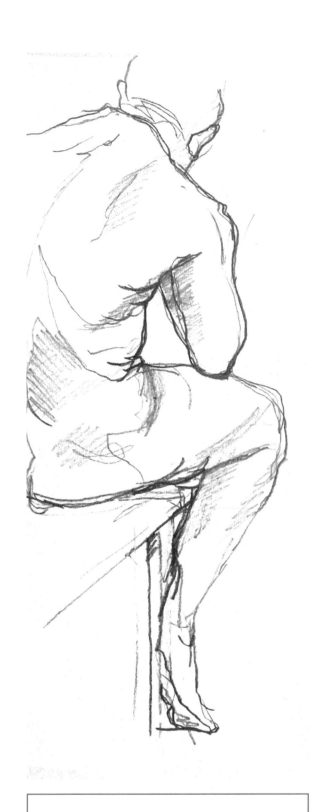

ABOVE: **This drawing, made with both hands and not looking at the paper, invites the viewer to savour the details, just as the artist did.**
ARTIST: BARBARA MORRIS

RIGHT: **Though drawn while intermittently looking at the paper, this sketch indicates the major role of the eye in its construction.**
ARTIST: MOLLY WATSON

Artist to model: 'Don't you feel insulted at being drawn like this?'

Model to artist: 'On the contrary, I feel more valuable and important because everyone is actually *looking* at me, to draw me!'

Explore all kinds of mark and note the techniques used.

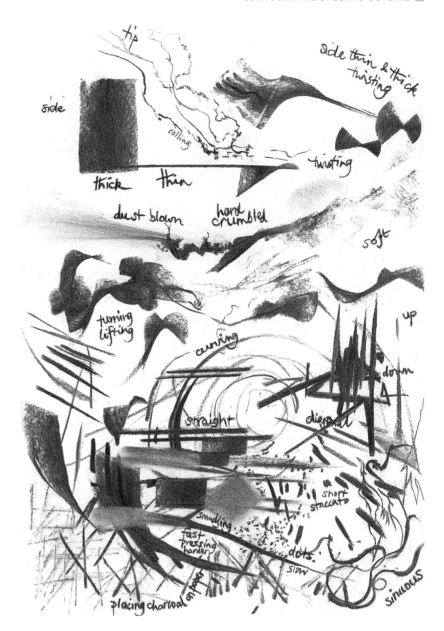

EXERCISE: **PASSIONATE LINE**

The preceding exercises have been focused on different ways of looking, and drawing accurately what is seen – the visual facts. Even by now, however, you are probably aware that these are a mere fraction of the myriad ways that can explain the qualities of the human body in many different poses: the surface textures of bone, skin, tendons and flesh; the subtleties of muscular tension and repose; the stretched and expansive, or contracted and folding shapes; the strong and exposed, or intimately protected areas.

What will you learn? Passionate Line introduces a voice of expression to drawing that adds punctuation and feeling to the facts, just as an exclamation mark, a comma, a question mark, underlining and italics put feeling into prose.

The aim is to freely express your response to the whole pose, or parts of it, as it appears to you; and although the departure point for the exercise is visual reality, and the vehicle is still line, the journey is one of the senses. The quality of the line made along the way should describe the traveller's subjective responses to the sights. It is not necessary to state everything: undrawn areas will not only lend weight and clarity to the drawn areas, they will also vary the pace and interest of the whole drawing.

— PREPARATION EXERCISE: No model
— MEDIUM: Thick (2 × 6cm approx.) chunk of soft charcoal

Make sure that the board is very firmly fixed to the easel, or work on the floor. Take a large sheet of paper, and make the largest range of marks that you, the charcoal and the paper can muster by varying:

- the angle of the charcoal – on its tip, its side, thick, thin, rolling it between finger and thumb;
- the pressure of the mark – press lightly to make a delicate 'whisper-smudge', or as hard as possible (till the charcoal crumbles!), and try gradually lifting, or turning as you 'travel';
- short and long smudges of the finger;
- the direction – up, down, diagonally, sideways, curving, straight;
- the length – short, staccato, long, dots, sinuous marks;
- the speed – from fast to slow in the same mark.

Put all these variables together, and imagine the infinite number of expressive marks available to your visual 'vocabulary'. In a group situation, compare your own variety of marks to each other, then compare the marks of the whole group, looking for the greatest range, and noting different marks to try. By sharing, and adding other people's marks to your own sheet, or starting another, you should by now have a formidable vocabulary and a huge range of 'punctuation' possibilities.

Now take a new sheet of paper and, taking it in turns to say one word that relates to either weight, texture, mood, posture or physical feeling, try to express that word with a mark. For example, 'strong' might be described by a short, clear, vertical line with the charcoal on its side and heavy pressure; while 'wistful' could be a thin, soft, broken and wandering line. These are only guidelines, and you, the artist, must choose for yourself, responding as directly and spontaneously as possible.

Do this until your imagination has been rehearsed and is brought out 'on stage' with your eye, brain and hand, and they feel comfortable to be acting together. Now you are ready to start.

— POSE: Any shape
— TIME: 5min, with a '2min-to-go' alert

Without thinking too much, draw the part of the pose that first catches your attention – a weight-bearing knee, a soft hanging breast, or a sharp jutting chin – with the most appropriate mark, the quality of which need only resemble feeling, not appearance. Now travel directly to another area, describing the journey only if it is really important; otherwise don't make a mark. Continue your journey, and stop after three minutes. Spend the last two minutes refining your expression of the pose by accentuating some marks and softening others. Initially it may feel difficult not to put a line around every edge (because, until now, this book has stressed the idea of making a complete statement), so for the first few drawings, actively erase the unimportant statements or areas where the message is 'space'.

Refer continually to your vocabulary to maintain an exciting and vigorous range of pace in your drawing until you can quite intuitively jump, slide or crawl across the paper, ready to attack or tenderly stroke it in your quest to express the feel of this pose.

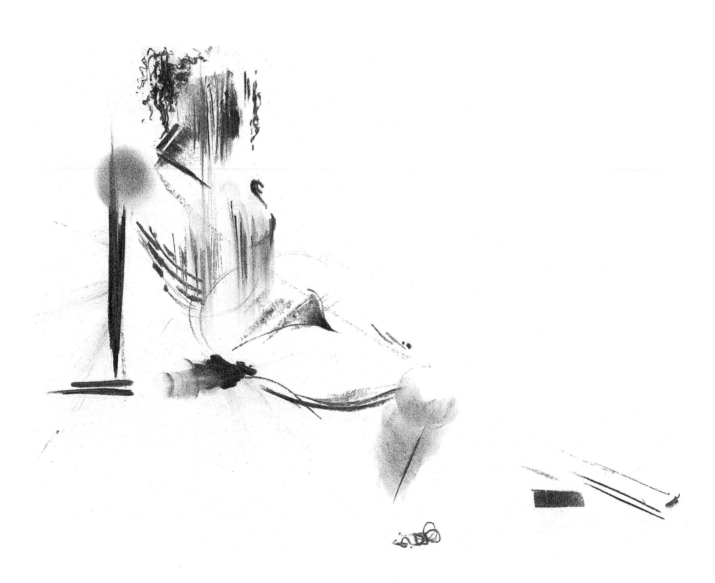

A sunlit pose with the supporting arm, neck and buttock contrasting the relaxed flow of the rest of the body.

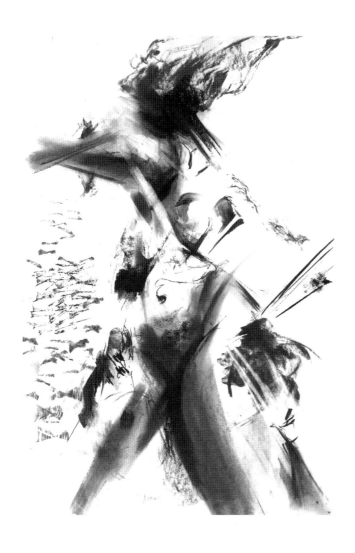

Be very selective with your choice of marks, and vigilant to the seductions of 'formula' drawing. Stay open and responsive. Don't worry about the proportions: accuracy is not the aim of this exercise (you will already be aware of large-scale proportions), and artistic licence is actively encouraged. Above all, let go, relax, and enjoy yourself!

What does this method convey? An abstraction of the pose that expresses the artist's intuitive response through visually exciting marks.

> There is no such thing as an ugly mark,
> only a mark in the wrong place.

Conclusion

Having explored many aspects of visual reality or the 'eye-world' – from large-scale dimensions and angles, pose dynamics, and attention to perspective, foreshortening and shapes – you will by now have developed a heightened visual awareness. Habitual processes of looking will be automatic, if not subconscious, and if you have followed these exercises so far, both your drawing skill and enjoyment of the process will have improved enormously. Repeat any of these methods as necessary until you feel comfortable with them all.

ABOVE: **A heroic pose viewed from a low eye level.**

This 'simple' drawing speaks directly of muscle tension and the power of gravity.
ARTIST: SUE SLADE

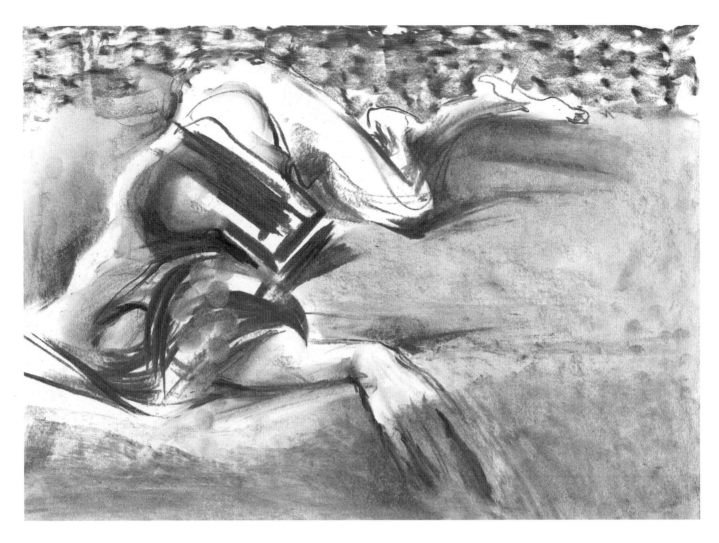

Eye-Trust and Passionate Line were used together, then, after looking, the drawing was selectively smudged and given background texture by putting the drawing on a wicker surface and rubbing it with charcoal.

Try putting different techniques together in combinations of two, or even three. For example, Passionate Line with Eye-Trust, or Rhythm and Curve with Circling, or Eye-Trust with Elastic Band (putting the index finger of the non-drawing hand, as a guide, at extreme points in turn). While the focus of Elastic Band or Journey A–Z and Eye-Trust may seem contradictory, they can be put together to great effect. By putting a finger on 'Z' and drawing, without looking, from 'A' towards it, a combination of considered, disciplined structure and sumptuous surface contours and details can be achieved with the day's destination 'preplanned'. This way you can leave home for short but safe excursions, and ramble at will!

Often the most unlikely bedfellows, such as Armadillo and Passionate Line, will produce an exciting and unique creation in the hands of a student who has an inventive and open mind.

If working in an untutored group, take it in turns to select a method to use. This can prise more experienced artists out of a rut, and it will also help to counteract the beginner's urge to settle too soon for the more comfortable methods that produce a 'good-looking' image. Eventually it will be absolutely essential to select what 'feels right', when developing your style and 'language'; however, then you will be able to choose from a point of *confidence* and with a developed awareness, and not simply from the 'easy options' box.

Initially, however, these exercises are intended to form the basis of a complete toolbox of skills that you may call upon intuitively and with ease in any drawing situation. This subconscious skill (created by you, and born, not of talent, but of practice) acts as the firm basis and foundation for the following exploration of tone, anatomy, movement, expression and personal style.

**Rhythm and Curve gives this
pose one integral intention.**
ARTIST: JO GIBSON

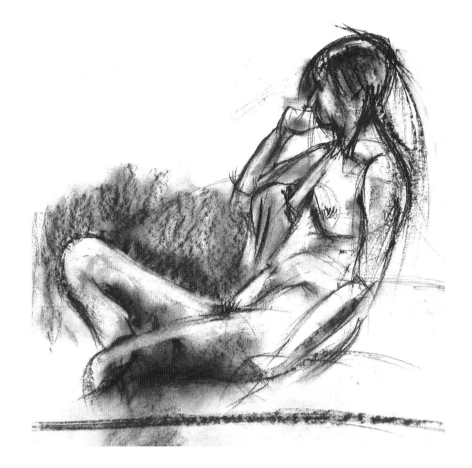

BELOW: **Every line of the body has been
considered and the construction erased
in this tentative but immaculate drawing.**
ARTIST: DENIS HUGHES

BELOW RIGHT: **The relationship of extreme
points give this pose dynamism.**
ARTIST: MILLIE GORTON

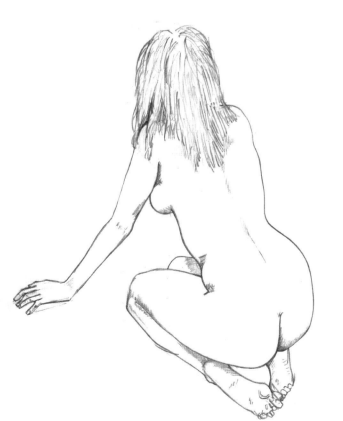

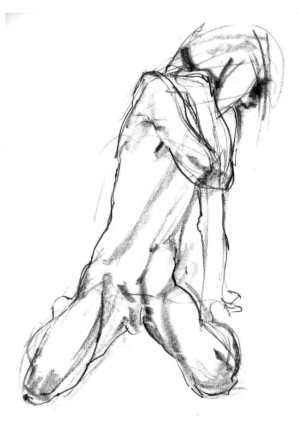

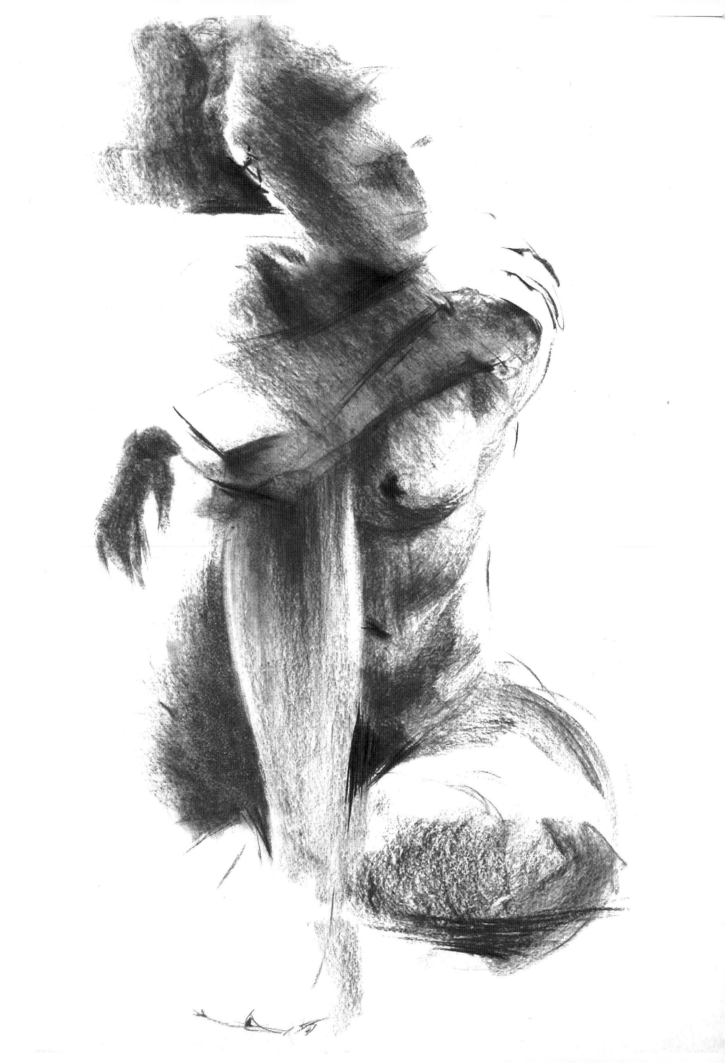

EXPLORING TONE

We know by experience and feel that a body is not flat, but how do we know visually that the surface is rounded, or angled, or softly dimpled?

By describing the body in terms of line (contour edges, boundaries, limits or discernible points that link or change) we have answered the question 'where is it?' – where the shapes appear to begin and end in relation to 'me', each other and the environment. Of course, there is no black line drawn on the edge of

the body at the point where, like the earth at the horizon, it disappears from view. A line drawing interprets reality in abstract terms in the same way that a map symbolically describes countries, lakes and seas only as flat, two-dimensional shapes.

Now, for a more realistic picture of events, we shall move on to the question 'what is it?' – what we see between the edges. Imagine a map that, on two-dimensional paper, describes the three-dimensional shapes of high mountains, forests, deserts, deep oceans and lakes as they might appear, in tones and colours, from an aeroplane or outer space. While colour tells us what hue the object is (brown, green or blue), tone tells us about its surface quality – contour, volume and texture. It is with this information that we can know more, by eye, about the form (and imagined 'feel') of trees and mountains, and even the roundness and craters of the moon, as seen from the earth, without *touching* them.

What is Tone?

Tone (also known as 'value' or 'shade') is the word used to describe the amount of light that an object reflects or emits. The variations of tone that our eyes see – for instance light, medium or dark – are caused by the following seven principal tonal factors:

1) Light – source and quantity.
2) The planes of the object.
3) The observer's position in relation to the object.
4) Cast shadow.
5) Reflected light.
6) Local tone.
7) Iris dilation and contraction.

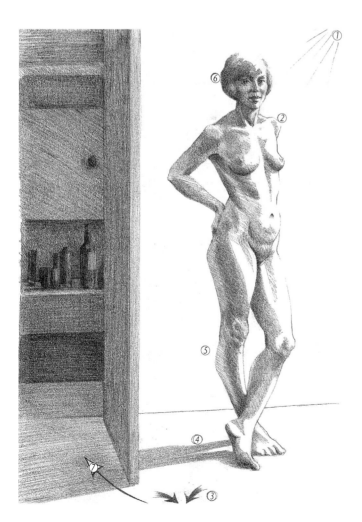

FAR LEFT: **Mid-tones and minimal use of line offer less information, but can evoke a sense of mystery.**

LEFT: **Seven tonal factors as listed above.**

PREPARATORY EXERCISE: **A TONAL TOUR AROUND THE MODEL**

— POSE: Standing relaxed (not immobile) with one high light source to the side of the model
— TIME: Until observation is finished, with breaks if necessary

Now take the time to walk around the model, stopping to observe the tone from different places, and looking at the following factors, one by one.

1) *The light source*: This may be the sun or the moon, electric or neon light, or candlelight, which makes it possible for us to perceive the varying tones and colours of our surroundings. When there is no light, we can see no variations, only lightlessness – that is, black. Looking at your model, ask these questions: Where is the light source? How strong is the contrast? Why? What percentage of the model is generally lit? If working in a group, compare your answers, then block or switch off the light and observe the difference.

2) *The planes of the object*: The angle of the surface of the body in relation to the light source causes areas to appear light, medium or dark. Which planes of your model are directly facing, oblique to, or facing away from the light? Does the body surface look soft or sharp? Shiny or matt? Does the 'mood' of the tonal image change as you walk around the model?

3) *Observer's position*: Your position in relation to the model is crucial to the tonal 'truth' that *you* witness, and it is unique. Your drawing of the model will be unlike any other, in tonal terms, because the angle of incidence from the light source to the model and back to the eye is specific to you. Compare the lightest areas from different points of view.

4) *Cast shadow or light interference*: Cast shadow is caused when an intervening object interrupts the passage of light rays to a surface plane that is facing the light. Hold a sheet of paper or your hand between the light source and the model, and observe the change of tone.

5) *Reflected light*: This is caused when light is reflected by a pale surface that is facing the light, back onto a surface that is not. Standing at a three-quarter angle to the model (back or front), angle a sheet of paper to directly face the light source. Now bring the paper, still catching light, towards the unlit surface of the model until you see its reflection on the body. Note that this is more, or less, evident from different view points. It is a very common error to assume that reflected light (surrounded, as it usually is, by a dark, contrasting, unlit area) is as light as the lit area. Try the same exercise with a dark sheet of paper and note how much ambient light is absorbed by the dark paper.

6) *Local tone*: This refers to the innate ability of any surface to reflect light and can be caused by the pigmentation (or colour) of the surface. Different pigments reflect and absorb differing amounts of light – for example pale skin, black hair, dark eyes. Local tone can also be affected by texture. For example, skin of the same basic pigmentation may reflect more contrasting tones if it is smooth, but fewer if it is matt, as will smooth or curly hair. In this category of tonal recognition, the brain is very happy. It is more interested in efficiently deciphering facts from visual data (such as the body is dark with light hair) than waxing lyrical about the lighting conditions or planes of the skin and hair. Note, however, that in the illustration the 'light' hair on the unlit side is darker than the lit side of the 'darker' body.

7) *Iris dilation and contraction*: The actual range of tone as perceived from one extreme (the sun) to the other (no light at all) is very great. As well as the eyelid, the human eye has its own inbuilt device to vary the amount of light that comes into the eyeball through the pupil (the dark hole or 'aperture' in the eye). The iris (the coloured area around the pupil) is a muscle that automatically contracts (closes down) to let in less light in very bright conditions, and dilates (opens) to let in more light where the conditions are darker. It is important to know this fact, because the reading of the relative tones of the dark and light areas of your subject can be easily distorted by the neutralizing effect of this brilliant regulator – the iris.

Try this exercise. Very quickly transfer your gaze from a very light area (for example, the sky outside) to a very dark area (the inside of a cupboard). Note how quickly you can perceive 'light, medium and dark' relative tones in both areas. The amount of light, if it were measured, is extremely different in each area. Nevertheless, the brain has the tendency to define relative tonal distinctions within each area, rather than from one area to another. This is because the iris can widen and narrow very quickly. (If you are working in a group, work in pairs to observe this.)

Another factor of note is that the central area of the retina is extremely sensitive to colour (and works well in light conditions), while its peripheral areas are more sensitive to tonal information and work more efficiently in lower lighting conditions. This is why artists often lower their eyelids to let in less light and gain a clearer picture of the tonal message, because this avoids the distraction of the colour information. (A filter that reduces the colour information may also be used to look through, but it is important that its colour balance is neutral in order for it to evenly absorb light.) Try closing down *your* eyelids a little to see the relative tones more easily.

The beginning of Chapter 1 discussed the eye/brain/hand relationship and the difference between the information: firstly as seen by the eye (visual); secondly as known by the brain

(interpreted); and thirdly, as drawn by the directed hand (recorded). To draw what is seen, it is very important to be able to 'rewind' this 'tape' of visual experience. By continually asking 'What do I see?', and inviting the brain to take stock (literally) of the information for its own sake, not just its meaning, your hand will now be able to draw seen shapes and lengths.

Tonal drawing requires the same 'tape-rewinding'. By taking the time to really look at these seven tonal factors, and comparing tones at any time, wherever you are, not only will your drawing be informed and enriched, but your increased awareness will add enormous pleasure to the feeling of discovery. To know, not just what it is that you are seeing, but also *why* you know what it is and how to express it, adds another dimension to sensory experience. Remember that each time you draw, you are the first person to discover and record *this* model, *this* pose, *this* lighting, *this* view, and in this way!

EXERCISE: **BLACK OR WHITE?**

What will you learn? The following exercise develops in the artist a keen awareness of where and when tonal values change, which is not always where the body parts do; this helps to avoid drawing either a fuzzy, woolly mass with lighter shapes appearing as random lumps, or something with a 'beaten pewter' look. Although the tones we see on the body are more often graduated than sharp-edged, this exercise encourages the artist to really study their shapes, just as a map-maker marks out hills with defining contour lines.

— POSE: Any pose with the model side-lit with one light source
— TIME: 30min with a '15min-to-go' alert
— ARTISTS: Positioned with a quarter- to three-quarter-angled view of the model – that is, neither in the light line, nor facing the light

Working quickly and alertly, use any methods that will help you to make, in fifteen minutes, an accurate line drawing with clearly defined and detailed edges and centre line (for instance, Rhythm and Curve plus Journey A–Z).

Now decide which areas, *including* cast shadow, are, in your opinion, more than 50 per cent light, or less than 50 per cent light, using key areas that you deem to be just either side; partition these with a fine black line into 'islands', as you did with the Armadillo exercise, looking carefully at the exact character of their shape – for example long, oval, narrow, square, spiky, like a maple leaf, and so on. Take your time to carefully draw these 'islands' through the *whole* pose. While it may be difficult to decide exactly where to put the line, be comforted by the 'good news' that at least the choice is simple and clear cut: black or white? If at any time the shape does not fit the drawing, don't fudge it, but check the larger dimensions (it will pay off in the long run).

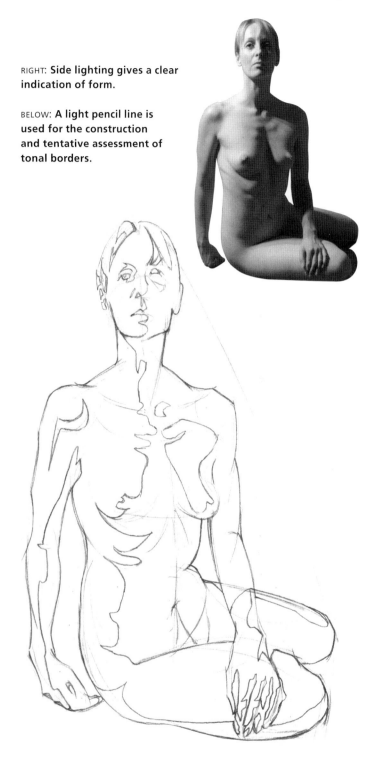

RIGHT: **Side lighting gives a clear indication of form.**

BELOW: **A light pencil line is used for the construction and tentative assessment of tonal borders.**

Then block in all the unlit shapes, very neatly, in pure, flat black, even though you may lose part of your original line drawing. (If you are working in pencil, use ink or charcoal for this.)

What does this drawing convey? Despite its stark contrast and apparently flat shapes, this image gives a dynamic sense of form.

After careful checking, blocking
in the unlit shapes is a relaxing reward
that reveals dynamic results.

BELOW: **This 'grey and white' alternative has crisp,
clean shapes juxtaposed with elegant curves.**
ARTIST: ELSIE OVENS

BELOW LEFT: **Shapes of charcoal and chalk in diagonal
strokes on grey paper emit a more masculine energy.**
ARTIST: VALERIE DAVIDSON

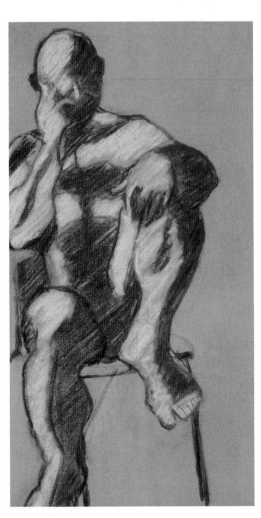

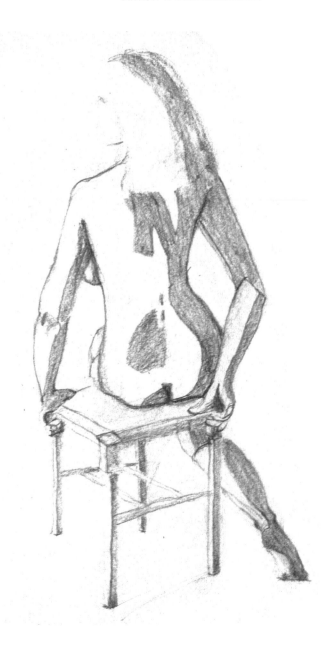

Though it can feel as if the black shapes 'heartlessly gobble up' much of the detail, it is for this very reason that the planes that are selected to describe the surface character, do so with a more strident power. Look particularly at the portrait – and remember, the eager brain needs only a little accurate information to be able to imagine the rest of the detail.

> After all my hard work I really didn't want to lose my drawing and mess it all up by blocking it in – but now it looks fantastic. I can't believe that I've created such a strong drawing!

PREPARATION EXERCISE: STROKE AND TWIST

— NO MODEL IS NECESSARY
— MEDIUM: Stick of chunky charcoal, soft and straight, approximately 1cm (diameter) × 3cm (length) on a large sheet of paper

Before you start drawing the model, do this short exercise: it will help you to record tone accurately and as quickly as possible (to avoid too much brain interruption).

Place the charcoal flat on its broad side anywhere on the paper and then slowly stroke it along on its side, travelling in *one* direction, and gradually turning your hand as you draw. This makes a mark that appears to twist from the widest to the thinnest capacity of the charcoal. Varying the pressure and widths, cover the paper with marks until you feel in control of the placing, width and tone of the shapes.

PREPARATION EXERCISE: MID-TONES ONLY

This fast and light sketching process is used to broadly identify the lit and unlit areas, and is ideal for making an economical record of shape and form. It also lays the broad foundation for subsequent, more subtle tonal modelling.

What will you learn? This exercise is relaxing and empowering. It enables the artist to understand the importance of the light source, the plane and the observer relative to each other, and it achieves a broad but effective statement of volume. It also avoids the problem of drawing the incidental tonal details 'piecemeal' across and around the surface, which, though tempting, produces a 'beaten pewter' or bruised look. By asking the most fundamental tonal question, namely 'which areas of the model are *generally* reflecting light, and which are not?', and by drawing the answer, a two-dimensional 'map' of the model suddenly becomes three-dimensional and has form.

Make many marks to familiarize your eye/ brain/hand team with Stroke and Twist.

— POSE: Standing, with light to one side of the body
— TIME: 5min, with a '2min-to-go' alert

Using Rhythm and Curve, take three minutes to lightly and loosely scan-draw across the body, looking for the weight, balance and larger-scale proportions, just to place your model on the paper.

In the last two minutes, look for all the shapes on the model that are generally not light and, holding the charcoal on the side, 'stroke and twist' it to describe these shapes, with enough pressure to give you an even, medium tone (halfway between black and white). Use your preliminary construction lines to guide you, but if the shape of tone really does indicate that the proportion is wrong, or could be refined, then change the shape, not with line, but with the tone. Start to look at shapes of tone and then draw them, rather than just 'filling in'.

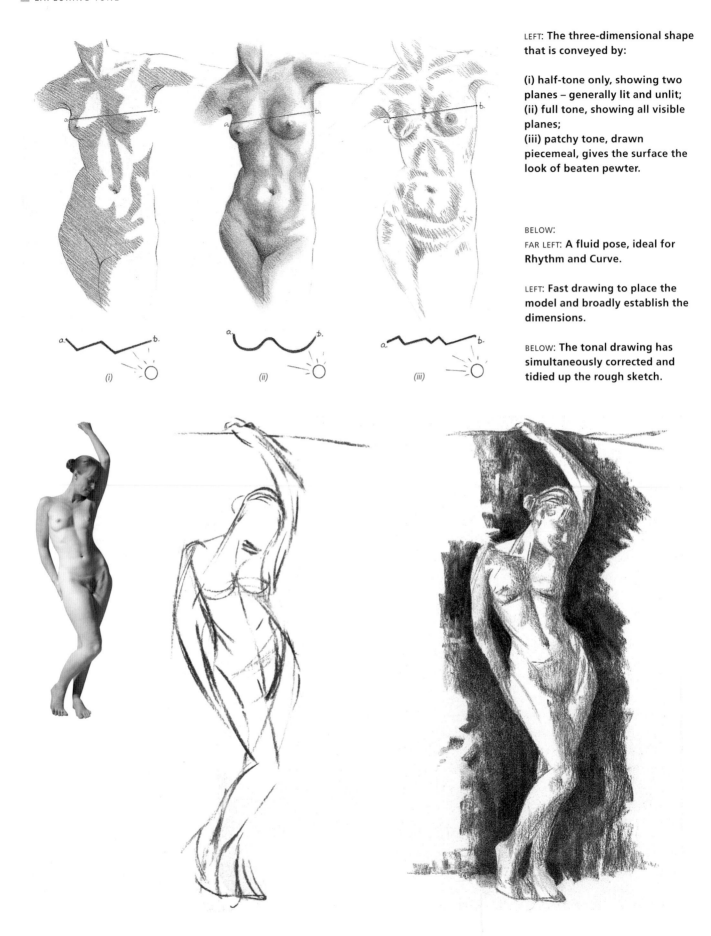

LEFT: The three-dimensional shape that is conveyed by:

(i) half-tone only, showing two planes – generally lit and unlit;
(ii) full tone, showing all visible planes;
(iii) patchy tone, drawn piecemeal, gives the surface the look of beaten pewter.

BELOW:
FAR LEFT: A fluid pose, ideal for Rhythm and Curve.

LEFT: Fast drawing to place the model and broadly establish the dimensions.

BELOW: The tonal drawing has simultaneously corrected and tidied up the rough sketch.

Mid-tone and line were used at the same time for this short pose.

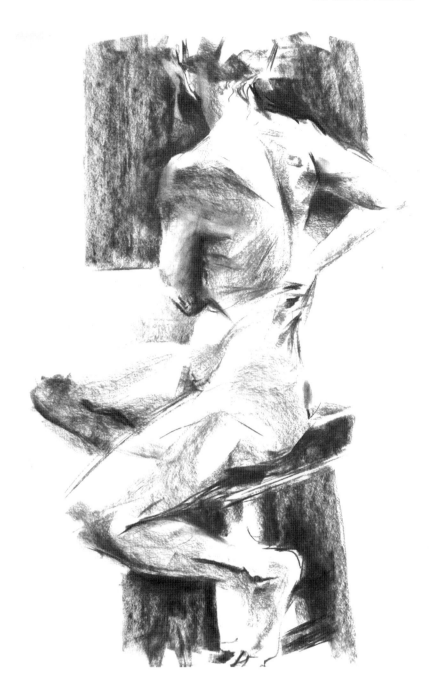

Work quickly to put in all the unlit areas, remembering to use only a medium tone, even for the darker shapes such as dark hair or deep shadows. If you have time you may want to block in some background areas in black which, though not actually seen, will 'hold in' your drawing on both the light and medium edges. By drawing from the background *towards* the edge, you will resist the urge to draw a 'black caterpillar' around your model!

If working in a group, put all your drawings down on the ground in a line in order of your positions around the model, and compare the percentages of light and mid-tone shapes. Discuss the ease or difficulty of tonal decision-making. If you are working on your own, do several drawings from different angles to compare.

You will have discovered that the tonal story and its drama vary enormously. When the light and the artist are both facing the model from the same direction and angle, the tones are generally light with subtle variations. To help make clear decisions about such understatement it is useful to find a key area of average 'non-light' tone to refer back to; this should help you maintain a tonal consistency in your drawing, even though the borderlines for your 'generally light' decisions may not be the same as those of a close neighbour.

If, on the other hand, the artist is facing the light source and the model between is back-lit, then very little body area will be lit, but the distinction will be easy to perceive. However, though the shapes may be small, they will be the only representatives of form-description, and it is important that they should be accurately left white, and drawn in exactly the right shape and place.

The artist who forms a right angle with the model and the light will enjoy both a full and distinct tonal story – the challenge from this viewpoint is that there are plenty of tonal shapes to describe in two minutes! For this reason make sure that you draw at least three lighting conditions from different places to experience this variety (the pose may remain or change). When, with practice, this important first stage has become comfortable and instinctive, it is a relatively simple step to progressively add the darker tones, knowing that both the form *and* the skills of tonal recognition are established.

What does this method convey? A sense of energy and dynamics (imparted by the Rhythm and Curve), together with a sound, broad feeling of volume. This unfussy approach conveys a lot of information about the pose, with the minimum of marks and effort.

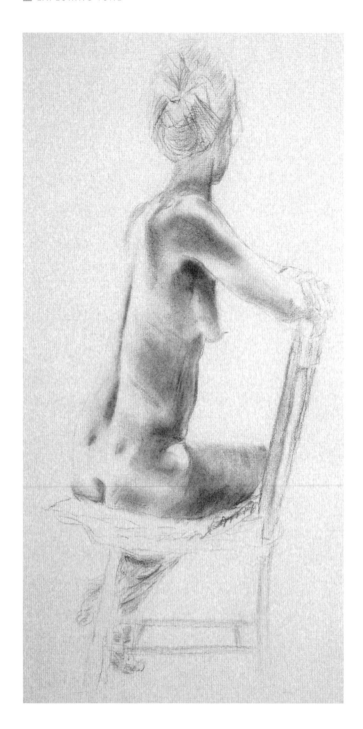

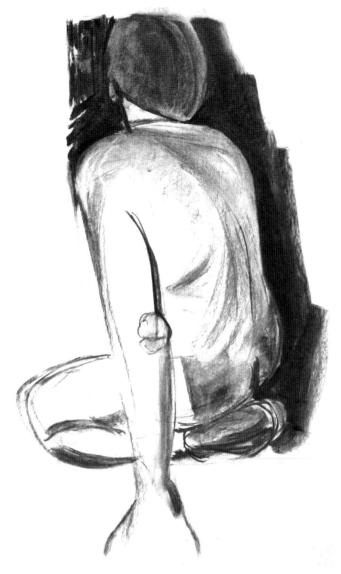

LEFT: **Subtle tones express the multi-directional lighting on this elegant pose.**
ARTIST: DOUGLAS GREEN

ABOVE: **A strong rhythmic statement with subtle tonal volume.**
ARTIST: CHRISTINA SMITH

EXERCISE: **CROSS-HATCHING**

Using a graphite or charcoal pencil, this method uses a 'mesh' of straight lines to gradually build up the tone on white paper. It is a methodical and convenient way of sketching, and also clean, if pencil or pen are used. Considered by many artists to be the 'default' method of drawing, it gathers together both profile definition and tonal information in a controlled and considered way.

What will you learn? To observe, categorize and draw accurate tonal values in a way that has a coherent and consistent rather than piecemeal volume. Also, drawing evenly spaced parallel lines develops a dexterity of control and pressure in handling the pencil.

— POSE: Any pose, but with medium-strength modelling light
— TIME: 40min
— MEDIUM: Soft pencil

This method entails the use of a tonal key. Construct this by drawing, in pencil, four equal and adjacent squares on the paper down the topside edge that is opposite to your drawing hand. Make sure that the key is drawn right to the very edge. The reason for this is that you will be able to hold your key alongside the actual reality and compare them if the lighting on both your paper and model is similar. If the lighting is different, find reference areas on the body that you deem to correspond to each category: that is, light = 0–25 per cent tonal darkness; medium-light = 25–50 per cent tonal darkness; medium-dark = 50–75 per cent; and dark = 75–100 per cent. (This is similar to using a ratio for dimensions, rather than drawing sight-size.)

Leaving the top square white, hatch (by drawing evenly pressured parallel lines quite close together) all over the three other squares in one process, not individually. Then over the previous marks, hatch the lower two squares in the other direction diagonally; and lastly, hatch the lowest square vertically. Stand well back to check that the key arrives at a very dark, final tone, and that the progress between each tone jumps evenly and is well balanced. Apply slightly more lines or pressure if necessary.

First, lightly, then very precisely and clearly, draw the outlines of the pose and its centre line. Now outline, as 'islands', the shapes on the model that, in your estimation, represent the light category. Then block out all the remaining area with even,

LEFT: **The tonal key (on the left for right-handers) can be compared alongside the real image if the lighting is similar.**
BELOW LEFT: **The first layer of medium-light tone immediately conveys form.**
BELOW RIGHT: **The second layer of tone is added to convey medium dark.**

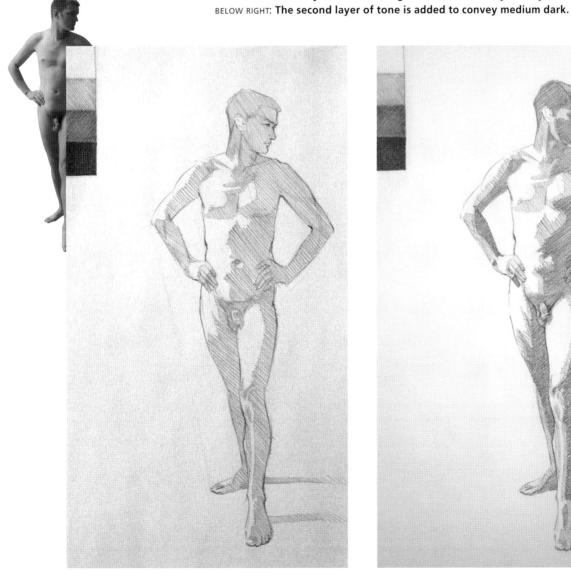
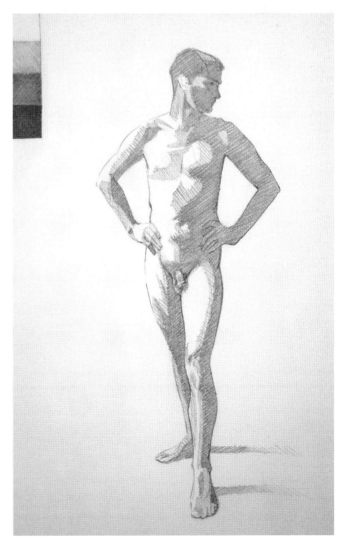

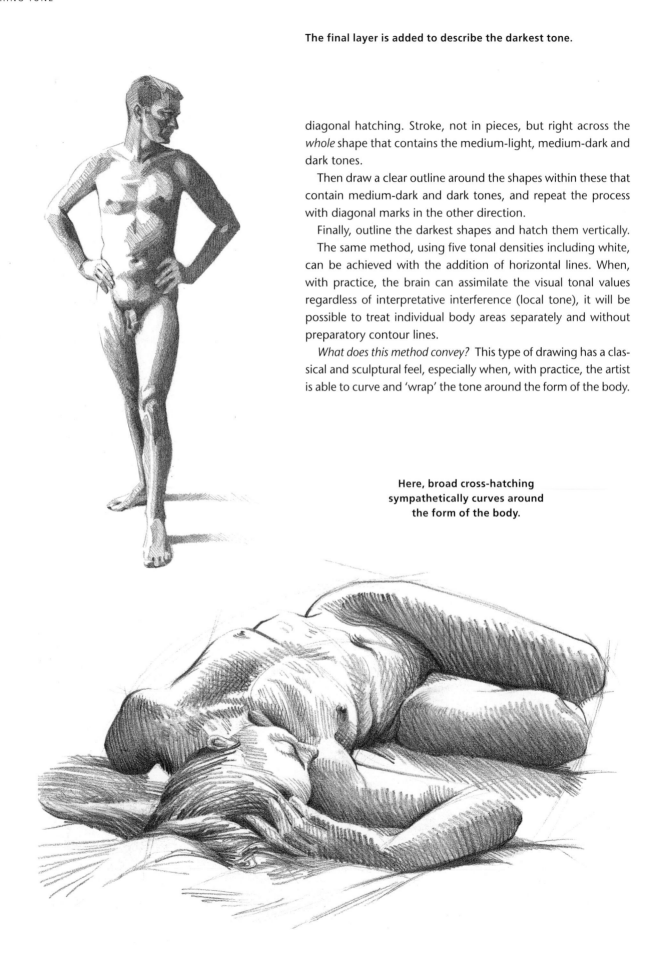

The final layer is added to describe the darkest tone.

diagonal hatching. Stroke, not in pieces, but right across the *whole* shape that contains the medium-light, medium-dark and dark tones.

Then draw a clear outline around the shapes within these that contain medium-dark and dark tones, and repeat the process with diagonal marks in the other direction.

Finally, outline the darkest shapes and hatch them vertically.

The same method, using five tonal densities including white, can be achieved with the addition of horizontal lines. When, with practice, the brain can assimilate the visual tonal values regardless of interpretative interference (local tone), it will be possible to treat individual body areas separately and without preparatory contour lines.

What does this method convey? This type of drawing has a classical and sculptural feel, especially when, with practice, the artist is able to curve and 'wrap' the tone around the form of the body.

Here, broad cross-hatching sympathetically curves around the form of the body.

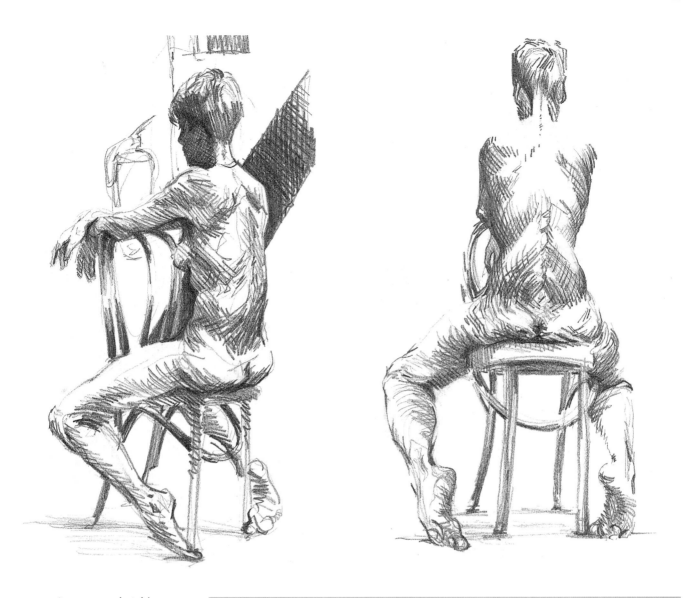

ABOVE: **Loose cross-hatching is used for quick poses.**

ABOVE RIGHT: **The same method used for the same pose, but viewed from ground level.**

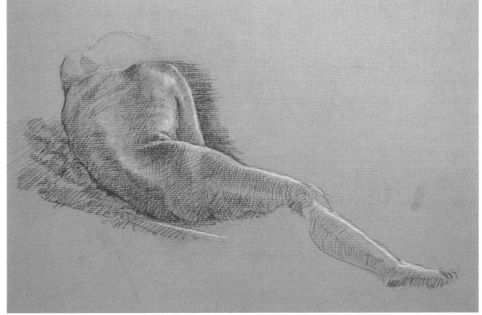

A classic use of conte that follows the form over and around the 'horizon'.
ARTIST: ANDREW DICKINSON

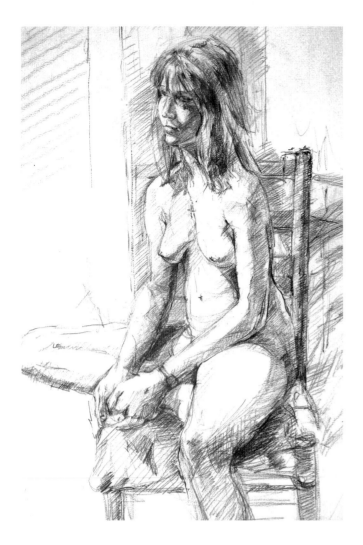

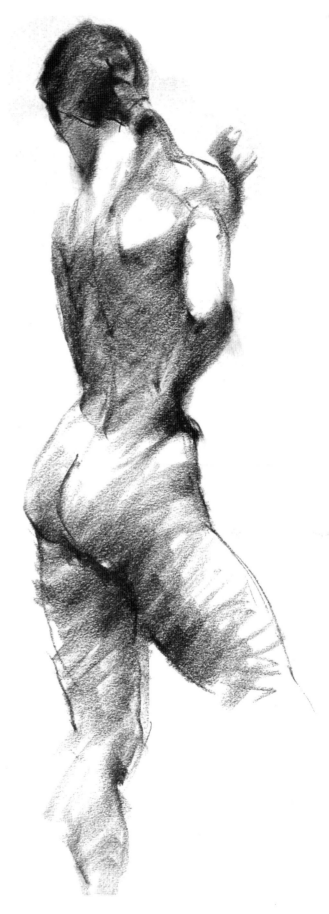

ABOVE: **Tentative searching and subtle hatching suit this gentle pose.** ARTIST: CATHARINE SOMERVILLE

RIGHT: **Extremely broad hatching contrasting with a nice line economically conveys volume and accuracy.** ARTIST: ROY PACE

EXERCISE: **SILHOUETTES**

To draw literally what we see it is necessary to shift the emphasis from the edges of the body to the planes and tones within. Drawing Silhouettes is designed simply to refocus the artist's attention and to encourage the 'letting-go' of line.

What will you learn? This preparatory exercise is designed to give you the courage to draw the model without that abstract but defining black line around the edge. This is a bold but necessary step to take, because tone has much less respect for 'naming' different parts of the body than line does. Though tempting, filling in an outlined drawing will only hold the attention focused

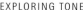

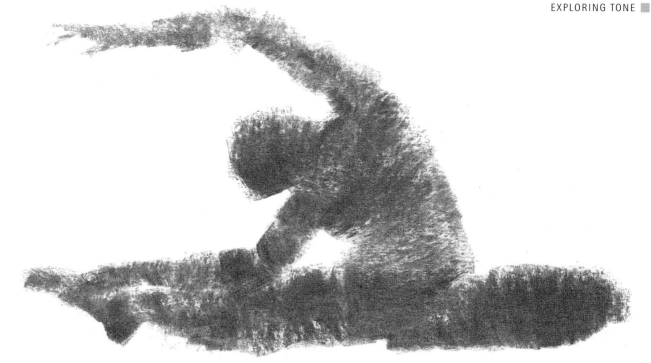

ABOVE: **A dynamic stretching pose for Silhouette.**

RIGHT: **Negative shapes and foreshortening are easier to identify using this method.**

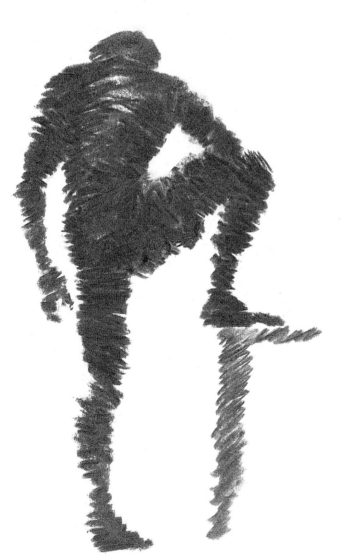

on 'territorial' body-part definition rather than form-definition. If two adjacent surfaces reflect the same amount of light, then no tonal explanation of the actual change in contour will be apparent. Shadow or light can often quite happily sprawl across an arm and a leg, for example, barely changing density at all on the way. If you feel like a first-time skater who is frightened to let go of the support bar at the edge, this exercise will help you to travel across the imaginary internal boundaries and confidently explore the whole ice rink!

— POSES: Three unusual, dynamic positions
— TIME: 3min

Using the charcoal flat on its broad side and starting in the centre of the largest body shape, block out any shape that is model, moving *across* the body shapes and limbs (not down). Tentatively edge back and forth from the inside towards the outside edges so that eventually you achieve a silhouetted shape in black, and are freely 'skating' across the 'rink'. When parts of the body overlap there is no need to identify them individually. You will start to see 'blocks' of model, instead of drawing separate arms, legs, body and head. Let the eye use the negative outside shapes to guide your hand, gradually, towards the extreme

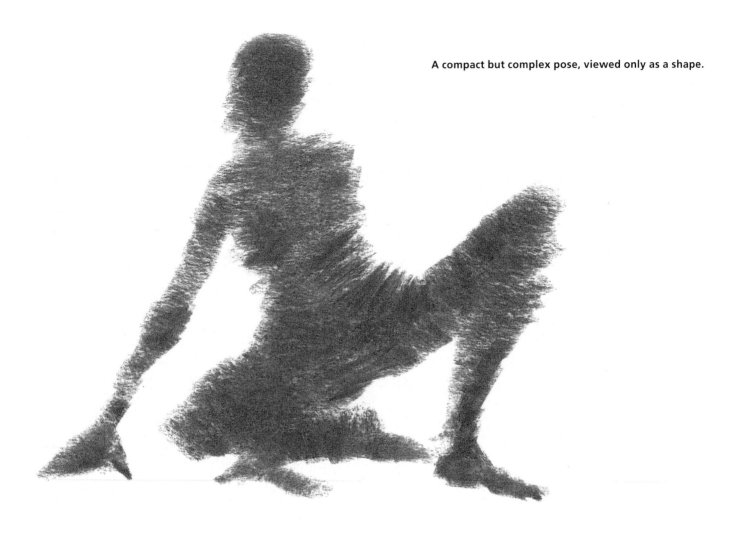

A compact but complex pose, viewed only as a shape.

edges and tips of the pose – though until you feel sure where they are, stay well within the boundaries. Keep standing back to see the whole shape developing.

Do this exercise several times just to let go of the 'rails' and the need to draw round and fill in. Resist the temptation even to travel parallel to the edges, rather hold your attention on the space between the edges. This may feel strange at first, but after drawing several of these silhouettes you will begin to feel the advantages of nudging your way towards an edge, rather than having to commit to it immediately. Options on exact placing, scale and proportion can be kept open till the end of the drawing. You will also feel more flexible for the next exercise, which involves 'naming' the tone, rather than the body shapes.

What does this method convey? Although it is only intended as a liaison between different ways of looking and mark-making, the unconfined edges and empty, dark interior of the image express a shadowy presence that is neither distinct nor static. In the same way that you may have felt tantalized by wanting to identify limbs and fine detail, rather than block them out, so the figure will appear as masked, mysterious and intriguing.

EXERCISE: **FIND THE FORM**

Although this exercise, like all the others, involves working on a flat surface, the experience for the artist approaches the tactile sensation of 'moulding' the paper with the hands. In order to work 'into' a ground of average light absorption and reflection, the basic condition of the paper in this case is therefore rendered grey. Just as a sculptor finds a body in a larger mass of marble, or builds on and carves away from a basic lump of clay, so you will see the form of the figure appear on the paper as though it had been waiting to come into existence.

What will you learn? To trust your ability to recognize shapes of tone, to relate them to each other across the body, and to identify whether they are light, medium or dark without the use of line.

— POSE: Any position with side lighting

— TIME: 30min

— PREPARATION: Take a thick, soft chunk of charcoal and, holding it flat on its long side, stroke it all over the paper to make an even layer of medium tone. Lightly rub it in with the fingers, if necessary, to lose stripes and blotches

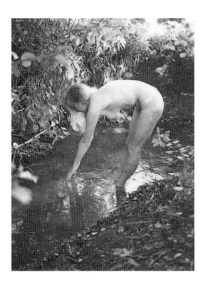

LEFT: **The flexibility of Find the Form makes it perfect for exploring short poses and expressing transient atmospheric qualities – prepare paper in advance!**

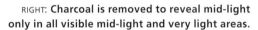

RIGHT: **Charcoal is removed to reveal mid-light only in all visible mid-light and very light areas.**

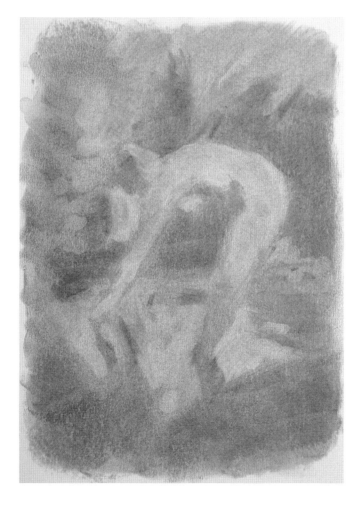

Charcoal is added to create mid-dark only in all visible mid-dark and very dark areas.

Begin by looking for the large, generally lit areas, not just on the model but also in the surrounding space. Closing your eyelids a little will help to identify the relative tones more clearly.

Then with an eraser or, preferably, using your fingers (if the paper surface is smooth), very gently feel your way around the light blocks of the pose, partially rubbing charcoal off these shapes until the mid-light tones begin to appear. Stand back often to check that these vague shapes relate to each other right across the paper both in size and placing. Whenever a shape is wrong, simply smudge it out with the fingers or block it back in with more charcoal. At this stage make sure to keep the shapes very non-specific and blurry.

Then with the charcoal on its side, gently stroke in all the large shapes that appear to be medium-dark, still keeping the edges soft and indistinct. Stop and observe that the form is already beginning to appear in a shadowy yet powerful way. Checking and rearranging these shapes will give you more confidence in the next stage.

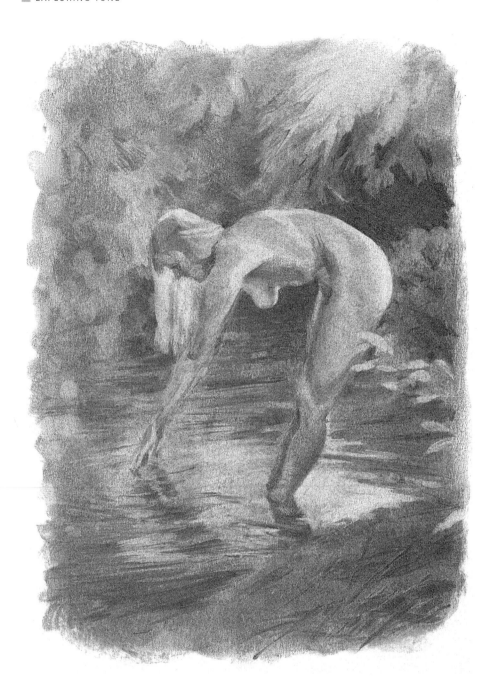

The finished drawing contains many lost edges and passages of tonal interchange.

Next, look for the lighter tones and start to erase more vigorously. Return to the charcoal and, applying more pressure, push in or 'model' the darker areas. A useful question to keep asking is 'How do I know that one surface begins and another ends – is it because it is darker or lighter than the adjacent surface?' If it is difficult to perceive the tonal edge between two surfaces it is extremely important to make *no* tonal statement, however tempting it may be, at first, to put a line or invented boundary in place. Even though these surfaces may be of differing colour, they are known tonally as 'lost edges'. Often in life, two adjacent forms may share the same tonal value, or gradually swap relative

roles along their connecting edge, changing from dark-against-light, passing through similar tone to light-against-dark, thereby creating a 'tonal interchange'.

Alternate between eraser and charcoal, as necessary, to achieve the darker and lighter areas until you reach the final commitment, the lightest lights and the darkest darks. These are usually small, few, and special, and are worth studying before drawing. The lights are to be found on light-catching projections – high peaks, shiny surfaces, and in light local-tone areas; the darks in areas hidden from the light – crevices, indents, shiny surfaces, and in dark local-tone areas. These extremes often describe the

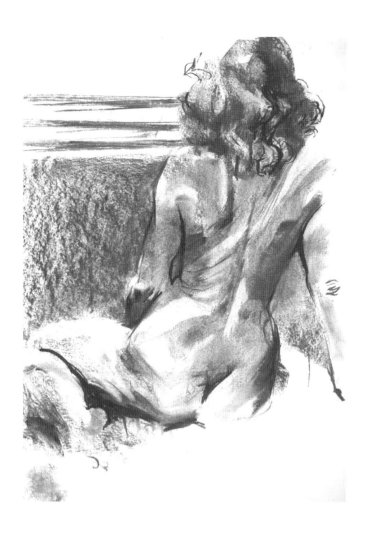

The middle area of torso and background were first
covered in mid-tone charcoal before re-finding the lights.

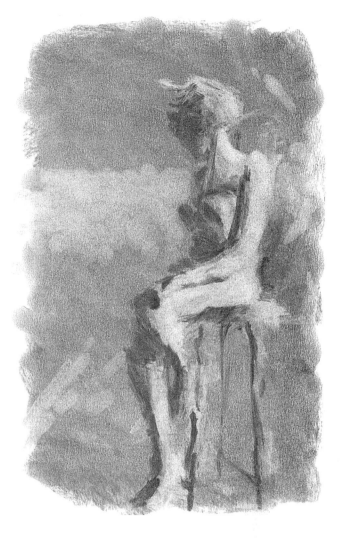

Two-Hand Eye-Trust (3min), first drawing the body and stool,
then looking and reworking (*not* looking at the paper) in batches.

sensory features of the human body, such as the finest facial details, fingers, toes, nipples, genital and intimate areas of the body. These marks are like the jewels in a crown, and are best defined last when you are sure of the larger proportions. It is important that they should be both placed with great care and savoured triumphantly. For a small, intense, light or dark mark, sharpen one end of the eraser or charcoal respectively, then press, and simultaneously twist the tool very firmly onto the paper.

The first time you do this exercise you may feel a little unnerved because the definition is drawn only at the final stages. It is for this very same reason, however, that you will soon begin to feel the freedom that this method offers. It is possible to relax and explore the general form before the final commitment, by which time you

will be confident about the proportions. Also, because you are drawing literally what is seen – the tones as you see them – rather than the lines that don't exist, the image is actually easier to create and compare to reality. The soft, flexible medium of charcoal gives plenty of scope for redefining and remodelling the form.

Explore this method fully by drawing the model in different lighting: lit from in front, side-lit and backlit. Eventually, with eraser and charcoal in each hand, you will be able to work the lights and darks into the paper simultaneously – *and* without looking at the drawing – and experience, as you did with 'Two-Hand Eye-Trust', the sensation of 'holding' the body in your hands. By doing several of these you keep clear the eye/brain/hand pathway. This is also particularly effective and

fun for very short poses. Prepare plenty of paper in advance, remembering to fix each sheet securely, and hold the eraser and the charcoal in the hand appropriate to the lighting.

What does this method convey? This type of tonal image will resemble the 'reality' of a black-and-white photograph to a degree that can range from highly precise to soft focus and mysterious, depending on the definition of the detail. Though the shapes you have drawn seem to be mere suggestions of medium-light and medium-dark, nevertheless they constitute a description of planes facing towards, away from, and oblique to the light. These not only express an idea of solid form, but are given extra weight by being selected from a neutral world of grey. Unlike white paper that, when empty, describes a world of light and 'non-existence', grey can describe not only planes that are angled obliquely to the light, but also a world in which other subtle forms *may* exist, but which are, as yet, unlit.

EXERCISE: BLACK AND WHITE ON MEDIUM

With this method, the tone is described by the addition of white and black marks to a medium-tone surface. This expression of tone is similar to the last in observational approach and visual result, but the actual statement is quite different in technique. The light tones are established in this case not by erasing/taking away tone, but by adding light marks. The darks, as before, are described by adding dark marks to the middle-tone ground. Although this method is, like the last, exploratory at the outset, the final look of the drawing often has a more finished appearance.

What will you learn? Again, you will be learning to draw your model as he/she is actually seen (though without the colour). You will gain even more confidence to go into the shadows of a neutral-ground paper and 'feel for' and 'find' the image, without using an artificial line for construction.

— MODEL: Not in pose during this preparatory stage, but unclothed for checking the tonal key
— MEDIUM: White conte, pastel or chalk, and black conte, pastel or charcoal. Pastel or sugar paper, must be middle-toned grey (halfway between black and white)

Start by making a tonal key on the very side edge of the paper (as you did with Cross-Hatching and for the same reasons), but this time for *five* densities of tone; this will act as a guide for a full tonal drawing. Construct this by drawing, with a pencil, five equal and adjacent squares on the pastel paper down the top-side edge, opposite to your drawing hand, making sure that the key is drawn right to the very edge so that you will be able to hold your key alongside the actual reality and compare them.

Firstly, using white, stroke a medium-light tone into the top two boxes. Then, using black, stroke a medium-dark into the lower two boxes. Now, pressing very hard, make the top box as white as possible and the lower box a solid black, leaving no evidence

of the paper tone in either space, and working evenly right to the edge. Stand back at least five paces and check that the gradation darkens and lightens in even steps. The effect should be that of a mechanical nut in sunlight, with each facet or plane catching less light. It should appear to angle forward from the very light top, then face the viewer at the untouched middle box and finally recede in the bottom square. If necessary, adjust the medium-dark and medium-light to achieve this illusion. (Ensure that there is no interruption between your key and the reality behind it, by putting your paper right on the edge of your board.)

If the lighting on your paper is similar to the lighting on the model you will be able to simply read off the appropriate tone for any part of the body by lining up key and model, edges flush to each other, and looking for the most 'lost' edge. Clear decision-making is called for when all tonal values are available to choose from. If the lighting on your drawing is different to the model's you can at least identify key reference points for your own interpretation of light, medium and dark to relate similarly to the model.

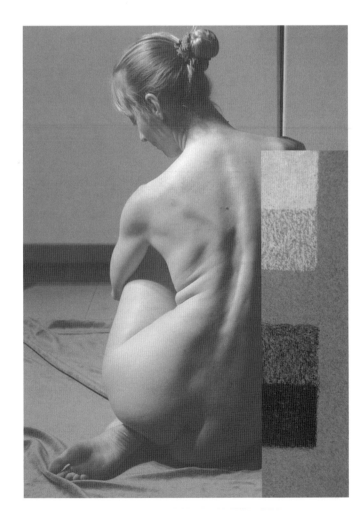

The tonal key can be compared to the real body tones if the lighting on both is similar.

— POSE: Any pose is suitable, but it must be side-lit from the artist's viewpoint
— TIME: 30min

Begin with white by stroking in the medium-lights very gently and loosely, looking, not for specific edges, but more for the relationship of general areas of both light and medium-light tone collectively, right through the model and surroundings as far as you wish your drawing to extend. If the model's local skin tone is light, do not assume that it always *appears* as light, but check the tone against the edge of your key (or compare to another area already chosen as light) to be sure that your eye is in charge of the assessment. Any area that is middle-toned should be left untouched.

Now stand well back and check the broad proportions and placing of marks, altering them if necessary. The surface of pastel or sugar paper is more robust than newsprint or light cartridge paper, and can withstand a tougher handling. However, because the surface 'tooth' is usually rougher, the embedded

marks will require more pressure to erase, especially if conte or pastel are used. Then do the same with broad areas of middle-dark tone until the image begins to appear on the paper.

Finally, with greater pressure, work towards the lightest and darkest shapes; these are often small and fine in the figure, but may be larger in the surroundings. Do not hesitate to clearly and boldly describe these background areas as shapes that have a life of their own. Avoid bordering the body with a timid 'caterpillar' of tone, which, clinging to the edge, would only serve to give a linear and two-dimensional appearance to the drawing. Finally, balance the intermediary tones.

As with Find the Form, try this method using Two-Hand Eye-Trust, first noting the lighting situation for the appropriate use of your 'light' and 'dark' hand.

What does this method convey? A full expression of form and volume that, featuring lost tonal edges, intrigues the 'eye' – really the brain – by drawing it in to interpret them. It also adds an authenticity to the translation of reality in a drawing.

The lighter areas are drawn in mid-light leaving the middle-tone areas untouched.

All the mid-dark to darkest areas are described as mid-dark tones.

THIS PAGE:
LEFT: **The lightest marks are savoured.**

RIGHT: **The darkest marks complete the tonal range.**

OPPOSITE PAGE:
TOP LEFT: **Two-Hand Eye-Trust. This 5min pose produced vigorous results.**

TOP RIGHT: **This example shows the tonal key as a mechanical nut.**

BOTTOM: **Sleeping model.**

EXERCISE: **EXPRESSIVE TONE**

Like Passionate Line, this exercise uses the fullest possible range of marks in your vocabulary. This time, however, the method is based directly upon the response of the viewer's eye to the tone and texture of the surfaces as they appear to the artist.

What will you learn? To trust your intuitive response and skill in describing the tonal values of the pose.

— POSES: Any dramatic shapes
— LIGHTING: Using a portable spotlight, change its position after each pose (from overhead, to side-, to underlighting)
— TIME: 3–5min
— MEDIUM: Soft, thick charcoal

This fast and lively exercise requires that the artist responds spontaneously and sensitively to the model's poses as quickly and as

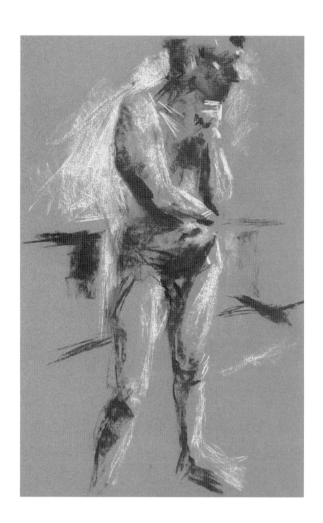

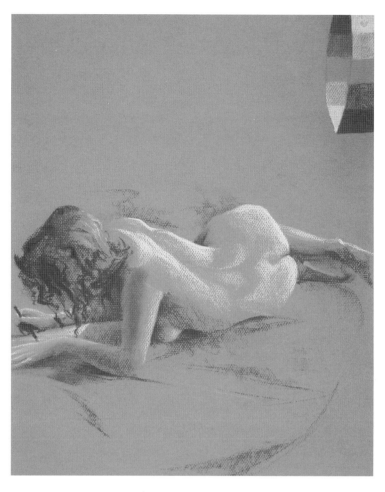

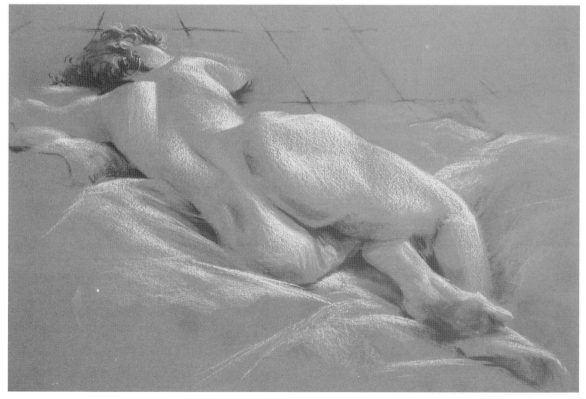

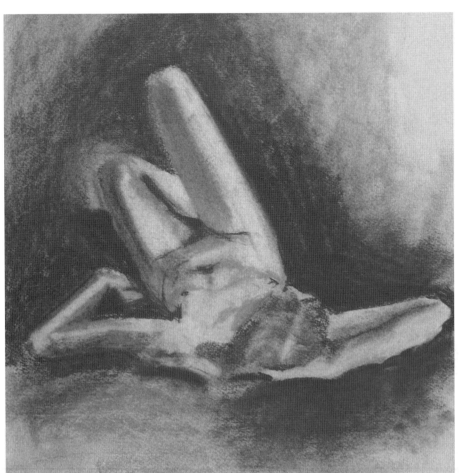

THIS PAGE:
LEFT: **Strong, abstracted shapes are contrasted by small 'clues' of detail by the knee, the hair and little finger.**
ARTIST: JO RAWLINSON

BELOW: **Here the face is underlit.**

OPPOSITE PAGE:
LEFT: **A dynamic pose of angles, causing jumpy tonal variation of arrow shapes.**

RIGHT: **Dark marks in compressed charcoal on tinted paper, made (and smudged) decisively convey volume, movement and sensuality.**
ARTIST: KAREN FORSTER

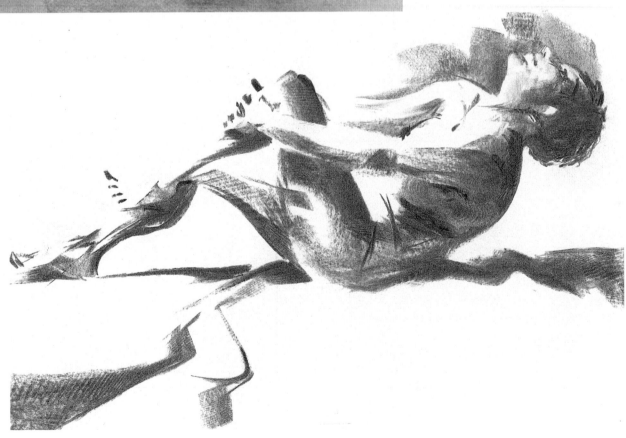

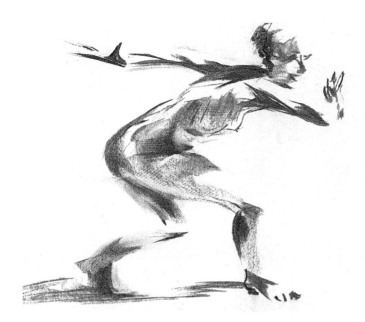

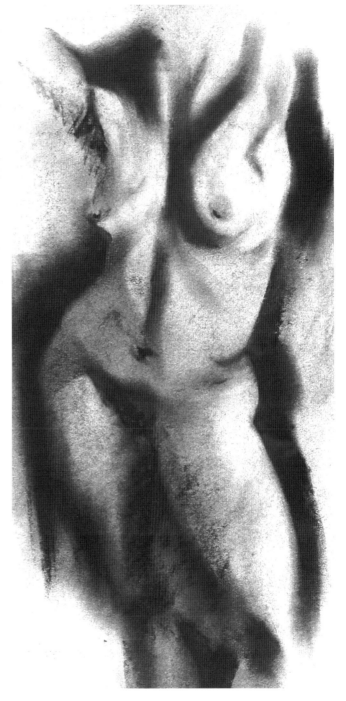

instinctively as possible. Use Stroke and Twist for covering large areas of tone, working gently and broadly for lighter tones, using extra or intense pressure for the darker shadows, slicing the charcoal lengthways for incisive, sharp marks, and using the tip for point marks. Smudge or erase the marks, and caress, dab or jab the paper as necessary. Unusual or strong modelling light on the subject often entails poor lighting for the artist to work by, so the incentive to look more at the model and less at the paper will be greater – and the better the results.

What does this method convey? A sense of drama and urgency that is expressed by the economy and selection of marks for each occasion. There is no time during these exercises to ponder or 'knit'.

Conclusion

Tone can take a drawn symbol and make of it a solid idea, fleshing it out with further information observed in the sensory world of form. In describing form, however, tone also describes the conditions of a primordial element of survival for human life – light. We are so dependent on light that our senses are *subconsciously* attuned to its changes. Tonal drawing skills are therefore of paramount importance to the representational artist, as they express more about mood and atmosphere than any other aspect of visual representation. You can exercise and refine your understanding of tone anywhere, and at any time that light is present, by simply *consciously* comparing tones and lighting contrasts to each other.

The line and tone exercises in the last two chapters may be used in combination with each other either to suit the artist's drawing style or needs, or to reflect the nature of the pose. Line usually represents symbolic reality while tone is more commonly used to describe visual reality, so while putting the two together can create a discourse of differing messages that is stimulating for the eye and brain, it is important to consider their balance, selection and quantity. The amount of information can be successfully reduced from a position of confidence, knowing that, given a few marks, the human brain will not only fill in missing information but will *enjoy* doing so. Visual interpretation is one of its primary functions.

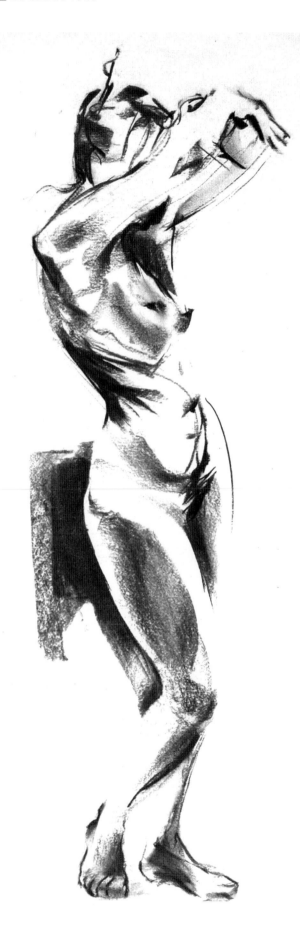

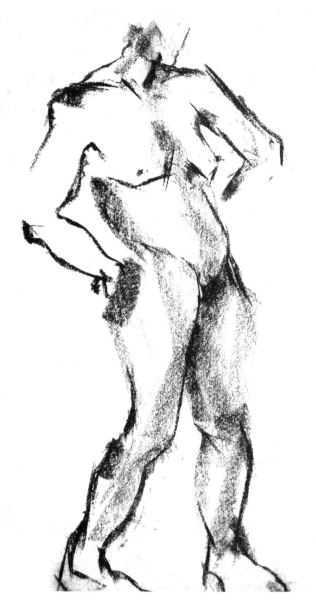

LEFT: **A short pose drawn with a range of mark-width and pressure.**

ABOVE: **Directly stroking, twisting and slicing conte stick gives an economical yet bold feeling of volume.**
ARTIST: SYLVIA STEPHENS

If working in a group, take it in turns to suggest a different combination of line and tone techniques – for instance, triangles that describe faceted planes of tone. A tonal drawing has the potential to look photographic, but it also has the ability to suggest ideas of 'presence', form and movement in ways that the camera cannot. We shall go on to explore these concepts after looking at the physiological reality of the human body: anatomy.

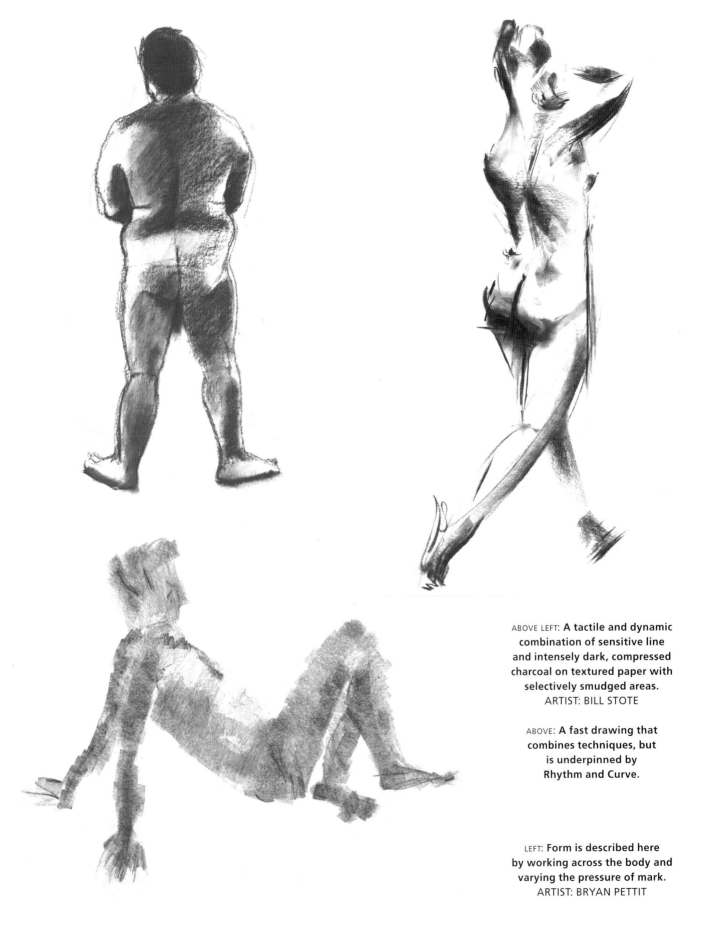

ABOVE LEFT: **A tactile and dynamic combination of sensitive line and intensely dark, compressed charcoal on textured paper with selectively smudged areas.**
ARTIST: BILL STOTE

ABOVE: **A fast drawing that combines techniques, but is underpinned by Rhythm and Curve.**

LEFT: **Form is described here by working across the body and varying the pressure of mark.**
ARTIST: BRYAN PETTIT

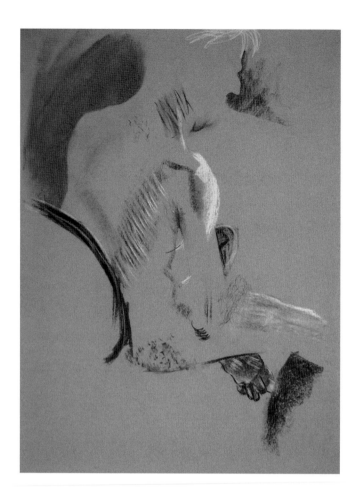

THIS PAGE:
ABOVE LEFT: **Passionate Line and Expressive Tone together express mood and surface texture.**
ARTIST: TOM PRICE

ABOVE: **Subtle tones and triangles give an elegant pose the look of cut glass.**
ARTIST: JOAN ADAMS

LEFT: **Strong tones and triangles evoke rock planes and manmade construction.**
ARTIST: PETER FOTHERGILL

OPPOSITE PAGE:
Environmental facet-finding and four-level tones.

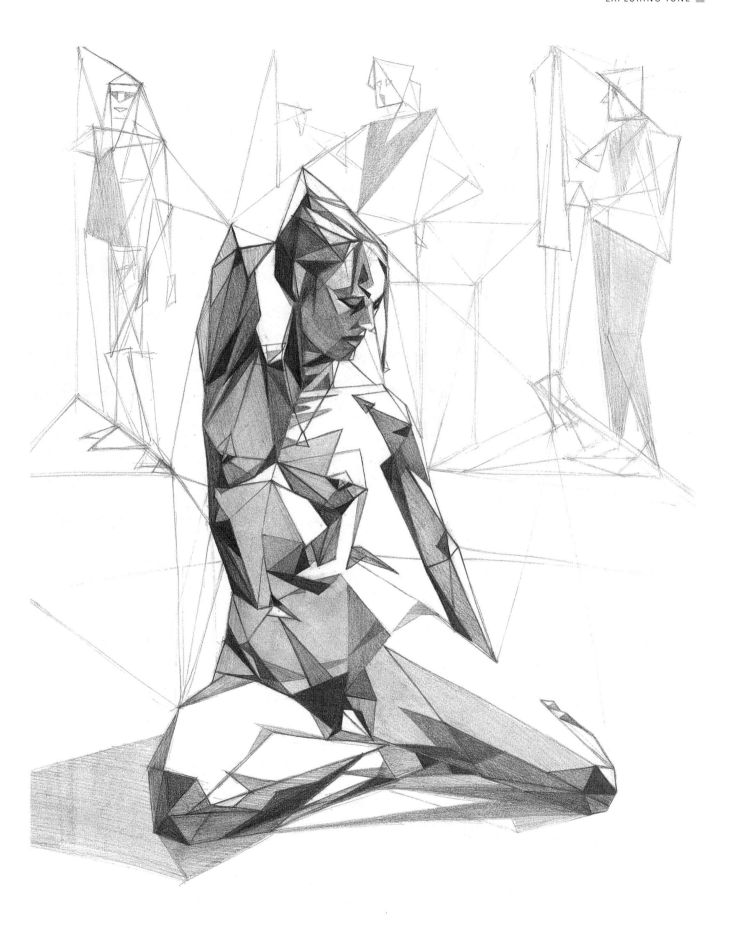

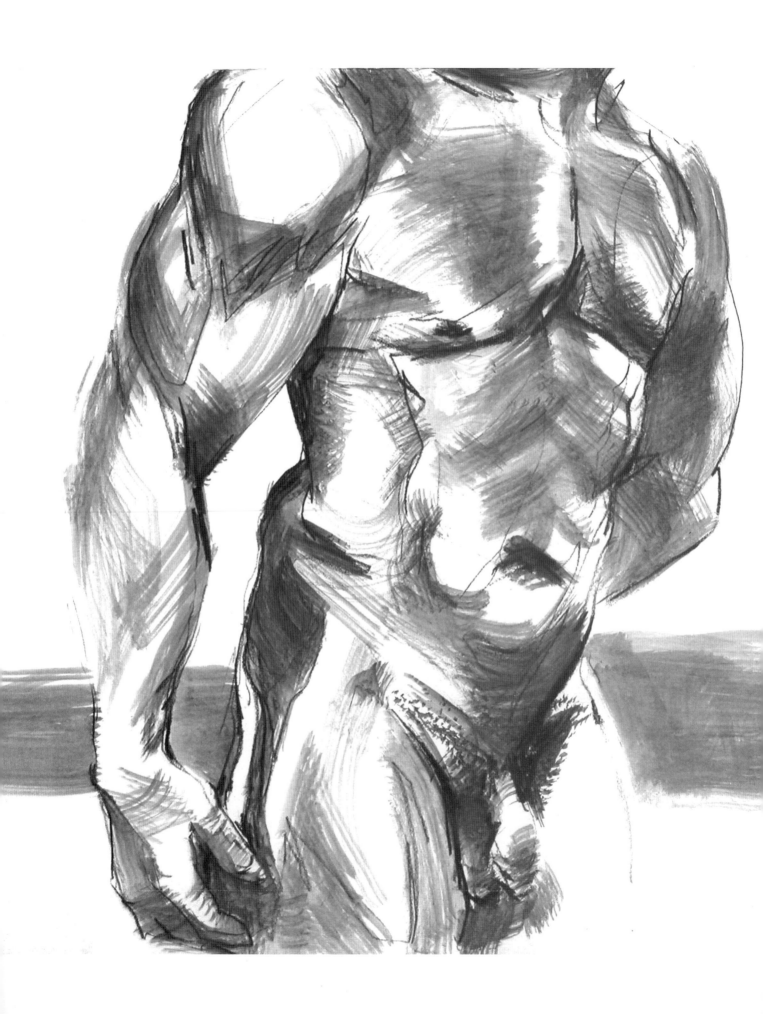

ANATOMY: THE INSIDE STORY

Do We Need to Know?

Whether we need to know much about anatomy is certainly a question for the life-artist to consider, and the answer will mostly depend on the temperament of the individual and their initial reasons for life drawing. For some people, the objective gathering and cataloguing of information is a preliminary part of any learning process, bringing with it the delights, comfort and satisfaction of recognition. Subjective experience, not academia, is the driving force for others, while yet others may wish to identify muscle and bone but much later, and only on a *strictly* 'need-to-know' basis.

Life drawing can be an end product in its own right, a statement based, not upon an intellectual or 'surgical' knowledge, but upon a direct, sensory response, unique to every model, pose, moment and mood. For others, life drawing can simply provide a welcome distraction for an anxious or wandering mind, while some painters and sculptors may wish to collect a library of visual information to use in work that will describe, not the individual, but 'Everyman'.

How much can an in-depth knowledge of anatomy help the drawing? At best, it can inform the drawing and enrich the artistic experience by focusing on the function and visual aspect of the human body. At worst, it can diminish the artist's enjoyment of reality by comparing the model to an average/ideal, or sometimes encourage a tendency to resolve all individual models back to the 'norm' (in the same way that some architects, deferring to their knowledge of perspective rather than reality, are tempted to 'straighten out' old buildings in their drawings).

Nevertheless, we *all* come to life drawing carrying with us an idiosyncratic perception of a standard or 'normal' body based upon various factors, ranging from the inner, personal knowledge (of our own body), our local, visual experience (the bodies we are most familiar with), to fashion (the popular shape). It is for this reason that a first-hand discovery of a variety of models is initially recommended to expand visual awareness, by lifting the 'blinkers' on reality, before proceeding to any in-depth study of the average or 'ideal'. How much more you wish to learn about anatomy after reading and following this chapter, which aims to take a 'middle way' approach, will be *your* choice to make. One truth is inescapable, however: the choice will affect your knowledge base and, as a result, the balance of emphasis and the look of your drawing.

While it is not essential to name every bone and muscle in the human body to be able to draw them, it is vital that you consider their role and function for physical survival and emotional well-being. Though the study of the individual bones and muscles may seem to some to be a dry and dusty business, the collective configuration of these elements is the key to understanding the messages that a body gives out without words. Having studied and drawn the basic visual elements of area, shape, surface contour and texture, we will now move on to the 'inside story': what lies beneath the skin and how it affects the character of the pose.

We all instinctively read body language on a daily basis, but the process of interpretation is so fast that, although we know the meaning, we may not be consciously aware of the visual facts. It is therefore worth rewinding the 'know-look-feel tape' back to our knowledge of the functions of the different parts of the body, in our own experience. This way we can more effectively understand the significance of the information that is received by the eyes. While you are reading the following list, feel and move the relevant part of your body, considering additional functions (which, because experience is idiosyncratic, may not be mentioned here).

LEFT: **'Is it important to know what is underneath the surface?'**

FRONT VIEW, MALE AND FEMALE.

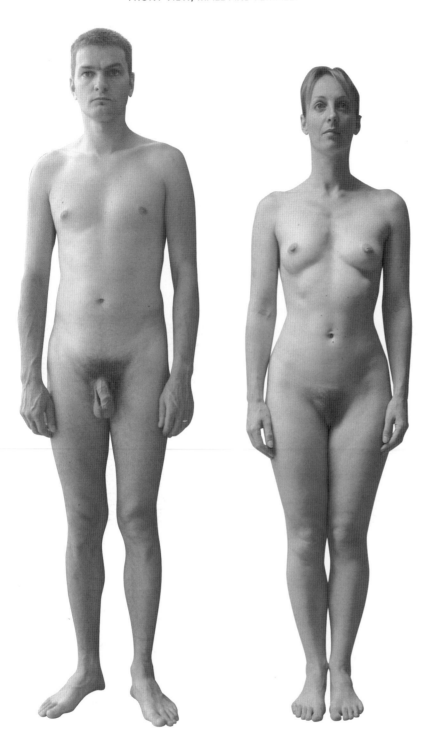

Compare within the figure:

■ the head and neck, torso, arm and leg sections;
■ the head, hand and foot size.

Some Functions of the Body

The head Houses the brain, the headquarters of the body, which is able to imagine, dream, plan, direct and respond to all parts of the body. It is also the home of four, and the site of all five, senses: eyes (sight), ears (hearing), nose (smell), mouth (taste) and nerve endings (feel – though there are, of course, nerve endings all over the body). While the cranium protects the brain, the major sensory organs need to be open to the 'incoming' messages of the outside world and are, therefore, relatively exposed, as are the mechanisms of 'outgoing' messaging, the mouth and lips and, to some degree, the eyes and eyelids. The head is also where the ingestion of food and drink, and the preliminary stages of their digestion take place. It is usually the first part of the body to be protected by the arms.

The neck Supports the head; it rotates and bends to allow 360-degree, all-round (though in some areas, peripheral) vision.

The chest and upper back Site of the lungs (respiratory organs), the heart (blood-pump), the breasts (in women, for feeding children), and the first stages of the digestive system.

The spine Supports the head, chest and arms, and, as their connective bone structure, allows subtle bending and twisting movements between the head, chest and pelvis.

The pelvis Holds the reproductive organs, the final stages of digestion and excretion, and supports the weight of the torso and head when sitting.

The arms Can bend in order to hold, enfold and protect the body, other people, and objects. They can also move the body, and, with the help of the hands, propel it by swimming.

The hands Designed to clutch, grasp, pluck, stroke, hit, pull, point and signal; together with the fingernails, they are capable of extremely fine manipulation. Individually, or cupped with the fingers together or overlapping, the hands also form a bowl shape for holding food, liquid, and so on, or for supporting a head. The fingertips are extremely sensitive to temperature and texture.

The legs Can lower and raise the height of the upper sections of the body and transport it, by running, walking, jumping, swimming, and so on. The knees can support the weight of the upper body and head in a kneeling position.

The feet Balance and support the bodyweight when standing, walking, running and so on.

The whole body Curves forward to protect the head, vulnerable parts of the body, another person or object, and also to lessen heat loss when it is cold. It also stretches when reaching, jumping, running, swimming or resting, and to increase heat loss. It is generally vertical when standing and walking, and lies down horizontally, dispersing its weight and allowing muscles to relax when sleeping.

Every shape and movement that the body can make serves a potential purpose, however subconsciously, for the owner of the body.

Bones: Their Structure and Role

Bones are rigid and jointed together to form a sturdy armature for the human body; together they constitute the underlying structure of the body. Some bones (the cranium, ribcage and pelvis) surround and form protective housing for the brain and the body organs; these are supported and transported, with the aid of the muscles, by other bones (those of the legs), leaving yet other bones (the arms) free, with muscle power, to perform handling tasks.

A ligament is made of strong fibrous tissue; it is attached to two bones and links them across the joint. The job of the ligament is to protect the joint by keeping the bones within a safe range of movement. Cartilage is a dense, connective tissue in two forms that both smoothes the articulation between two bones and acts as a shock-absorber.

As you read on, it is important that you feel in your own body the shape, placing and range of movement of each of the relevant bones. Using the drawings as a guide, treat this as a vital exercise, and if working in a group, compare variations of bone structure. It will deepen and internalize your understanding of bone structure.

THE BACK VIEW, FEMALE AND MALE.

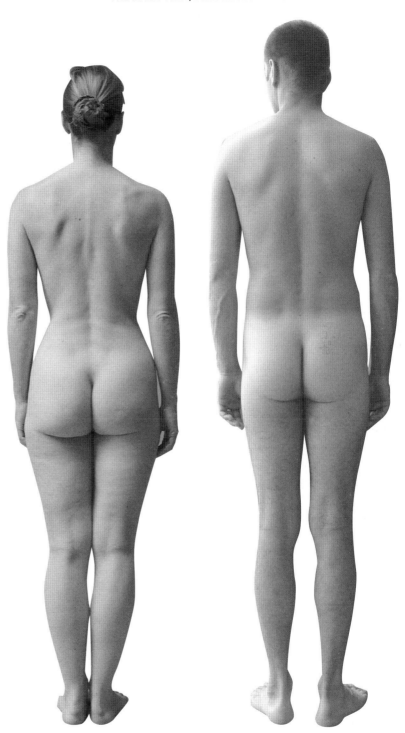

Note the similarity in size between:

▦ **the upper and lower torso, height and width;**

▦ **the upper and lower arm sections;**

▦ **the upper and lower leg sections.**

The Head

The skull has only two moving parts: the brain box and facial skeleton (cranium), and the jawbone (mandible). Each of the two rows of teeth is fixed into the upper and lower jaw in a curve around the front of the face. The hyoid is a U-shaped bone at the base of the tongue that is held in place by ligaments and muscles. The hinged jaw makes an opening, and together with the holes in the facial skeleton, the brain can both receive incoming signals from the environment, and send some outgoing signals to other animals via the senses.

The Spine

The spinal column is made up of twenty-four bones (vertebrae) that are linked together and join the head, the ribcage and the pelvis to each other. They are cushioned from each other by shock-absorbing cartilage (fibro-cartilage) and, although each individual vertebra is only able to swivel and bend to a small degree in relation to its neighbour, the range of movement of the whole spine is considerable. The neck column is particularly flexible, and the whole torso can bend and twist on most axes. (Experience the full range of flexibility of your spine by making as many curves, arcs, bends and rotations as possible.)

Though straight and symmetrical when viewed centrally, the spine has an interesting curve when viewed in profile. The neck vertebrae curve forwards, the chest area (where the ribs are attached) curves out to the back, then the lower-back vertebrae (at the pelvis) curve forwards, and the base of the spine curves outwards again, finishing with the last bone (the coccyx) pointing forwards. This also helps to absorb physical shocks in movement. Accurate observation and drawing of the curve and placing of the spine is invaluable because it usually encapsulates the essence of the pose, being both central to, and linking the most important parts of the body, namely the head, the ribcage and the pelvis.

The Ribcage

At the back the ribs are attached to the vertebrae below the neck column; at the front, the upper ribs are joined to the breastbone (sternum), and then to each other as they diminish in size, thereby forming a rounded cage, while the smallest lower ribs are only joined to the spine.

The Hips and Shoulders

While the pelvis is actually comprised of three bones, they are fixed together so firmly that they can be considered as one rigid structure, making a strong ring of support, of which the most visible projections, at the front planes of the pelvis, are the iliac crests. The hip joints connecting with the thighs are, accordingly, bound to each other at a fixed distance.

The shoulder joint, though apparently comparable as a junction of the limbs with the torso, is attached to two bones that enjoy more flexibility of movement: the collar-bone (clavicle) and the shoulder blade (scapula). Though joined together, the articulation of the clavicle with the sternum on the front side of the body, and the freedom of the shoulder blade, which is not jointed to the spine at the back, allow the shoulders and arms to move with some independence, not only of one another, but also of the head, spine, ribcage and hips.

Whereas an accurate statement of the angle and distance between the two hip joints will give a clear, reliable message about the aspect of both pelvis and lower spine, the angle between the shoulders does not necessarily indicate the aspect of the upper body. (Try moving your shoulders up, down and around the ribcage to observe this.) It is for this reason – and importantly, because of its central placing in the body – that the pelvis, in forming a clear, fixed basis for the whole torso, can be considered as the anchor to any pose.

The Arms, Hands, Legs and Feet

Although the arms (and hands) and legs (and feet) have the same number of bones and are sufficiently similar in their bone structure to compare, they are different from each other in several respects. Most obvious is the fact that while the arms bend forwards from the elbow, the legs bend backwards from the knee; also that the leg bones, including the feet, are proportionately longer. The joints of the hands, for reasons of dexterity, are more evenly distributed and flexible than those of the feet, which help to constitute a more developed ankle and heel structure, for reasons of weight support. Thus the complex middle joint of the arm, the elbow, allows the two bones of the lower arm (the radius and ulna) to twist, giving the hand great flexibility for dexterity (you can experience this by turning the palm of your hand face upwards, and then downwards while holding your elbow rigid with your other hand). The two bones of the lower leg (the tibia and fibula) also allow the foot to twist, but with far less range of movement. The knee, like the elbow, is a complex structure but has an additional bone, the patella, for weight support and balance.

When the arms hang down by the sides of the body, the elbow reaches to the waist, just below the ribcage, and the wrists reach the outward evidence (the greater trochanter) of the thigh–hip joint so that the arms can mirror the articulation of the torso and fold around it.

The bone of the upper arm, the humerus, is relatively long. The slightly shorter bones of the radius and ulna join to the wrists in

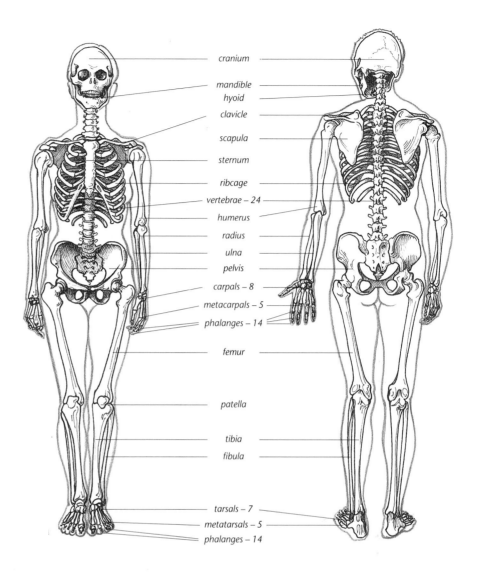

**THE BONES OF THE BODY
front and back view.**

cranium

mandible
hyoid

clavicle

scapula

sternum

ribcage

vertebrae – 24

humerus

radius

ulna

pelvis

carpals – 8

metacarpals – 5

phalanges – 14

femur

patella

tibia

fibula

tarsals – 7

metatarsals – 5

phalanges – 14

a complex arrangement of eight bones (carpals). The inner and outer bumps of the radius and ulna are usually quite visible here.

The five 'palm' bones (metacarpals) and the finger-bones (phalanges), together with the bones of the wrist, comprise the twenty-seven bones of the hand. While the whole body has fourteen major articulation points, one hand alone has fifteen articulation points between nineteen smaller bones (excluding the less articulated carpals). It is this arrangement, and the amalgam of small bones, that enables the hand to make such precise, subtle, and highly complex movements. By closing the fingers tightly, a hand can become a small ball of powerful and dense volume: a fist – and yet, with subtly different movements made by each digit, that same hand can select one sewing needle, or a grain of sand from many.

The area of one hand, with fingers spread, is similar (though smaller) in coverage to the surface shape and length of the face or the back of the head. Both hands, with fingers together, can completely cover the important front plane of the face (put one, then two hands over your face to test this). The hand is, surprisingly, almost as long as the lower arm (observe this by putting your wrist knuckles together, with hands outstretched, and facing in opposite directions).

The thigh bone (femur) is the longest bone in the body, and if bent upwards, nearly reaches the shoulder. The head of the femur (which sits in its socket in the pelvis) and its neck are together about 5cm (2in) long; they are not in line with the main thigh bone, but are angled outwards to the greater trochanter, which is the clearly visible bump at the side of the hips. Here the open L-shape of the femur turns downwards towards the knee at an angle which, though gentle, is nevertheless important to the artist. (This angle is not so noticeable when the bone is clothed in muscle because, with the legs straight, it visually compensates for the outward angle at the neck of the bone, and re-sites the knee back in direct line with the hip joint *and* with the ankle.)

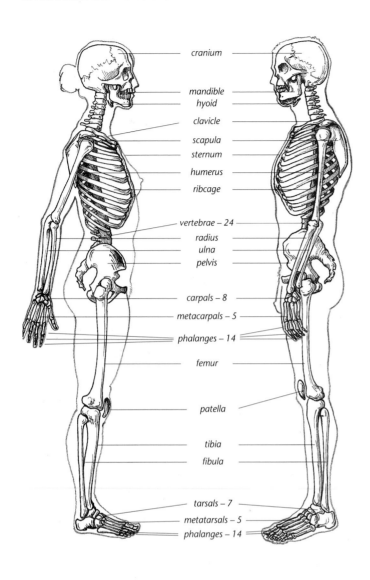

cranium
mandible
hyoid
clavicle
scapula
sternum
humerus
ribcage
vertebrae – 24
radius
ulna
pelvis
carpals – 8
metacarpals – 5
phalanges – 14
femur
patella
tibia
fibula
tarsals – 7
metatarsals – 5
phalanges – 14

LEFT: THE BONES OF THE BODY
side view.

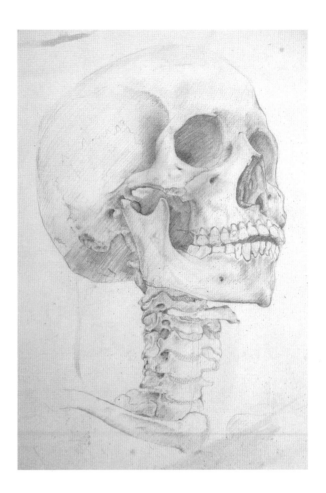

ABOVE: **The skull.**
ARTIST: ANDREW DICKINSON

The knee is an extremely complex joint, covered at the front by the kneecap (patella), and linking the femur to the lower leg bones (tibia and fibula). The visible bones at the bottom of the leg, the 'ankle', are in fact the base of these two bones, the tibia being the higher bump on the inside, and the fibula the lower bump on the outside.

The foot itself, like the hand, has nineteen bones (metatarsals and phalanges) and measures about two-thirds the length of the lower leg. It has, however, one less bone in the ankle structure (tarsals) than the hand has in the wrist – a total number, therefore, of twenty-six bones. The hand and the foot, though both having fifteen articulation points, do not share the same proportional design. The role of the foot is dedicated less to dexterity and almost entirely to supporting and balancing the bodyweight when standing or moving.

PREPARATORY EXERCISE: **DOT-AND-LINE BONES**
This exercise simplifies the bone structure by concentrating principally on the major articulation points and the direction of the bones between them, rather than their individual shape.

What will you learn? To see to the 'heart' of the pose, in the initial drawings, by ignoring the surface distractions of musculature, texture and detail, and by developing an awareness of the mechanical operation of the bones in the unseen areas. This method will help your drawing to express the weight, balance and collective intention of the body structure as controlled by the mind of the model (and in this case, directed by the pose).

— POSE: Standing with a body twist, arms up, legs apart and bent (as though in mid-swing)
— TIME: 3–5min

Quickly and lightly draw an Elastic Band to broadly establish the placing of the whole shape on the paper, then, using the illustrations as a guide, look for, and draw, clear dots to represent the fourteen major articulation points. These are the shoulder joints, the elbows and knees, the wrists and ankles, and the spine at the base of the back of the neck, and the spine at the centre back of the waist. In the case of the hip joints, do not mark the actual joints, but mark the greater trochanter on both sides, not only because it is more evident, but because it is directly linked to the knee in a straight line. Remember to leave space for the feet, hands and head.

Try to visualize the centre of each joint, and if you can't see the spine or a joint behind the body, move round to locate it by sight before moving back and drawing it where you imagine it to be in relation to the others. Check interrelated angles and lengths before finally drawing in the bones as straight lines between the joints, and curved lines if necessary along the spine. At the hands, draw only a line from the wrist to the tip of the middle finger; at the feet, from centre ankle to tip of middle toe (curves are allowed here, too, if necessary); and at the head, draw a line from the neck to the crown, the back 'corner' of the cranium. Draw several varied, dynamic, open and closed shapes or sitting poses in this way, before moving on to the next stage.

What does this drawing convey? While this simple image is apparently naive and reminiscent of a 'stickman', it nevertheless holds the key to the 'code of intention' of the pose.

EXERCISE: **FLESHING-OUT THE BONES**

— POSE: Any pose
— TIME: 10 min, with a 5min alert

This time, after carefully drawing the joints and bones with Dot-and-Line for five minutes, 'clothe' them by using first longer, then shorter, 'aeroplane' marks. This can be done with vigour and confidence, because the bones of the drawing are already on the paper. Draw the head, hands and feet very simply initially, paying attention only to their general shape, height and width (in the case

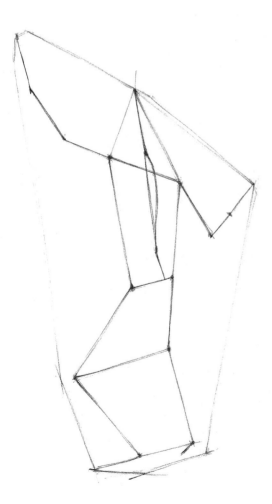

Several Dot-and-Line drawings will develop an awareness of articulation centres.

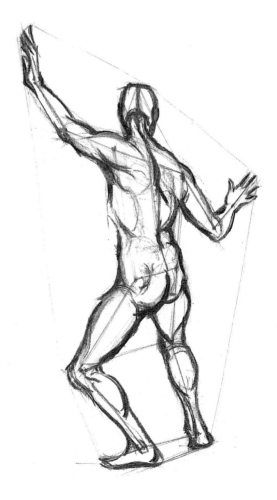

Dot-and-Line 'clothed' with flesh.

of a spread hand, draw first the extremities and the whole area covered). Remember that the dot represents the centre of the articulation point (except in the case of the greater trochanter), and allow, accordingly, for its distance from the surface of the body (the spine, for example, is some distance from the navel, but is, quite evidently, close to the body surface on the back).

If possible, make separate drawings of a male and a female model in the same pose, and note the difference in muscle shape and general body proportions, especially around the hip, shoulder and neck areas.

Musculature, the Power Base

Muscles and tendons are the means by which a body and its limbs can move independently; without them, the bones could neither stand up nor move. A muscle can only shorten (contract) or relax, but although it cannot lengthen by itself, the surrounding muscles may lengthen or stretch it by *their* contraction. Tendons surround the muscle and anchor it to a bone. When a muscle shortens, it pulls the tendon, which in turn pulls the bone and causes it to move. If a muscle is fixed to two bones on the inside of a joint, it can pull them together (flexion) and when it is fixed to the outside of the joint, it can open the angle (extension).

The muscles of the body are brilliantly designed for all the subtle and dramatic movements that a human being might wish to make, either by intention or (because the body is rarely absolutely still) subconsciously, all through the day and night – weight-shifting, breathing, digesting and dreaming, for example. The muscles are, however, not only extremely complex in their specific functions and sizes, but also numerous and, over much of the body, multi-layered. To deal only with the surface muscles belies their true collective and inter-related nature. The visible contour of one muscle may often, in reality, be attributable to the volume of other, underlying muscles. This book will therefore name and describe only the most important and visibly evident muscles. Take the time, while reading, to flex, stretch, and feel the individual muscles mentioned here – the exercise will help your drawing posture and strengthen your drawing arm(s)!

The Muscles of the Back

Just as the shape of the spine is important to the essence of any pose because it is the central chain-link of the body, so are its adjoining muscles. It is here, therefore, that we will start.

Erector spinae: These maintain and are responsible for the erection and movement of the spinal column. Running alongside the vertebrae like a column of outriders, the aptly named *erector*

spinae is a group of muscles that collectively forms a continuous line of support and connection from head to chest to the bottom. They attach the spine to the cranium (for bending and rotating the head), and to the ribcage and pelvis, right down to the coccyx (for extending and side-bending the spine).

Sternocleidomastoid: This runs from the breastbone (sternum) and collar-bone (clavicle) to the side of the cranium behind the jaw, and allows the head to flex and bend to the side.

Trapezius: The large, triangular muscle along the side of the spine at the top of the back. It attaches to the base of the skull, the spine at the neck, and right down to the bottom of the ribs (covering part of the *latissimus dorsi*) on one side, and on the other to the clavicle and the shoulder blade (scapula). A powerful muscle, the trapezius can move the scapula and the neck.

Deltoid: This surrounds the side of the shoulder; it is attached at the back to the scapula, and at the front to part of the clavicle. Anchored by a tendon into the humerus, its function is to rotate the arm inwards and draw it forwards, backwards and away from the body.

Latissimus dorsi: A thin muscle that covers a large area of the middle-lower back laterally. On its long side it is attached

MUSCLES OF THE BACK.

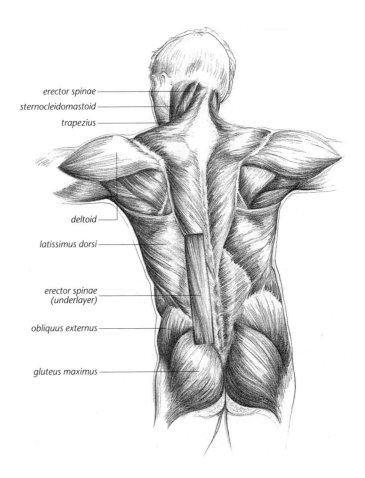

erector spinae
sternocleidomastoid
trapezius

deltoid

latissimus dorsi

erector spinae
(underlayer)

obliquus externus

gluteus maximus

around the pelvis (from the sacrum to the iliac crest) to the spine and to the lower ribs. Then finally it wraps around the back to the base of the shoulder blades, and dramatically narrows to be fixed in by a tendon to the upper arm (humerus). The *latissimus dorsi* can draw the arm back and turn it inwards.

Gluteus maximus: Running from the iliac crest, sacrum and coccyx to the femur, this muscle rotates the hip and extends the trunk.

The Muscles of the Face

By comparison to the larger lifting and weight-bearing muscles of the body, the face muscles are generally small and finely tuned to functions such as eating, speaking, talking, eyelid-blinking and making facial expressions. Those of most significance are the following:

Orbicularis oculi: This muscle can close around the eye like a sphincter. Its inner part, the eyelid, has independent movement.

Levator and zygomaticus: These are the muscles around the mouth and the zygoma, the cheekbone. They form the central part of a swathe of small individual muscles that run from the bridge of the nose around the nares to the edge of the lips, and finally the chin.

Masseter: This comes from the cheekbone (zygoma) to the lower jaw. For chewing and teeth-clenching, the masseter is very strong, unlike most facial muscles.

Orbicularis oris: This muscle surrounds the mouth, and is linked outwards to the muscles around it: this augments its range of movements for eating, drinking, expression and vocal sounds.

The Muscles and Visible Organs of the Front of the Body

Pectoralis major: The large triangular muscle on the front of the chest (as is the trapezius at the back of the body). It is attached to the clavicle, the breastbone (sternum) and along the upper ribs, and it also converges into the humerus. It can bend the body forwards, and flex and turn the arm inwards.

Serratus anterior: This muscle wraps around the side of the ribcage from the back to the front of the body, and is attached

MUSCLES OF THE FACE AND OF THE FRONT OF THE BODY.

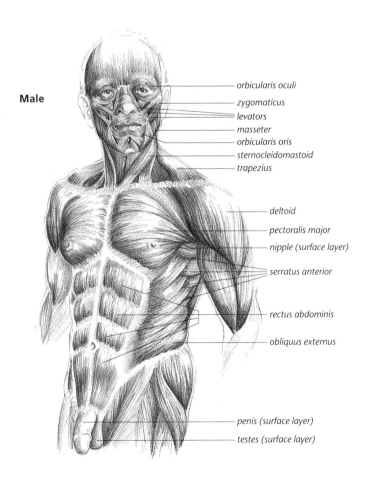
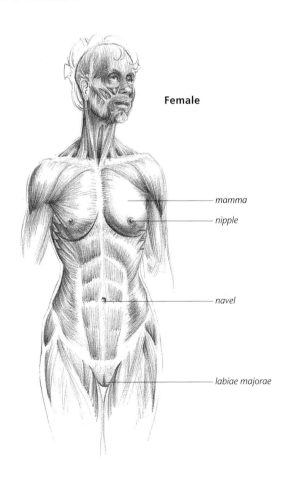

Male

orbicularis oculi
zygomaticus
levators
masseter
orbicularis oris
sternocleidomastoid
trapezius

deltoid
pectoralis major
nipple (surface layer)
serratus anterior
rectus abdominis
obliquus externus
penis (surface layer)
testes (surface layer)

Female

mamma
nipple
navel
labiae majorae

to the upper ribs and shoulder blade (scapula). This muscle rotates and pulls the scapula forward. It is covered at the back by the *latissimus dorsi*.

Mamma: Meaning 'the breast': it is a combination of glandular tissue and fat, attached one to either side of the sternum, superficially very evident in adult females.

Obliquus externus: These muscles run diagonally down from the lower ribs to the pubic bone, interlinking with the *serratus anterior* and the *latissimus dorsi* and attaching to connective tissue on the front of the body. They cover the *obliquus internus*, which run diagonally upwards, and the *transverse abdominis*, which run horizontally. Together this cross-meshing of important muscles can cause the torso to rotate forwards and bend sideways; they also support the internal organs. Furthermore, they assist with the exhalation part of the breathing process, in conjunction with the *diaphragm* and the *intercostal* muscles that push and pull the ribcage in and out, and expand and deflate the lungs.

Rectus abdominis: This is the superficial muscle from the low-centre ribs to the pubic bone; it helps to flex the trunk.

Penis: The male sexual organ; it is comprised of erectile and muscle tissue, and is situated at the base of the *rectus abdominis*.

Testes: Lying just behind the penis, these are glands surrounded by membrane.

Labiae majorae: The female organs, at the base of the *rectus abdominis*; they comprise two folds of mostly glandular tissue and fat surrounding the clitoris, the much smaller counterpart to the penis in the male.

The Muscles of the Arm

The muscles of the limbs are largely responsible for either decreasing, or closing, the inner angle of a joint between two bones (flexor muscles) or increasing, opening and straightening the angle of the inner joint (extensor muscles). In general terms, the muscles at the front of the arm are used for bending (the flexors), and those at the back of the arm for extending and straightening (the extensors). Some muscles, however, curve over from front to back. The principal muscles are these:

Deltoid: *See* The Muscles of the Back, page 102.

Biceps: This muscle has two heads and links the shoulder to the 'thumb-side' bone of the lower arm (the radius).

Triceps: This has three heads and links the scapula, the humerus and 'little-finger side' bone of the lower arm (ulna).

Brachialis: Attaching the humerus to the ulna, this muscle flexes the elbow.

Brachio radialis: Linking the humerus to the radius, this flexes the forearm.

Extensor carpi radialis: From the humerus to the hand, this muscle extends the wrist and flexes the elbow.

Extensor carpi ulnaris: This runs from the humerus and ulna to the hand, and bends the hand inwards.

Extensor digitorum and *extensor digiti minimi*: Linked to the humerus, these muscles extend or spread the fingers and little finger respectively.

Palmaris longus: This muscle runs from the humerus to the hand to flex the wrist and fingers.

Flexor carpi radialis: This muscle links the humerus to the hand, which it bends outwards.

Flexor digitorum superficialis: Attached to the humerus, ulna and radius, these muscles flex the wrist and fingers.

Flexor carpi ulnaris: Running from the humerus and ulna, this muscle flexes the wrist and pulls the ulna towards the body.

Pollicis muscles: These control inward thumb movements.

Digiti minimi: This performs inward hand movements on the ulna side.

The Muscles of the Legs

Rectus femoris: Running from the pelvis to the tibia via the patella, this muscle flexes the hip and also extends the knee.

Biceps femoris: This two-headed muscle runs from the pelvis and femur to the tibia and fibula. It flexes the knee and extends the hip.

Vastus lateralis, intermedialis and *medialis*: Running from the femur to the patella and tibia, these muscles extend the knee.

Gastrocnemius: A two-headed muscle running from the femur to the achilles heel (*tendo calcaneus*), it moves the foot downwards and flexes the knee.

Tibialis anterior: This runs from the tibia to the big toe to pull the foot upwards and inwards.

Tibialis posterior: This runs from the tibia and fibula to the toes and Achilles heel, to turn the foot downwards and inwards.

Soleus: Running from the tibia and fibula to the Achilles heel, this muscle angles the foot downwards.

Extensor digitorum longus: Running from the tibia and the fibula to the toes, this muscle pulls the foot and toes upwards.

Flexor digitorum longus: Running from the tibia to the foot and toes, this muscle moves the toes and foot downwards.

EXERCISE: LOOK AND FEEL

This exercise is designed to strengthen the links between intellectual knowledge, touch, visualization and drawing. How long you spend on it will depend on the individual's stamina and needs.

What will you learn? This experiential exercise will heighten your sensory awareness of the human body, both outside and inside, and this in turn will inform and enhance your drawing skills, and help you develop a greater identification with the model.

deltoid

biceps

brachialis

brachio radialis

deltoid

triceps

biceps

palmaris longus

brachio radialis

flexor carpi radialis

flexor digitorum
superficialis

flexor carpi ulnaris

pollicis muscles

digiti minimi

MUSCLES OF THE
ARMS AND LEGS.

extensor carpi radialis

extensor carpi ulnaris

extensor digitorum

extensor digiti minimi

rectus femoris

vastus medialis

vastus intermedialis

vastus lateralis

gluteus maximus

biceps femoris

gastrocnemius

soleus

tibialis anterior

tibialis posterior

flexor digitorum longus

extensor digitorum
longus

Using these illustrations and standing in front of a mirror, identify the major muscles of your own body. Feel the difference between active and inactive, and by flexing and relaxing them, note the work that individual muscles perform. Then take a large stick of charcoal, and a large sheet of paper that is firmly fixed, and with your eyes closed, draw the physical *feel* of your own thigh (in a completely relaxed state) from knee to hip. Do this by feeling and squeezing with the non-drawing hand, and use Passionate Line to convey the sensation of skin, flesh, muscle, bone, ligament and tendon. Is there more flesh on the front, back or sides of the bone? Don't be tempted to look at the paper while you are drawing.

Next, stand with all your bodyweight on the same leg and draw the thigh again. Then put all your bodyweight on the other leg, this time bent at the knee, and draw that by feeling with your dominant hand and drawing with your non-dominant hand, still with eyes closed. Compare the three drawings. Then if working in a group, compare them with those of the other artists, grouping them as first, second and third drawings.

What does this method convey? Very individual images that, although based more on personal experience than appearance, will express three different modes of muscle function.

Drawing, with eyes closed, of the right thigh, relaxed. Note changes of mark pressure, texture and shape.

Right thigh under some tension.

Left thigh under great tension.

Arm muscles at rest.

Arm muscles flexed.

TWO-PART EXERCISE: **TENSION**

This interesting exercise involves comparing, by drawing, the visible difference between muscles at rest and at work.

What will you learn? To recognize the changed shape and dimension of resting and working muscles, an ability that is particularly useful for understanding and drawing movement.

— POSE: Sitting pose with arm bent, hand resting on a high bar, easel or similar support. Distinct side-lighting
— TIME: 15min

Lightly draw only the arm in profile. Then model the shape and form of the arm using cross-hatching, paying particular attention to accurate tonal values.

— POSE: As before but with muscles flexed, supporting the weight of the arm
— TIME: Pose held only for short periods, as dictated by the model

Work as quickly as possible to complete a tonal drawing of the arm, as before.

What does this method convey? In complete contrast to the previous drawings, these will have a more classical appearance, both in technique and focus.

EXERCISE: **'JIGSAW' MUSCLES**

This comfortable introduction to musculature simplifies the drawing of complex shapes. By clearly outlining the muscles, as interlocking shapes their relative position within the body is more easily understood.

What will you learn? To identify the shape and relative scale of visible external muscles.

— POSE: Model, preferably slim and/or muscular, standing, and strongly side-lit
— TIME: 40min (with a rest, if necessary)

Lightly draw the pose with a pencil, starting with the large-scale dimensions, and a well placed centre line to ensure accuracy. Then, using the Armadillo method and referring to the illustrations, draw the large body shapes completely, surrounding them with a strong, clear line, and still using pencil. Work gradually towards the smaller identifiable muscle shapes, drawing round the whole shape each time and savouring its individual character until the whole body appears as a completed 'jigsaw'. Then with the help of this basic construction, draw a line round all the shapes that are 50 per cent unlit, as you did with Black or White? (you may need to lower your eyelids to clearly identify them). But this time fill them in with an even *medium* tone so that the underdrawing is still clearly visible.

What does this drawing convey? Like Armadillo, this drawing will give the impression of armour plating. This time, however, with

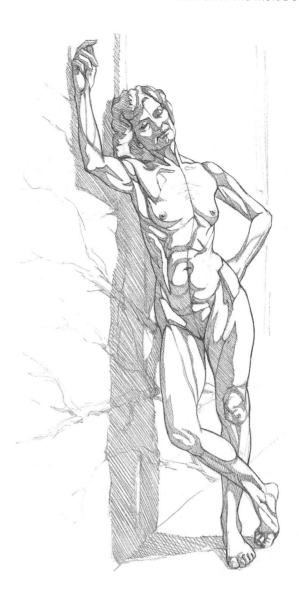

A slim model with clear muscle definition
is ideal for 'Jigsaw' muscles.

NEGATIVE SHAPES AND RADIUS LENGTHS

To accurately draw the relative lengths between head and shoulder or, when these are bent, the hand and lower arm or the foot and lower leg, view the angle that they make, either as a triangle by joining the third side of this negative shape with an imaginary line, or simply as an L-shape. It is then easy to compare the two lengths. It can also help, using the foot as an example, to visualize the distance from the back of the heel to the tip of the toe as a radius-arc from the heel, and to gauge its length when 'rotated' *up* the lower leg.

An aerial view adds visual power to the muscles of the shoulder.

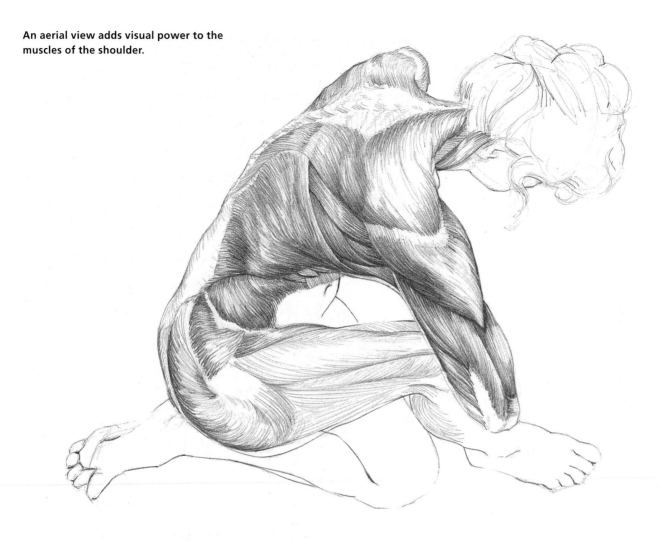

the addition of simplified tone, the image will have a three-dimensional feel of volume, reminiscent of a science-fiction robot.

EXERCISE: **FOLLOW THE FIBRES**

A fuller description of the muscle direction and coverage in this exercise makes an extremely interesting study.

What will you learn? This exercise will further develop your awareness of the muscle origins, direction and, in some cases, insertion by the tendons into the bones.

— POSE: As before, using a slim/muscular model, in any well lit pose that shows muscle definition
— TIME: 40min, with rests if necessary

Choose a part of the body that you would like to study in depth; it may be necessary to quickly draw the whole pose to discover this. Using a pencil, draw that area on quite a large scale, lightly and loosely as before, to establish the large proportions. Then look for, and mark out, the evident muscle shapes with light pencil lines.

Next, using the illustrations as a guide, gently draw across the individual muscle shapes with lines that travel in the same direction as the muscle, and that diverge and converge as the muscle goes to insert into (or attach to) the bone. By drawing in this way, you will be following the path of the actual muscle fibres. (Remember that this is only an *idea* of the musculature, as greater and lesser amounts of fat cover the muscle. If you are drawing the breasts, which are not muscles, draw the underlying 'imagined' pectoral muscle tissue.)

Work carefully to begin with, in order to observe the placing of overlapping edges.

What does this drawing convey? Although this exercise is concerned more with muscle direction and shape than tone, the converging lines will give the effect of darkening towards the insertion point, and lightening towards the fullest part of the muscle, which in many cases will express the lighting situation appropriately. It may be necessary to accentuate the visibly darker areas by adding lines in the same direction with stronger pressure, or by using a softer, darker pencil.

Drawing the Hands

There is no other part of the body that has such a chameleon-like quality for performing the differing purposes of function and expression simply by the expansion (extension) and contraction (flexion) of its individual muscles. Many beginners to life drawing are both enthralled and awestruck by this complexity, but, as with most subjects, if the whole picture is considered first, then the parts of the whole don't seem so daunting thereafter. Whatever the drawing method employed, this is also a useful approach to use in a quick drawing, where time allows only for the essential or 'shorthand' statement of the whole hand, or when a bundle of black lines at the end of the arms could unbalance the drawing. However, we will start with a simplification of the structure.

EXERCISE: **KNUCKLING DOWN – THE HANDS**

In preparation for this exercise, close your eyes and feel one hand with the other to locate the bones and joints and their surrounding distribution of flesh. Then draw around your non-drawing hand, locating the knuckle centres with a dot on the drawing, and noting the general size of the carpal structure between the radius and ulna and the phalanges. The hands, and particularly the fingers, are capable of so many subtle actions and configurations that a practical way to draw them is to use two different methods: the Elastic Band and Dot and Line.

What will you learn? Firstly, the Elastic Band technique will help you to be aware of the vast range of three-dimensional shapes and surface-area sizes that the hands can describe. Then Dot and Line will explain the visible interrelation of the joints of the hand.

— POSES: Ranging from tightly clenched (flexed), with the fist facing both upwards and downwards, to other poses that show the variations of the finger shapes; for example, holding a pencil or a cup handle, or making a cup shape with the fingers closed or apart, as if to hold a small ball. The hand may be your own, non-drawing hand. (The joints of slim, or older, hands are easier to identify at first.)
— TIME: 15min per pose
— MEDIUM: Pencil, and later, charcoal or conte stick

Begin by very quickly drawing the Elastic Band shape in pencil around the hand, lightly travelling directly from one extreme point to the next, and making one shape of the whole hand to the wrist. Artificially join across the wrist knuckles with a line that runs over the wrist, feeling for the knuckles if you are not sure of their placing. Check the dimensions and angles of the shape by eye, then by measuring. (Take care, if the hand is your own, not to tilt the pencil away from your eye, and to measure from exactly the same position at the same distance from your eye.)

Next, observe the principal knuckles of the hand – the metacarpal joints. Imagine their centres and, using Dot and

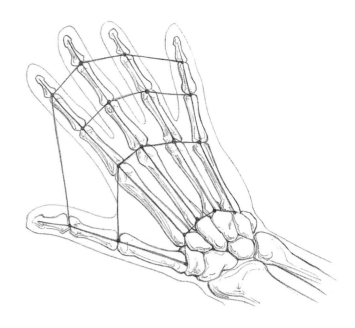

The outlined hand showing a Dot-and-Line description of the fingers and palm, and an approximation of the inner bone structure.

Line, draw these joints as clear dots, then join them with a light line, checking the hand–finger proportion. The actual length of the palm to centre wrist is, though not identical, neatly similar to the length of the finger bones (phalanges).

Now look for the next row of joints along the digits and draw them, using Dot-and-Line, checking the relative distance between the metacarpal joints and the tips of the fingers (your Elastic Band). You will see that, yet again, there is a similarity of actual length between the nearest finger bones (the proximal phalanges) and the rest of the finger bones, with the exception of the thumb, which has only two joints as opposed to the three of the fingers.

Next draw the last joints of the fingers, again with Dot-and-Line, noting that the distance is smaller again. Notice the variation of the curves between the finger joints.

Now draw in the lines, the 'bones', from the wrist, which also has a curved configuration; follow along the actual length of the fingers to the tip, feeling for them with your other hand if they are not visible.

Next take the charcoal (which will make a mark that is easily distinguishable from the pencil) and, using the negative shapes to help, draw the surrounding hand and fingers; start by pressing very lightly, then apply more pressure where the edges are dark.

After several drawings like this, draw five or six more complicated 20- or 30min poses that incorporate Rhythm and Curve to draw the hand. Concentrate initially on the longest significant

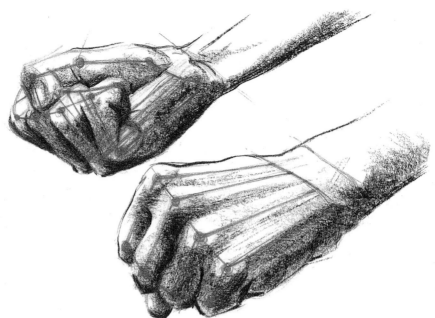

RIGHT: **A conte drawing of clenched hands showing underlying Dot-and-Line construction.**

BELOW: **A drawing of cupped hands showing Rhythm and Curve construction.**

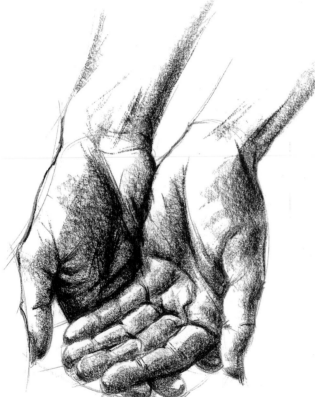

What does this drawing convey? A feeling for the dynamic structure of the hand and, because of the connecting 'strings', a 'cat's cradle' appearance that expresses the collective function of the fingers. It is also strongly recommended that you explore hands with Look and Feel (ask your model or a friend), and with other preliminary drawing techniques, for example Five Star, Circling, Triangles and Armadillo, which all concentrate on the primary simplification of complex information to one 'digestible' shape, and progressively study the components in descending order of size. Eye-Trust, on the other hand, is a direct translation of the visual information, and will therefore act as the perfect complement to these methods.

Drawing the Feet

While the principal function of the hands is manipulation, the feet are the most important part of the body for load bearing and balance. The articulation of their joints is therefore not nearly as complex as in the hand, with more length given to the ankle and heel development. The notable differences in structure are that the phalanges of the foot are shorter than in the hand and do not have a long middle digit, the big toe bones are thicker (though, like the thumb, this toe has one less bone than the other digits), and the weight-bearing ankle bones and heel (calcaneus) are notably larger than the wrist, though one fewer in number. While the hand can comfortably bend inwards or outwards from the body, the foot and toes have less range of movement.

curves, then subdivide into the hand (the block to the finger separations) and the whole shape of the fingers. Then divide the fingers' shape into two similar portions (often *not* two fingers on each side), and finally to the individual fingers within, noticing that, outwards from the body, each next row of finger bones achieves not only a greater range of movement from the wrist, but also independence from each other. Then use charcoal or conte to describe the tonal values of form.

110

EXERCISE: **KNUCKLING DOWN – THE FEET**

Use the same methods as for drawing the hands. Start by feeling and drawing around your own feet. Again, it is important to locate the junction of the tarsal and metatarsal bones, and to clearly establish the relationship between this point, the fullest part of the heel, and the more visible ones at the 'ankle', which are, in fact, the base of the tibia and fibula. Also note, as with the fingers, the approximate similarity in length between the metatarsals and the composite phalanges.

Drawing the Head

The bone structure of the head is made up of only two moving parts: the cranium (the brain box, usually partially covered with hair) and the lower jaw. So to draw it should be as simple as drawing any other part of the body. However, because no other part of the body holds so many senses crucial to survival, of which the features are the outward manifestation, it attracts the most attention. So much importance and stored knowledge is apportioned to this small area of the body, that the idea of drawing it can seem daunting for many beginners to life drawing.

If the complexity of the hand lies in its bone structure, the complexity of the head lies in the subtle differences between faces and expressions. These are mostly caused by a combination

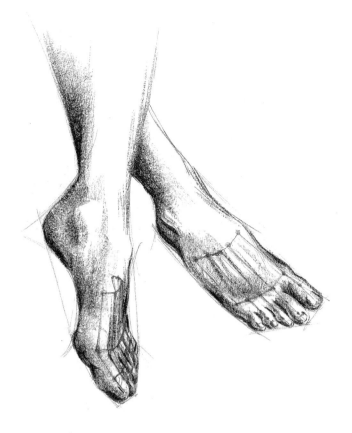

Dot-and-Line and Rhythm and Curve are clearly shown here as the basis for this drawing of feet.

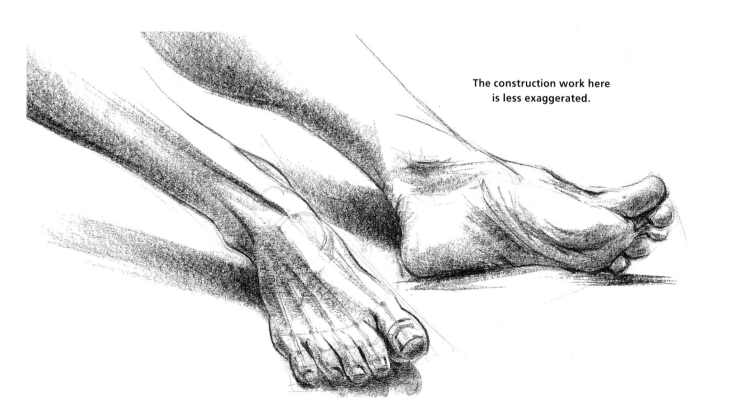

The construction work here is less exaggerated.

111

of facial muscle *and* underlying skull variation. So, rather than worrying about fine detail at the beginning, but by concentrating on a sound structural statement of the general shape and scale of the individual head, you will have already established the unique placing of the sensory inlet and outlet holes of the features.

Close your eyes for a moment and ask the question 'Where am *I* in my body?'. We tend to imagine that the centre of our existence or consciousness is behind the eyes and therefore at the 'top' of our body, overseeing everything below and around us; however, the real headquarters is the brain, situated mostly above the eyes. Protected and hidden from view by the cranium and hair, this 'brain' area doesn't *seem* as important as the surface features, and is certainly not as visually interesting. For this reason, the most common mistake that is made in portraiture is to place the eyes too high in the head. When the head is viewed straight on, the eyes in their sockets (orbits) are only just above halfway between chin and crown; and with the inclusion of

springy hair, they can very often be *lower* than halfway down the perceived length. With eyes still closed, feel your head shape and face, assessing the lengths of height, width and depth, and discovering where the orifices of the senses are situated.

EXERCISE: **A GOOD HEAD START**

What will you learn? To look beneath the superficial information and recognize the *underlying* differences between individual heads and their aspects, so that you will soon be able to quickly construct the 'house' (the head) *before* arranging 'the furniture' (features).

— POSE: Model sitting symmetrically, looking at a point of focus
— TIME: 30min
— ARTISTS' POSITION: At an angle that gives neither a profile nor a straight-on view

1. Begin by generally outlining the *whole* visible head shape – including the hair – asking only these two simple, but crucial,

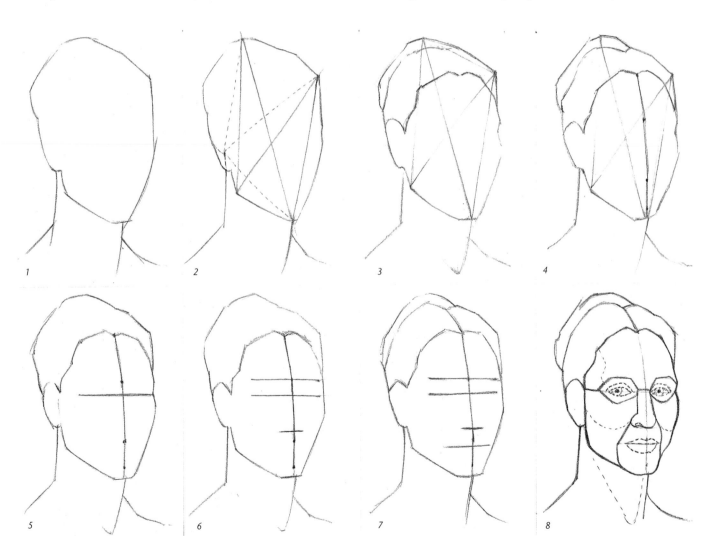

1 2 3 4

5 6 7 8

This construction process can also be used as a troubleshooting checklist.

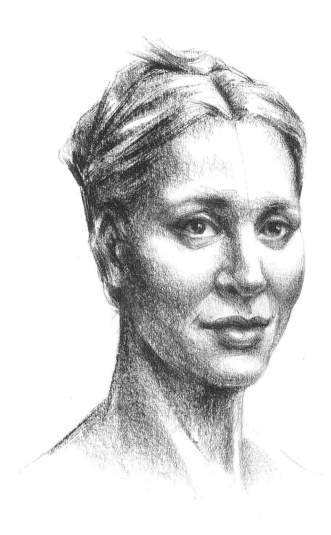

The finished drawing in conte. All the underlying construction work in pencil is now less visible.

4. Look for, and clearly draw, the centre line (excluding the nose), concentrating only on its axis and placing. The exact placing of the centre of the eyebrows and the top lip will be checked later.

5. Draw a line (maybe curved if the head is tilted) that follows the angle across the eyeline.

6. The next important proportions to compare and mark *within* the existing face shape are the three relative lengths of brow (hairline or hair edge to centre eyebrows), nose (to the base of the nose, the *septum*), and nose to chin.

7. Look at the last two lengths to check the exact eyeline, and find the lipline.

8. Then draw the Armadillo shapes (shown in a continuous line) of cheek, brow (if visible), 'muzzle' (nose-to-chin area), eye-shapes (from eyebrow to lower eye-socket), nose and ears. This will be sufficient preliminary information with which to progress to the smaller areas (shown in dotted line) and subsequent tone.

What does this method convey? The impression of the construction drawing, because of the lines, is mask-like. Nevertheless, it contains the code for each *unique* head and face, and when the detail of the features is constructed and tonal shapes added, it will give a recognizable likeness. Construction drawing can be seen as forming good 'looking' habits so that you will be less tempted to draw the face that you know best (from the 'known' memory bank), and will become familiar with both the container-like structure of the basic head, and the fact that there are endless variations, even at the basic-shape stage of drawing. Familiarity, together with this good practice, will eventually allow you to *start* with any facial detail, in line or tone alone, and then work outwards, knowing that the eye and the brain will still be *automatically* scanning the whole shape simultaneously for relative proportions and large-scale composition. With this sound knowledge of 'house construction' you *can* visualize the 'furniture' – and even 'hang the curtains' – first!

questions: 'Is it higher than it is wide, or wider than it is high?' and 'Is it oval, square, rectangular, triangular...?'; and you should also establish its position relative to the neck and shoulders. (When you *do* draw a profile, simply Elastic Band to the tip of the nose.)

2. Observe, then very lightly draw, diagonal links between points that are evident (hair shape can affect your choice): for example, from the crown (the fullest point at the back 'corner' of the head, including hair) to the lowest tip of the chin; and from the highest point of the front (or edge) of the hair to both the base of the occipital bone (at the back, where the neck meets the cranium, if visible) and the corner of the lower jaw.

3. Draw the edge of the visible hair shape, leaving the appropriate proportion and shape of face.

Conclusion

Has your perception or enjoyment of drawing the human body changed at all, and if so, in what way? It is as important as ever, if working in a group, to look at each other's drawings, and share your responses to the various exercises. One interesting aspect of anatomical study is the knowledge that we all, as men or women, possess similar basic body equipment, and yet, due to gender, genetic disposition, body use, posture and so on, our external appearances are so infinitely varied.

Having concentrated for a while on the quality and function of our subject – the human body – out there *and* inside, we will now go on to explore and refine ways in which you, the artist, can express your findings and responses to that subject.

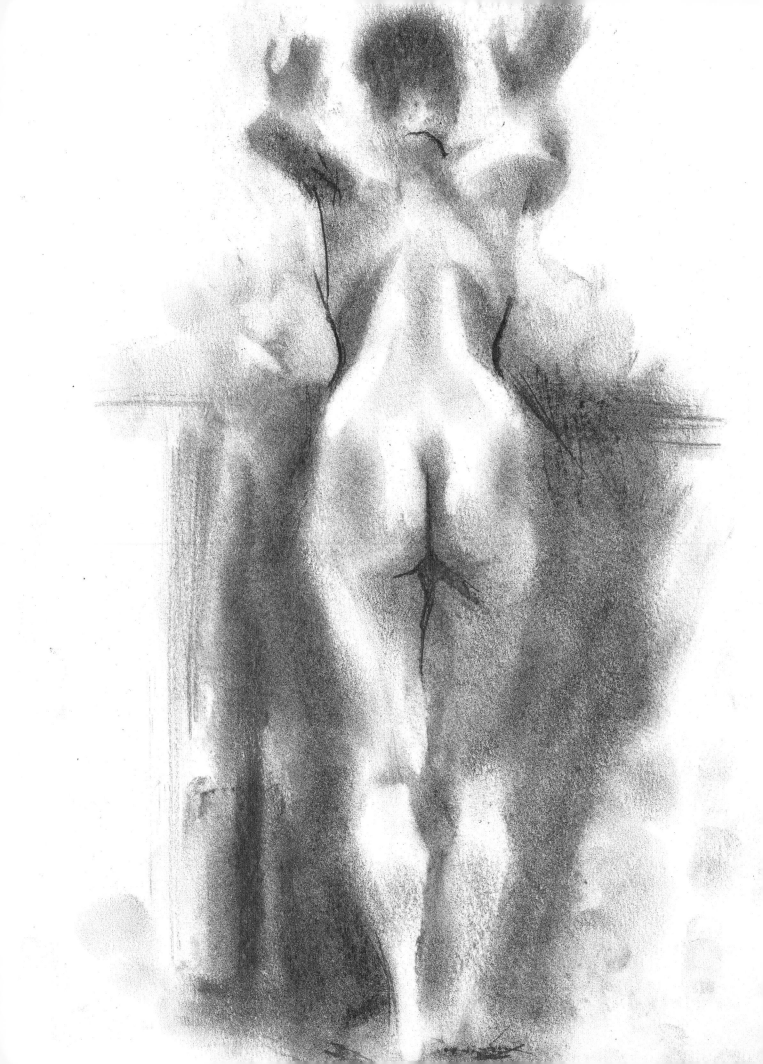

MARKS: METHODS AND MEDIA

So far we have studied the visual and functional aspects of the human body – the 'subject' – and just as language has letters and sounds to form the written and spoken word in order to communicate facts and findings, so your drawing will have developed a visual alphabet and vocabulary. The next step is to thoroughly explore different types of mark, as this will expand your visual 'dictionary' for communication, and also your experience of the physical *feel* of making different marks. Already your own unique style will be evident, and inevitably you will be inclining towards certain methods – but before settling on any particular techniques, try all the following in turn, experimenting with their uses in different situations.

The following ideas are really the tip of a gigantic 'iceberg' that represents as many ways of mark making as there are people in the world, and explains why everybody can have their own style, similar to handwriting. Drawing is much more personal, however, because there are no restrictions or constraints on spacing, letter forms and grammar – or bad language – as there are with writing. Nor is it necessary to explain the *meaning* of this universal means of expression. So you have every reason and right to experiment and play with different marks in order to find the right texture and quality of visual language to suit *your* personality and *your* message.

To find out which mark-making techniques you like, or feel are appropriate for drawing different models or poses, consider these exercises as experimental projects to expand upon. To begin with it is useful to carry all these mark-making tools with you in order to have immediate access to the techniques at any moment; for instance, a long pose with extremely difficult foreshortening may call for a vague and tentative venture onto the paper in pencil first of all, in order to establish the overall shape and composition before committing to either clear, fixed edges, or no line at all, but dynamic cross-hatching in charcoal. A short,

dynamic pose with some intricate detail may be quickly captured by a single line drawing in ink with Eye-Trust; and a pose that involves extreme counterbalance and dramatic lighting may call for A–Z straight lines in black and white conte on mid-tone paper.

Pointed Tools

EXERCISE: **PERPETUAL MOTION**

What is this technique good for? It gives the drawing an intensified, almost tangible three-dimensional image, and is ideal for slowly feeling one's way into a pose.

— METHOD: Use pencil, charcoal, pen or biro – in fact any tool that gives a continuous and flowing mark. Without lifting the mark maker off the paper, circle round and round the body and limbs into the third dimension on the unseen side behind, but never *along*, the peripheral edges as seen.

EXERCISE: **DRIZZLING**

What is this technique good for? Because it makes a random, continuous line with no outline, it is brilliant for moments when you feel lazy, unsure, or simply exploratory.

— METHOD: Use any continuous mark-maker, and without lifting it off the paper, travel in any direction with a very random, curvy, wool-like mark, roaming backwards and forwards in spirals or figures-of-eight, intensifying and building up the image as you go. This is a non-committal process where the figure gradually appears from 'nowhere'.

LEFT: **The body emerges into the light from a base of charcoal dust scratched with the nails and rubbed in with the fingers.**

Perpetual motion is a relaxing exercise.

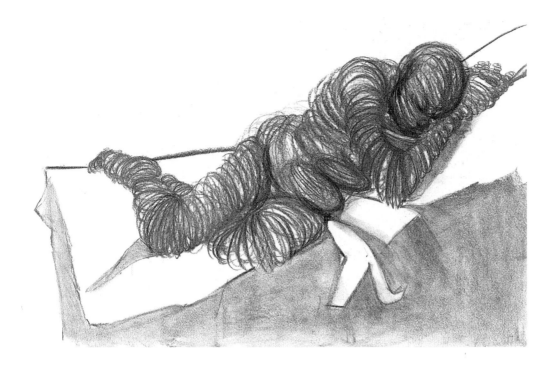

BELOW LEFT: **Though no centre line is drawn, the subtle tilts throughout this pose are clear.**
ARTIST: DIANA KING

BELOW: **Drizzling allows plenty of time to consider the tone.**

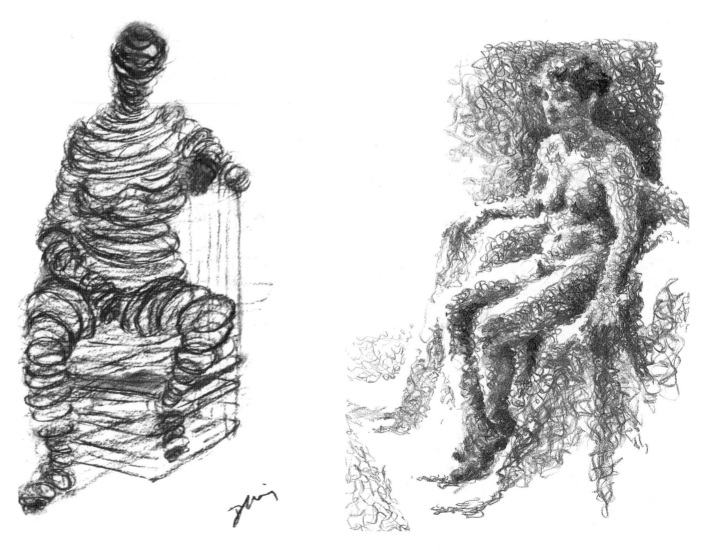

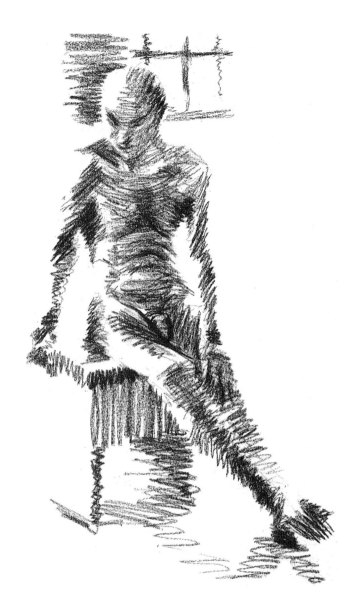

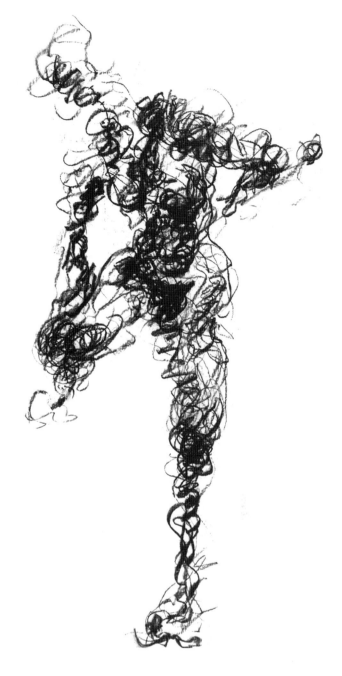

ABOVE: **This variation starts inside shapes and travels across and outwards to describe tone and plane.**

RIGHT: **A drawing with light and energy suits this precarious pose.**
ARTIST: ŠÁRKA DARTON

EXERCISE: **PARALLEL LINES**

What is this technique good for? If, whilst studying the pose before drawing, you discover several parallel edges that strike you as dominant, this method can accentuate them. Despite its apparent lack of character (because all the lines are even, straight, and travel in one direction) this drawing can be, nevertheless, visually intriguing, because the 'encoded' image within the unrevealing bars needs to be virtually deciphered.

— METHOD: Any pointed medium is suitable for this technique, which starts by looking for significant parallel edges or lines of 'intention' running through the pose and its surroundings. Lightly draw them on the paper, paying attention to their relative placing (the length at this point is not crucial). Then, little by little, add more lines in the same direction, using intensification to describe the tonal values of the form, gradually working towards the darkest areas and eventually the finest areas with shorter lines.

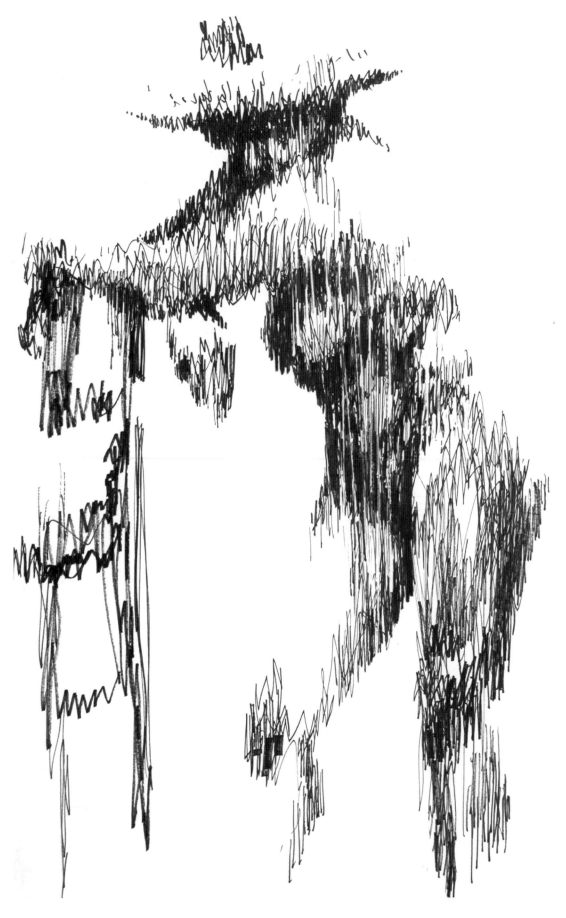

EXERCISE: SWORDPLAY

What is this technique good for? A cut-and-thrust approach that yields a drawing with a dynamic and incisive feel.

— METHOD: The marks, which may be either straight or curved in one direction (this decision may be influenced by the feel of the pose, for instance, whether it is formal or bending) *must* be single. See where the weight and balance need to be stated incisively (if possible take the same pose yourself to feel the weight distribution), and begin with long, sweeping, energetic marks; then progress to shorter, finer, clipped arcs and straights. Straights are often appropriate for direct bone links between obvious joints (knee to ankle), while muscle usually inspires the use of curves. Clipped 'aeroplane' marks lend dynamism and a feeling of form because they tail off at the end to suggest the overlapping contours of flexed muscle.

EXERCISE: WATER-SOLUBLE GRAPHITE PENCIL

What is this technique good for? With brush and water, it is particularly useful for quick sketching, and with the use of a water-brush (that releases water when squeezed to spread the mark), it is a very convenient and portable way of making non-smudgeable, though not very large, tonal images.

— METHOD: The drawing can result in a combination of line and tone, or tone alone, because it is possible with softer versions of the pencil to fully dilute and spread the mark. The range of tone is achieved, firstly, by putting more or less marks – i.e. quantity of graphite – in an area; and secondly, by the

OPPOSITE PAGE:
Vertical lines in italic pen convey the downward impression of overhead sunlight and gravity.

THIS PAGE:
ABOVE: **Selected diagonal lines combine with verticals to emphasize the upward stretch.**

Sleek diagonal crayon marks express a svelte model sliding into a snooze.
ARTIST: JANE GROVES

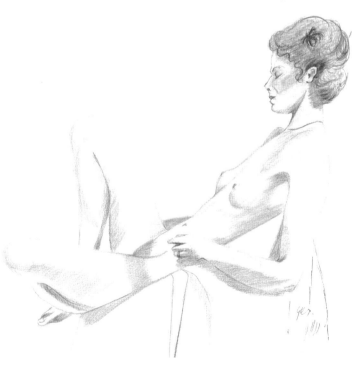

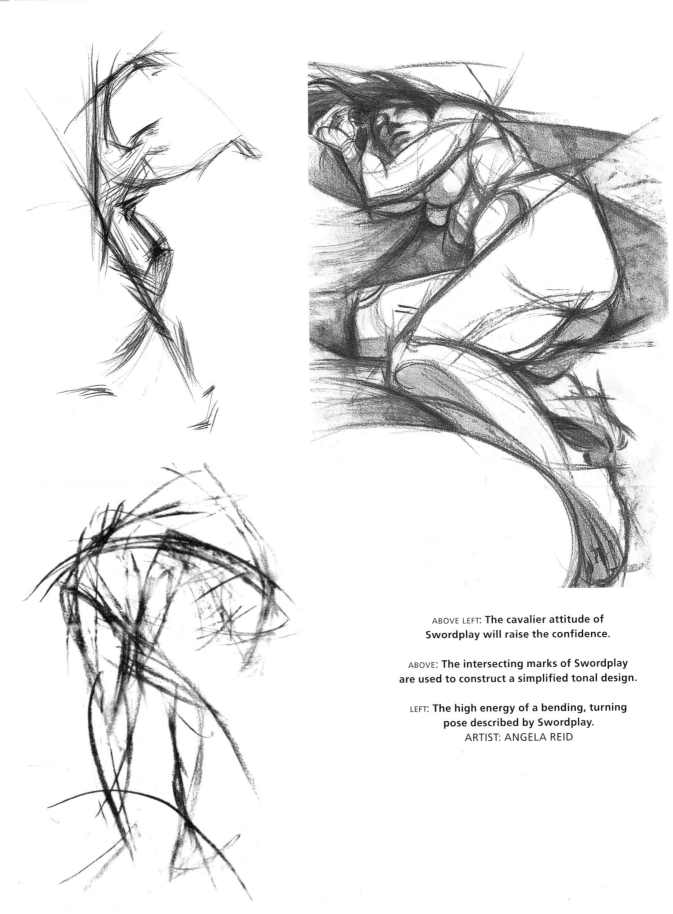

ABOVE LEFT: **The cavalier attitude of
Swordplay will raise the confidence.**

ABOVE: **The intersecting marks of Swordplay
are used to construct a simplified tonal design.**

LEFT: **The high energy of a bending, turning
pose described by Swordplay.**
ARTIST: ANGELA REID

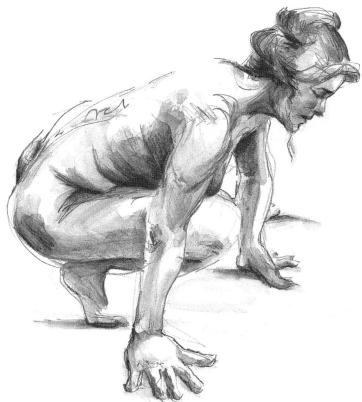

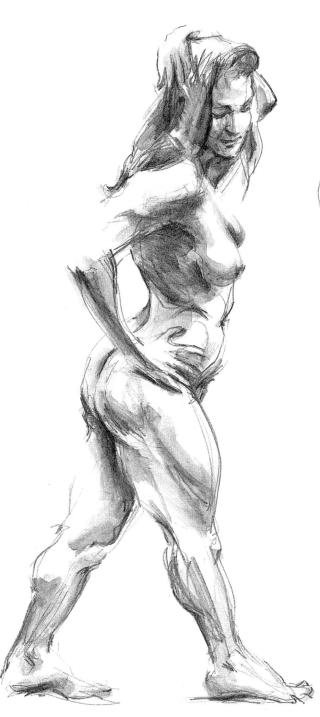

ABOVE: **A limbering-up sketch.**

ABOVE RIGHT: **Water-soluble graphite suits short poses.**

degree to which the graphite is spread when wet. Also, these marks, when dry, are to some degree erasable.

EXERCISE: 'CAVE' PAINTING

What is this technique good for? The enjoyment of tactile involvement with the drawing surface through the use of fingers, pigment and water. It is therefore useful for poses either with character and drama, or, like Passionate Line, for the expression of emotion and feeling.

— METHOD: Crumble or shave charcoal or compressed charcoal to make a small pile of pigment powder, have a pot of water to hand, and a large sheet of strong paper. Pick up some powder and scatter it liberally in selected areas and, using the palms, or one, two, or all fingers, of one or both hands, rub the pigment across the paper to make broad expressive marks that fold around the body contours to the unseen side, describing the rhythm, 'feel', essence or tone of the pose. Then erase, as necessary, to re-find specific 'lights', continuously adding, taking away, and working back into the surface with darks and lights. Use your nails as pens or use a sharp tool to scratch into the paper, then rub powder into the broken paper and erase across it to leave an etched line. Add water to specific areas that need an evenly coated or clear edge.

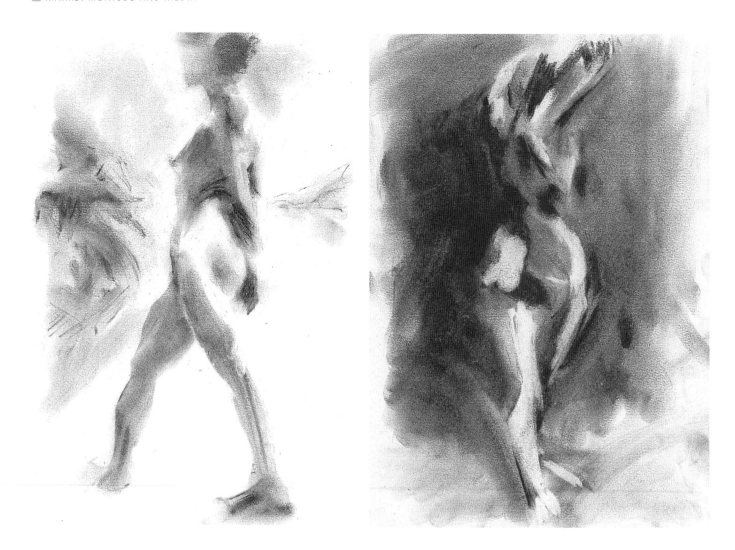

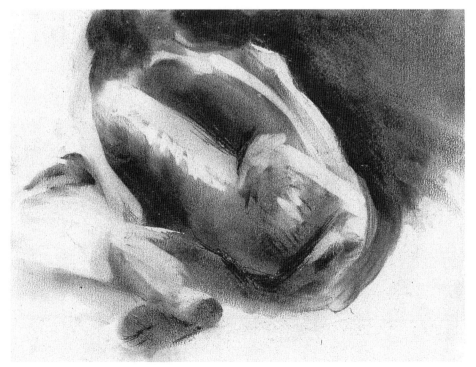

ABOVE LEFT: **The body is initially described in patches of charcoal dust, then the contours erased and scratch marks darkened.**

ABOVE: **The figure has been 'found' in a liberal covering of charcoal. Water has been dripped in and drawn across with a fingernail to solidify broken patches.**

Straight edges, scratching, light-against-dark and vice versa, give this spiral pose a cave-like appearance.

The soft edges that a blow-pen creates can be sharpened with water.

BELOW: **A minimal use of drawn line, and compressed charcoal dust smudged on with the fingers, giving an exciting and fidgety energy.**
ARTIST: JONICA BRIDGE

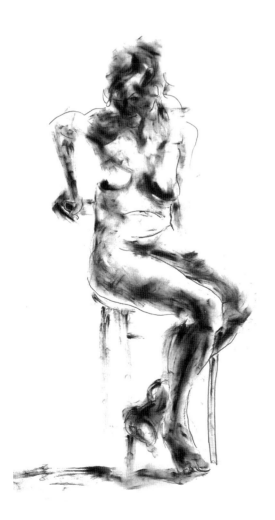

Keep going until you have physically and directly built up a picture that gives the feel of the pose. Different surfaces and media behave differently, so experiment. Note that, although it is tempting to do this exercise for very long periods of time, it is *not* wise to do too much before the hands and fingers have hardened up. In this case, use gloves or a cloth, dry or damp, if necessary, or try using a blow-pen!

Using Ink

EXERCISE: DIP-PEN/STICK/BAMBOO/QUILL/ DROPPER AND INK

What is this medium good for? Each of these tools gives the ink mark a high degree of individual character because they have no large reservoir, so the flow of ink is neither consistent nor continuous, and therefore the thickness and intensity of line will vary enormously.

— METHOD: Use the 'pen' freshly loaded for important or dark statements, and drier for softer, light marks. Try dragging and lightly trailing the pen, balanced *on* the middle finger of the upturned hand, as well as pushing and pressing it. Draw in any way that feels right for the drawing tool you are using, from single line to hatching, paying attention to the balance and pattern of the dark marks compositionally on the paper. It

**Dip-pen and ink sketch, varying
the pressure and thickness of line.**

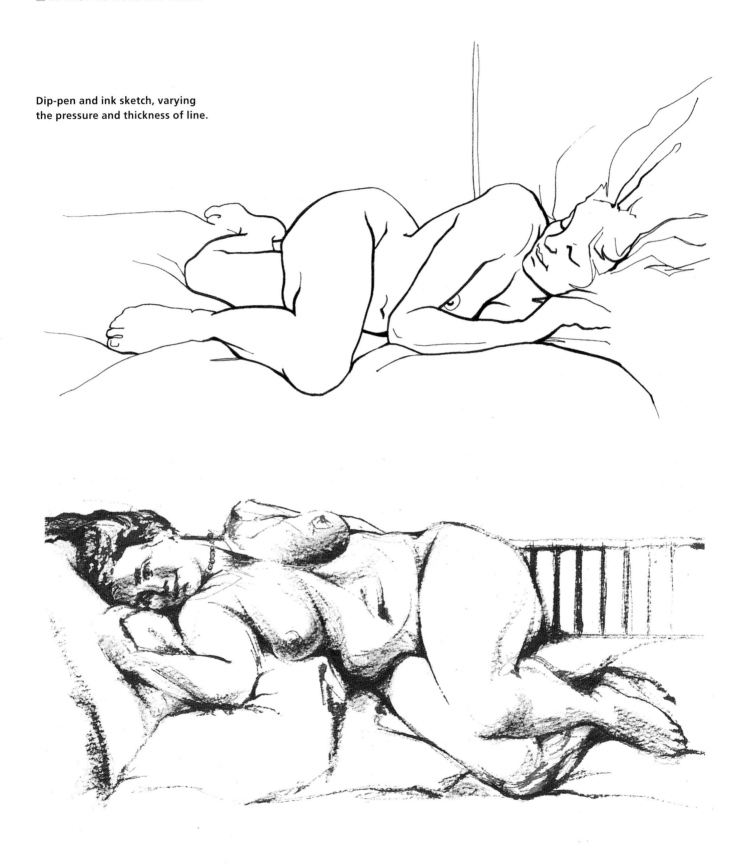

Bamboo pen and ink on watercolour paper.

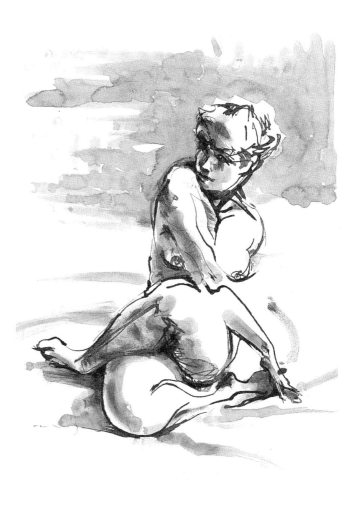

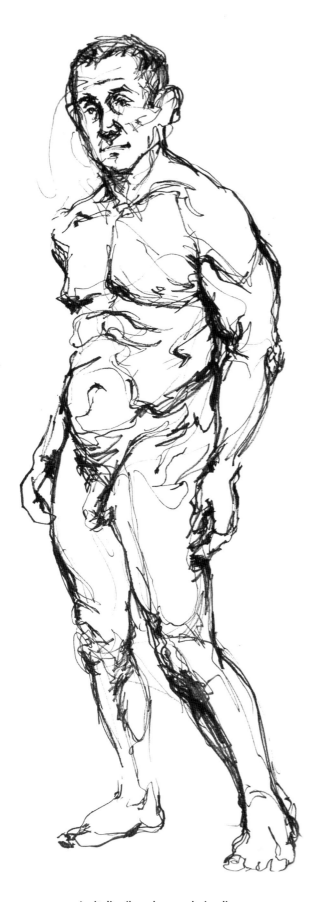

An italic nib and a wandering line.

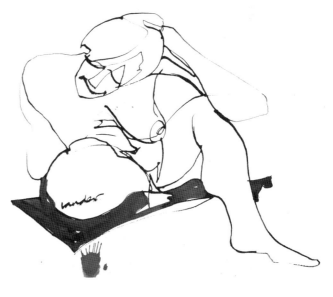

TOP: Ink dropper was used for the line drawing, then the ink was spread with wet fingers.

ABOVE: The wandering bamboo pen and ink mirrors the relaxed character of the pose.
ARTIST: BEATRICE LANDER

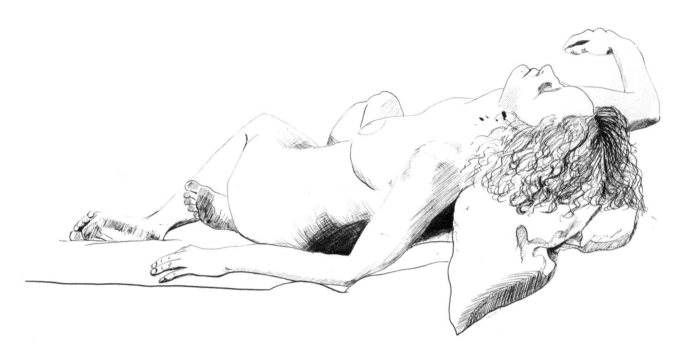

ABOVE: **Fine line and scrupulous detail contrast with the pose to add focal intensity.**
ARTIST: CAROLYNDA GIBSON

LEFT: **A trailing stick-and-ink line held in the 'other' hand, bold finger-painting in ink, and a low viewpoint create a powerful image.**
ARTIST: NICOLA ROSE

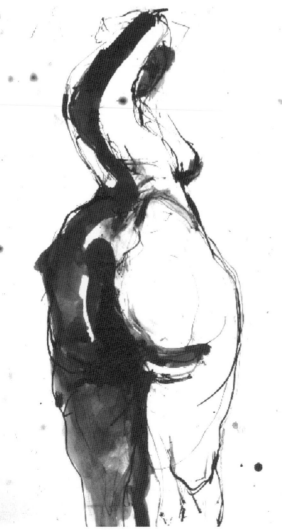

is important when using ink to enjoy the fact that every mark is permanent by engaging with it courageously. Similarly, appreciate its varying arbitrary qualities.

EXERCISE: **EMERY BOARD/CARD ON TEXTURED PAPER**
What is this medium good for? With this technique you can make either slice marks, or drag the ink, which tends to create an incisive and positive drawing. Because control over the mark may vary enormously, the arbitrary quality gives an edgy dynamism.

— METHOD: Slice off the top edge of the emery board diagonally, to create an 'italic' nib. By using this type of tool, you will actually *feel* more incisive because the card edge

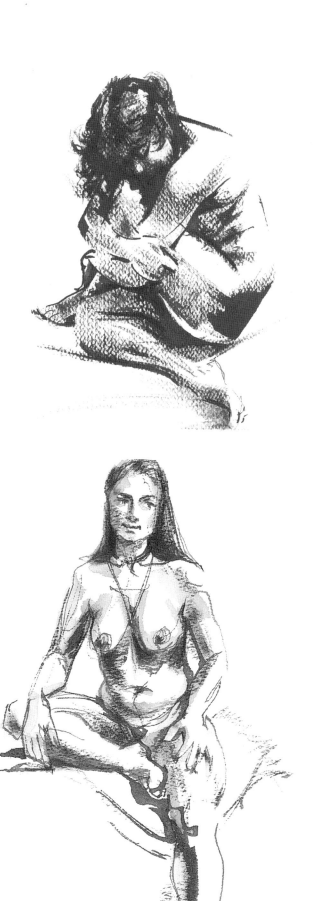

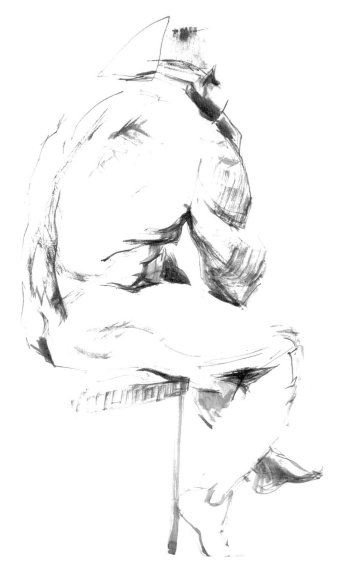

ABOVE LEFT: **An emery board is flexible and delivers fine lines with the tip and slabs of dark when used on the side.**

ABOVE: **Emery board used with a light ink wash.**

LEFT: **Here, water-soluble ink applied with an emery board has been subsequently spread with a water-brush.**

drives you along like an exhilarating sled-run, the ink is uncompromisingly black and permanent, *and* the edge may be very wet or almost dry. Instinct, authority and command are called for. Use the card or emery on the tip for fine, narrow or detailed marks, and on the side for wider areas.

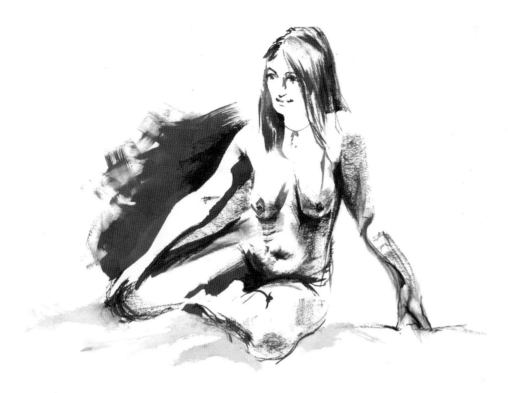

Like throwing dice, the unpredictable quality of card or emery board and ink adds serendipity and challenge to skill.

EXERCISE: **WATER-SOLUBLE INK/BRUSH/WAX**

What is this medium good for? It gives an expressive drawing with a large range of marks or layered washes.

— METHOD: Prepare a small puddle of ink, another puddle diluted by half with water, and have a pot of water to hand. Chinese and Japanese brushes are ideal to use with ink because they make marks of maximum versatility. Hold the brush vertically and use the tip for thin marks, pressing harder for thick marks. Hold the brush on its side and scrape it sideways on the paper for broad, square, or rough marks. Then try other types of brush. Work either from light to dark or vice versa, using the brush in all conditions of saturation, from well loaded to quite dry. If using wax, first identify and quickly draw the light areas throughout the drawing with uncoloured candle-wax, looking at the sheen on the paper to guide you. Then, as with the brush and ink, work either from light to dark ink, or vice versa, using the brush in all conditions of saturation from well loaded to quite dry.

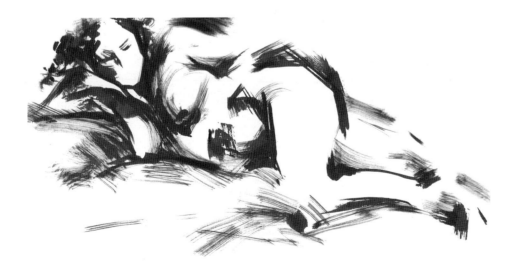

Soft chisel brush and ink, loaded and dry.

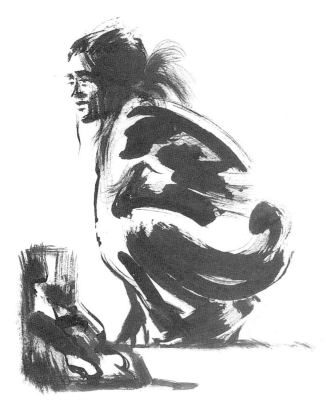

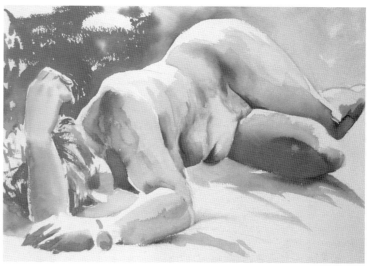

LEFT: **Hoghair brush, used both loaded and damp.**

ABOVE: **The preparatory drawing was made in
water-soluble graphite before broad washes were laid over.**

BELOW: **Brush and ink with wax resist
was used for this quick sketch.**

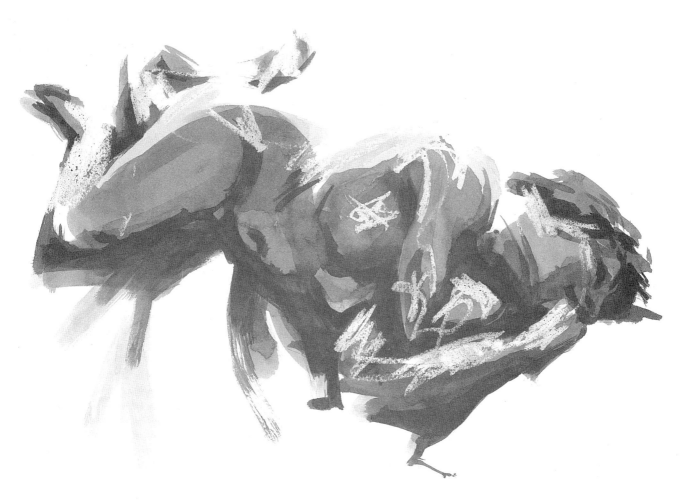

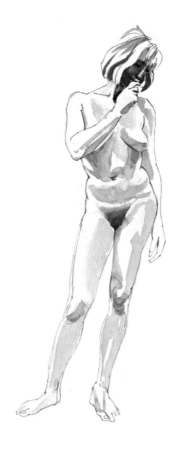

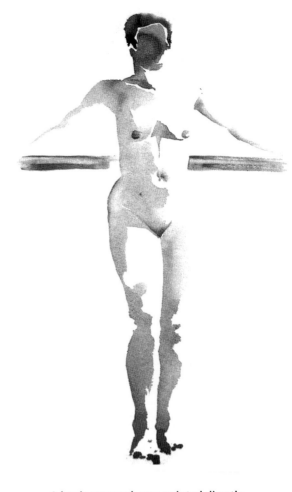

A few ink marks, neat and diluted, say it all!
ARTIST: BILL STOTE

Skilful pen-line and light wash subtly express the twist and counterbalance of this pose.
ARTIST: PETER IDEN

A luminous wash was painted directly onto the paper in this glowing study.
ARTIST: DEREK MUNDELL

EXERCISE: **WHITE INK/CHALK/PASTEL ON BLACK PAPER**

What is this medium good for? A line drawing made with a finely pointed tool 'normally' consists of dark marks on a light surface. This reversal of a familiar drawing concept can make a refreshing change for the artist, and intrigue the interpretative skills of the viewer's brain.

— METHOD: Use a dip-pen, stick or 'chalk', and start by lightly exploring the paper. As with white paper, it is easy to become 'blind' to the overriding or default tone of the paper, so prepare to work very vigorously on the intensification of the light areas, if necessary.

Drawing with Both Hands

The experience of two-handed drawing evokes the feeling of 'holding' the body in both hands. The following exercises progress with the use of different media from form and line, through light and dark and, finally, to wet and dry texture.

EXERCISE: **CHARCOAL AND CHARCOAL PENCIL**

What is this medium good for? It can be used with great effect for a large-scale drawing, and it is ideal for drawing quick poses or movement. While the pencil takes care of the finer, lit profile, the charcoal, being very versatile, is good for both line (used lengthways on the side) and tone (made light or dark by pressure alone), and for covering a big area very quickly.

— METHOD: Hold the pencil in the hand that corresponds to the light side of the subject, and a big thick chunk of charcoal in the hand on the shadowed side, and draw the model without looking, as much as is possible. This really puts your attention out there with the model.

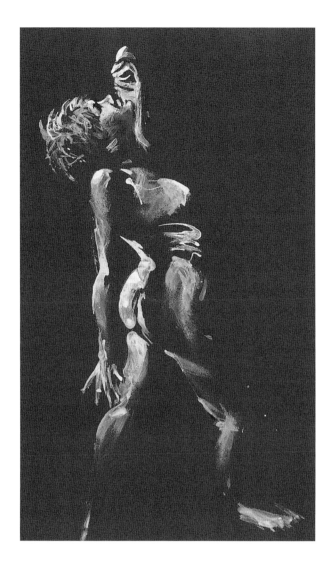

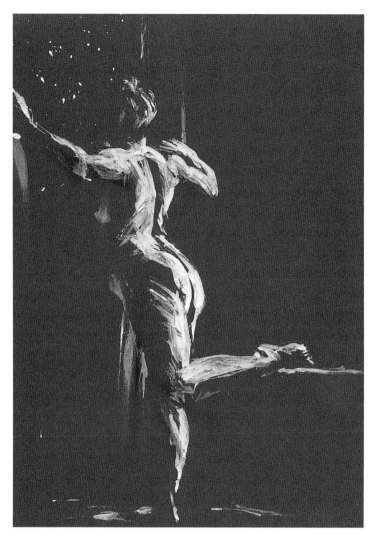

ABOVE: **The model was spotlit in a dark studio. A dip-pen was used both on the tip and on the back of the nib allowing the white ink to flood through the reservoir hole.**

ABOVE RIGHT: **Emery board and white ink.**

A dramatic and intimate image in white ink and card.
ARTIST: NICOLA ROSE

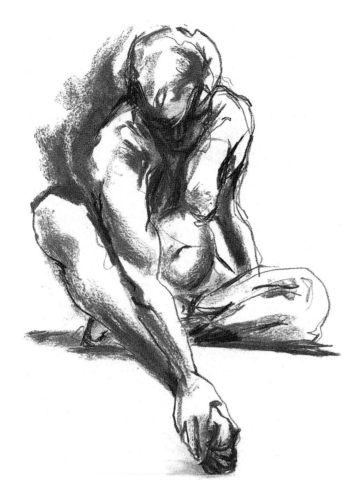

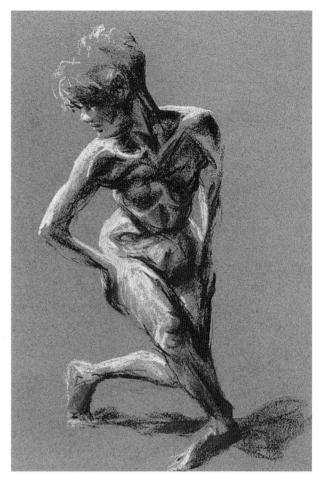

THIS PAGE:
ABOVE: **Looking only at the model, charcoal and charcoal pencil were used simultaneously for shadow and edge respectively.**

ABOVE RIGHT: **Drawing with both hands using black and white pastel on mid-tone pastel paper.**

OPPOSITE PAGE:
TOP LEFT: **Emery board and ink was used in the left hand, and white chalk in the right hand.**

TOP RIGHT: **First using ink (left hand) and white chalk (right hand), then swapping to charcoal (left) and ink (right).**

BOTTOM: **This etching was made from a photocopy of a lively Two-Hand Eye-Trust drawing made in pen and charcoal. ARTIST: ŠÁRKA DARTON**

EXERCISE: **WHITE AND BLACK PASTEL**

What is this medium good for? It is perfect for the spontaneous expression of form and drawing on a broad scale.

— METHOD: Make sure that your model is side-lit. Use a mid-toned paper, and with the dark and light pastels in the appropriate hands for the light and dark sides of the form, work on individual body shapes, one at a time, to express the tonal values. Hold both pastels on their broad sides so that you can negotiate both thick and thin areas of drawing with Stroke and Twist. Look only occasionally at the paper to start a new three-dimensional body shape, so that while you are drawing it is possible to experience 'modelling' the form between both hands.

EXERCISE: **INK AND WHITE CHALK**

What is this medium good for? It is particularly effective in situations when the model may be strongly lit, but the paper may not be.

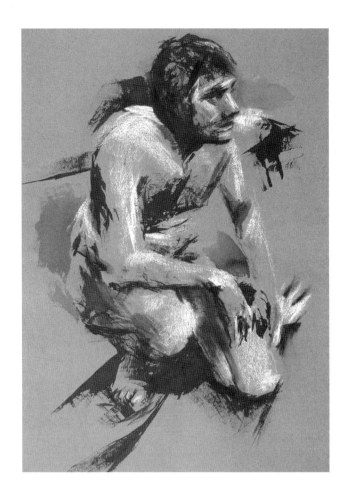

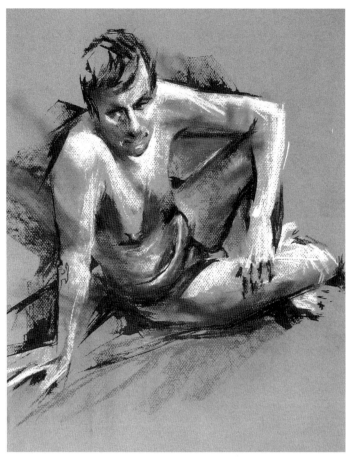

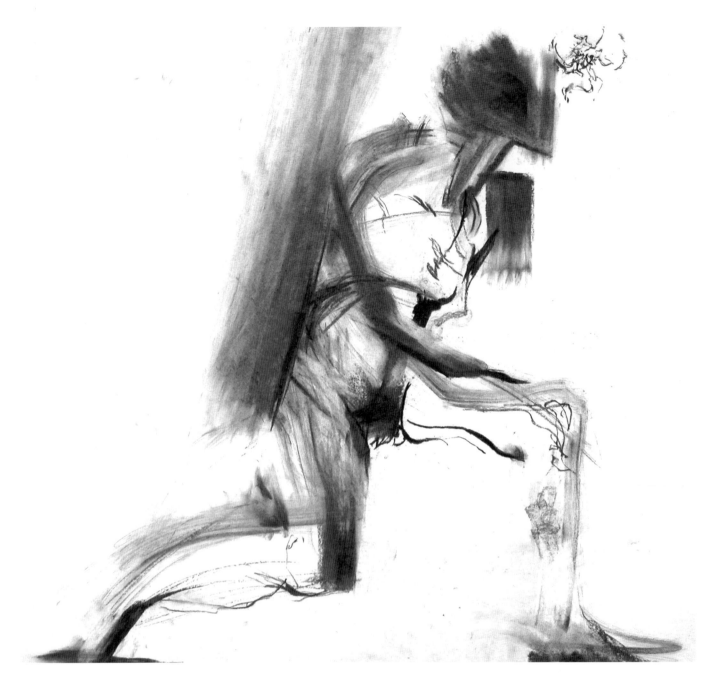

Passionate Line and Cave Painting together intensify the wide range of textural contrasts.

— METHOD: Use mid-tone pastel or sugar paper, and chalk or pastel and ink (applied with either emery board or brush), and hold the two media in the hands appropriate to the light source, as before. Work quickly and spontaneously, only looking at the paper from time to time (when loading up with more ink, for example). By responding to your eyes and taking a direct approach, it is possible to savour the textural contrast of ink and chalk.

Conclusion

You will probably by now have a clearer picture of, and feeling for, the kind of marks that you both want to see (having made them), *and* physically enjoy making (at the time). Remember that your mood can radically change your choice of mark, as can the model or pose. If you have followed the exercises so far you will be sufficiently experienced to support any decisions that you

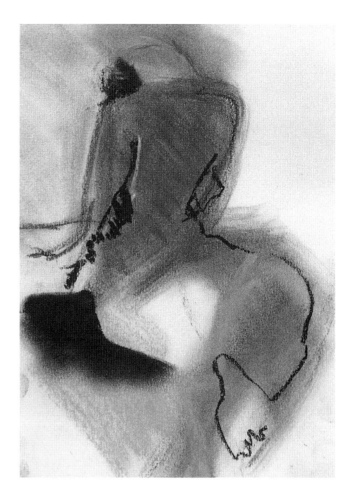

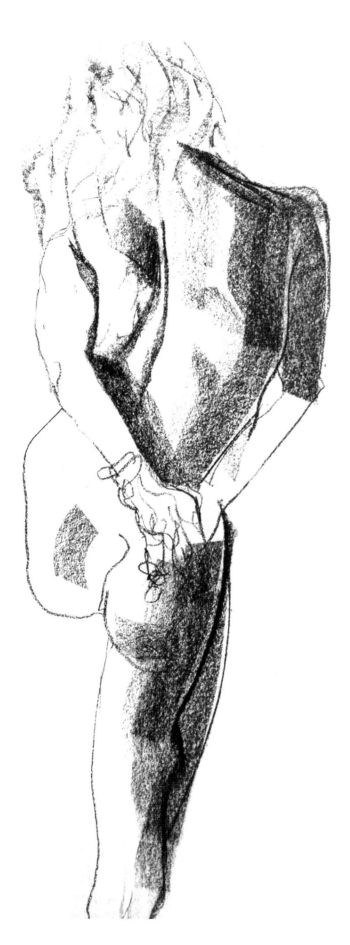

LEFT: **Pencil and charcoal Two-Hander – without looking at the paper – used to quickly express the tone of a turning pose.**
ARTIST: DOUG GREEN

ABOVE: **This drawing powerfully combines soft and incisive marks in pastel and charcoal.**
ARTIST: CAROLYN BOOKER

make concerning style. Don't be tempted to settle for the method that other people like, simply to please them. Quick, 'good-looking' techniques are useful for instant gratification or for when time is short and you simply need to gather information. Long, immaculate drawings are vitally important for subtler exploration, and can express a meditational mood – *but* if they don't stimulate you and stretch your interpretative skills, and do render both you and your model inanimate, they can be kept for occasional, and not everyday use. Keep the physical and mental act of drawing alive by staying open and attuned to your own needs, and to the message and expression of every pose, by every model. With this in mind, you will now be ready for the exciting challenge of the moving model.

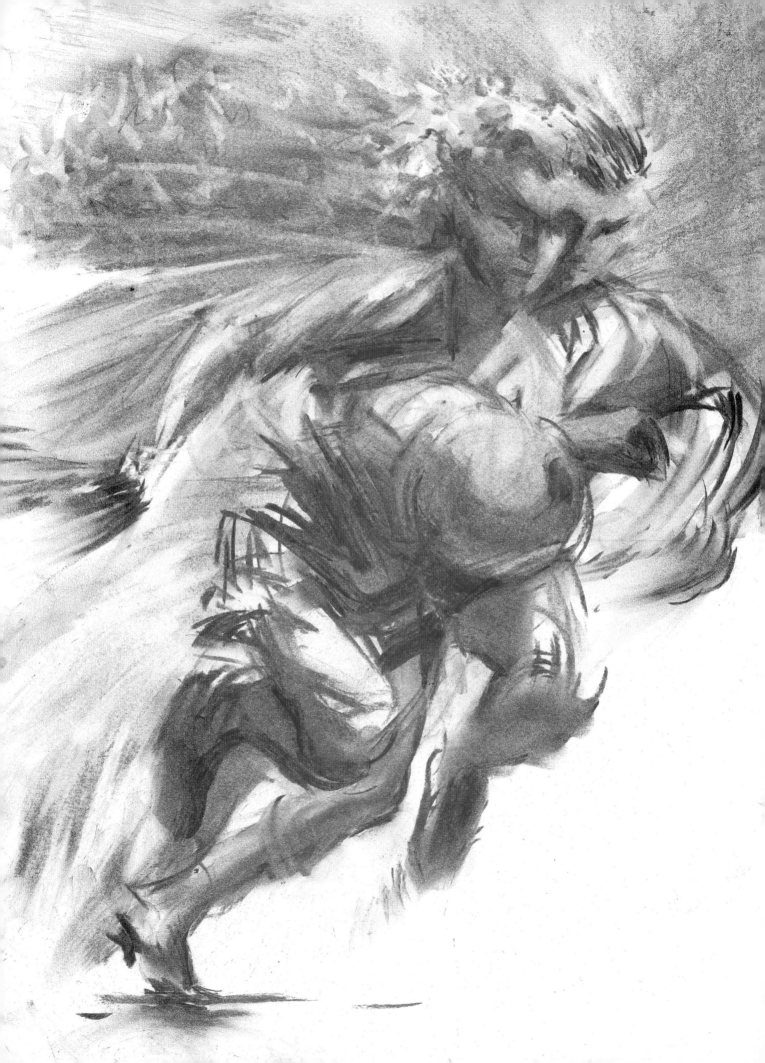

MOVEMENT: THE BODY IN ACTION

Life is so closely associated with movement that the words are often used synonymously: 'Is it moving?' often really means, 'Is it alive?'; and 'There's life in this drawing' implies that the image looks as though it is 'breathing'. The evidence of movement is 'living' proof of the life condition and coming to life, or 'quickening'. Even when asleep, the internal system keeps working: lungs inhale, exhale, food is processed, and the heart pumps on without conscious effort, while simultaneously our bodies turn and eyelids flicker as, with rolling eyeballs, we roam around in a world of dreams.

While it is useful and fascinating to study the appearance of inanimate bones and muscles of the body, it is their *function* that constitutes the most exciting aspect of life drawing – that our subject is *alive*. The movement of our own and other people's bodies is a matter of life-and-death importance to our primal instincts. If you have ever gazed at a 'statue' that suddenly moves, or conversely, turned to talk to a 'person' who is, in fact, a lifelike statue, then you will remember that the experience can send a shiver down your spine. This can even happen when we know *in advance* that the former is a person and the latter is a statue. Equally we may jump, with heartbeat racing, at the unexpected (even expected) movements in a film shown on a 'non-threatening' screen, or feel soothed merely by watching physical movements that express calm or tenderness.

Although the 'normal' scenario in a life class is to draw a live model and not a photograph, the situation is, nevertheless, anything but normal. Naked and sitting still for thirty minutes in the middle of a room, surrounded and stared at by a number of clothed people, is far from the normal everyday condition of a human being. But, ironically, a long pose offers the timespan in

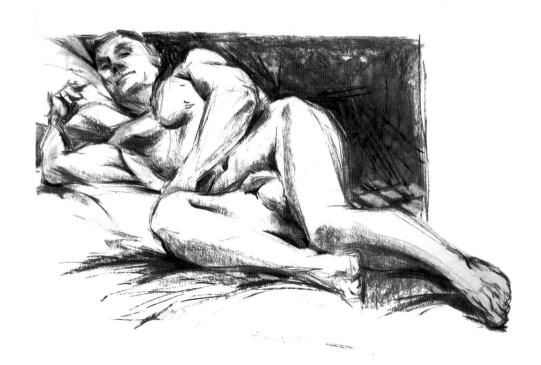

LEFT: **Two footballers move as one with the ball as their focal point.**

RIGHT: **While we drift off into sleep, our internal functions keep working.**

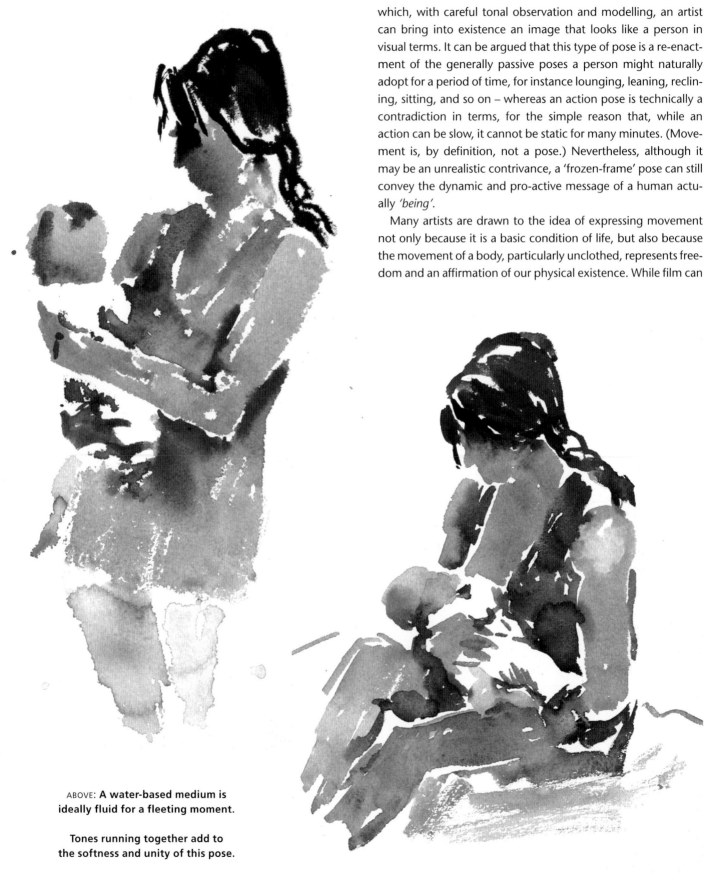

which, with careful tonal observation and modelling, an artist can bring into existence an image that looks like a person in visual terms. It can be argued that this type of pose is a re-enactment of the generally passive poses a person might naturally adopt for a period of time, for instance lounging, leaning, reclining, sitting, and so on – whereas an action pose is technically a contradiction in terms, for the simple reason that, while an action can be slow, it cannot be static for many minutes. (Movement is, by definition, not a pose.) Nevertheless, although it may be an unrealistic contrivance, a 'frozen-frame' pose can still convey the dynamic and pro-active message of a human actually *'being'*.

Many artists are drawn to the idea of expressing movement not only because it is a basic condition of life, but also because the movement of a body, particularly unclothed, represents freedom and an affirmation of our physical existence. While film can

ABOVE: **A water-based medium is ideally fluid for a fleeting moment.**

Tones running together add to the softness and unity of this pose.

ARTIST: ANNIE ROLLS

perform this task in one way by literally copying the sequence of visible movements and replaying them so that they appear to re-exist, the thought of recreating movement on one sheet of immobile paper may seem unfeasible. However, if the desire is to express 'life' without a captured or stilted look, it is, nevertheless, possible to transmit the *idea* of movement, and in this respect the artist has an advantage over the cameraman. An artist may use, or interweave, any images stored in his/her memory bank, or create any illusion from 'image'-ination (without having to pay or direct the actors). Prehistoric man knew this when, by drawing on his visual knowledge, he 'directed' bison and antelope across the cave wall. *His* basic needs may have been to 'capture' his subject, while we may also be interested in setting the person free to 'roam' the paper.

To achieve this impression, the artist needs to be prepared to work quickly, particularly in the early stages, to gain knowledge of the body in action. Many natural poses and body shapes are denied to the life artist, who needs to spend a long time drawing a pose; but a developed *awareness* of movement will enable even a long drawing to have an infusion of 'life'. But first we will consider the nature and function of movement.

How and Why Do We Move?

The human body that we know is the successful product of so many years of adaptation to this planet, and subsequent continuing refinement, that like anatomy, the subject of its movement is enormously complex.

There are three main types of pose. A balanced, static and often symmetrical position, with the bodyweight and the muscle-work for its maintenance distributed evenly. The counterbalanced pose might fulfil the same general function as the balanced pose, for example standing, sitting, leaning or lying, but it does so by zig-zagging the weight distribution from one side of the body to the other asymmetrically. Finally, an unbalanced situation is one in which the bodyweight is pushed off the centre of gravity and could fall. This is effectively what happens when we walk or run. The body is moved by the contraction and extension of muscles, causing the balance of weight to shift from one centre of support and 'fall' onto another (or to spring into the air in order to 'fall' to the ground in another place). As the bodyweight begins to lurch, another part of the body moves smoothly into position to 'catch' it (aptly named toddlers demonstrate the early stages of this process).

These everyday actions do not, however, just use the muscles of the legs, but most, or all of the body to make the movement and to ensure that it is smooth. A spiralling muscular interaction throughout the body not only eases the workload for one limb, but also helps to protect the joints in that area by distributing the shock of 'landing' impact to many other joints. This sharing of effort and strain by 'many' to perform one common task is the holistic aspect of movement that fascinates most artists.

Why the body moves can, for the purposes of drawing, be roughly defined in three groups of visible movement. Firstly, it moves in the performing of everyday functions such as walking, eating, reading, running, driving, carrying and manipulation, and generally shifting weight from one part of the body to another. Also in this category come the everyday signalling movements of speaking and body language. Some of the stages of these movements feature regularly in the poses that are found in an average life class.

Secondly, there are the movements made by sportsmen and women (either for recreational or competitive purposes) in order to hit or kick a ball to a goal, walk, run or swim faster, climb or jump higher or longer. They may also fulfil similar criteria by

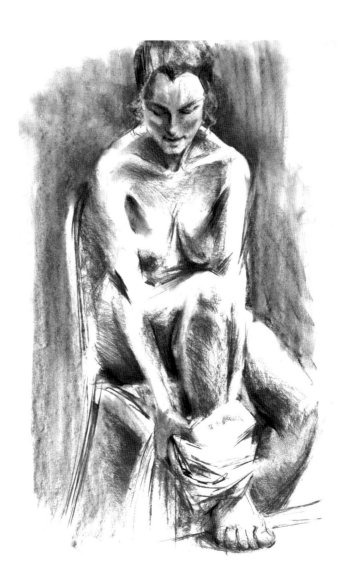

An 'everyday' activity.

139

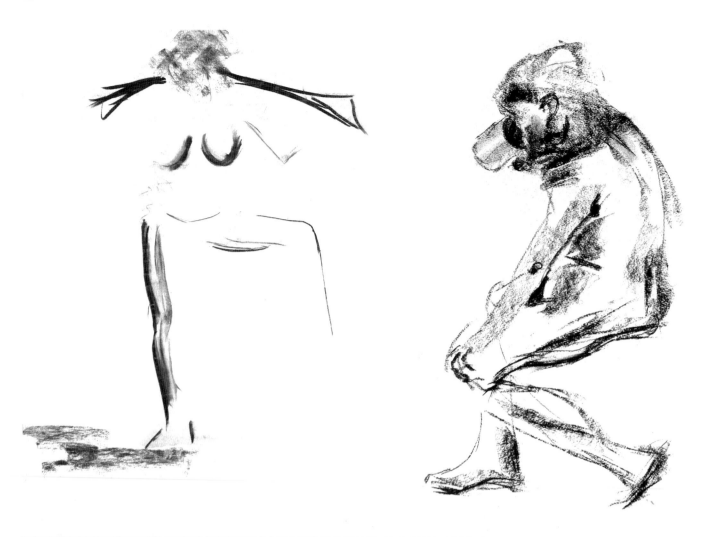

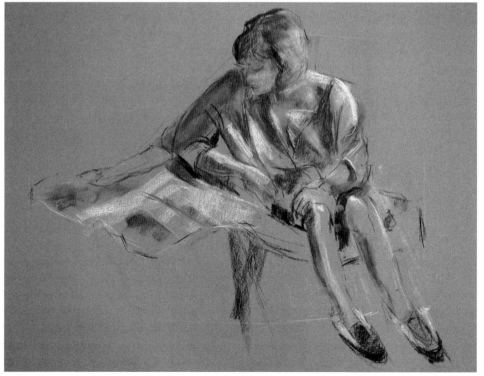

ABOVE LEFT: **Minimal Passionate Line exactly describes the action of this body with a 'happy' face.** ARTIST: NIKKI RIMMER

ABOVE: **The whole body is involved in this activity.** ARTIST: RICHARD HARDING

Note the 'moving' arm of this model reading the newspaper. ARTIST: JILL CHANDLER

Thirdly there is dance, which uses the body to express in mime a ritual, story or emotion without words. In formal display, dancers (sometimes masked) were, and still are, often used as a means to express a political idea of government or to symbolize a model of moral values. Dance is also used in popular form as a communal activity, to acknowledge specific social cohesion for the expression of mutual approval of taste or acceptance of the individual by the peer group. As an outlet, dance is used for the consumption of surplus energy, the expression of feelings, or by individuals, looking for a mate, as a sexual display of physical attributes.

Movement is also used, in combination with words, to entertain, to display lush costumes and acrobatic physical prowess, or to parody and mimic human behaviour (at the circus, theatre, film, opera, and so on). These three categories, however, are all intertwined and have their roots in the same earth – the human condition – with its built-in survival mechanisms and needs for life-affirming communication and sensory stimulation.

Expressing the Image of a Moving Body

So fundamental is the concept of movement to life that it is worth considering *how* we might draw the idea of these functions, from the everyday to sport and dance. To draw any subject, however abstract, it is first necessary to ask 'What does it look like to my eye?' The answer, in the case of movement, involves the addition of another dimension to your drawing. So far you have drawn a person who, in reality, has a height, width and depth (three dimensions) in terms of shapes and marks on a flat piece of paper that has only height and width (two dimensions). This type of image represents the tonal information that comes into our eye through the lens and lands on the back of the retina. (In fact the pupil of each eye, being approximately 65mm apart one from the other, receives a slightly different view, which is more significant at close range.)

When a body moves, however, it appears to us as a smooth sequence of configurations of the parts of the body changing in position, not only in relation to each other, but simultaneously changing in relation to the background. This diversity of shapes does not appear to us all at once, but takes *time* – the fourth dimension. It is possible to express this concept principally by noting your response, working quickly in the early stages, and using both long- and short-term memory.

If you have followed the exercises in the book so far, then drawing a moving subject will now be well within your range. With the observational speed-drawing and Eye-Trust skills that you now possess, your eye–brain–hand mechanism will be

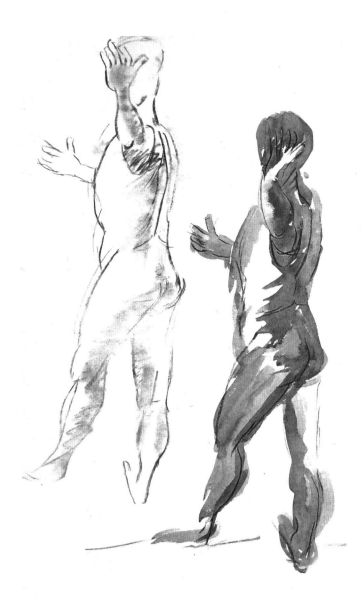

Light, lively sketches in wash and charcoal.
ARTIST: KATHLEEN DIXON

enlisting *other* means of transport, such as a horse, car, bicycle, boat or plane. Speed and strength are often desirable common denominators to possess for success in this arena. Also in this category are the combative sports, such as wrestling, boxing, fencing and the martial arts. Sport can fulfil social needs, and offers the pleasures of teamwork for both players and spectators alike, by supplying a large or small-scale group or 'side' to identify with and collectively belong to. For some, it also provides the opportunity to develop their stamina and to function at the peak of their physical capabilities. For others, the goal to be the best in a particular physical field is psychological.

smooth and automatic. Your long-term memory will also have a great store of 'likely behaviour' knowledge to draw on (foreshortened legs, and the range of the spine's curve and so on), while your short-term memory will be familiar with the habit of holding and transferring information to paper.

Everyday Movements

EXERCISE: **STRIP CARTOON**

As a preliminary step towards working from a moving model, it is possible to draw one movement in stages. Because it is more complex, this process is worth planning well to ensure the fullest enjoyment.

What will you learn? To study the process of movement and natural counterbalancing throughout the body in response to weight-shifting. This exercise also expands, for the artist, the concept of inhabited space, explored in Triangles, Chapter 2 (*see* page 43). To achieve the feeling of continuous movement in space you will require a large sheet of paper, a lightness of touch and, initially, some degree of mental flexibility for the process of juggling six images, joined at the foot, into one space.

— POSES: Model walking from one foot to the other, first slowly, then in six 1min sequenced stages, to be repeated continuously at least six times (a timer is recommended). The foot common to all poses (the left in this case) should be marked on the floor beforehand:

1. Weight on right foot, left leg stretched with heel only on floor.
2. Weight equally on right foot (ball and toes) and fully flat left foot.
3. Full weight on left foot with right foot inclined alongside, leg and ankle bent.
4. Weight mainly on flat left foot balanced by right heel stretching forward.
5. Weight mainly on flat right foot with some on left foot (ball and toes only on floor).
6. Weight fully on right foot with bent left leg alongside (toes only on floor).

— ARTISTS: Best positioned not too close to the model, and facing a strong three-quarter or profile view of the model (in order not to superimpose too many confusing images)
— MATERIALS: Large sheet of paper, soft charcoal

The aim will be to draw six figures that represent six stages of one movement, which relate to each other on the paper around the *one* common foot. Prepare for many overlapping lines, and the fact that the model will not necessarily find exactly the same

position each time the sequence is repeated. It is for the artist to accommodate this by lightly redrawing on top of the previous statement.

To ensure that the body shapes of these frozen stages of 'movement' are in keeping with the natural appearance of walking, it is wise to begin by asking the model to walk at a normal speed first in the most relaxed, arm- and hip-swinging way that is possible (so, *not* in marching mode). This will help your model to feel and re-enact the counterbalancing processes that naturally occur in fluent movement, and you, the artist, will be able to observe the shifting of weight from one foot to the other. When walking at a normal pace, the shoulders and the hips, if relaxed, rise and fall in opposition to each other to maintain a counterbalance as weight is transferred from one hip to the other. Simultaneously the arms swing, one forwards, one back, in opposition to the leg movement.

Now ask your model to perform the six-stage sequence several times at a slow but relaxed pace, trying to maintain this arm-swing and the counterbalance of the shoulders and hips before slowing down to the six static poses. When drawing a sequence pose, it is crucial to first mark the placing of the common feature and the full extent of the pose around it on the paper (as you might use Five Star with one figure) *before* starting to draw. Do this by noting and marking with light dots or a light tracking line the model's extreme range of movement in relation to surrounding information – for example the ceiling, walls, easels and floor – comparing the height of the model at the highest point, to the width of the whole sequence. If you follow the progress of the top of the head only, for example, by pointing at it with the tip of your charcoal as it moves, this will help to familiarize your hand and arm with the 'shape' of progression.

Then, using Rhythm and Curve, lightly and quickly mark the longest single curve of the body, then the next longest, and so on. When the pose changes, don't worry that you haven't finished the drawing, but get straight on with the next position, remembering to link the head with the common foot. Keep working lightly until you feel that you are establishing the undulation of the foot and hand movements. The secret of fluid sequence drawing is to think in terms of *one* action, rather than six life drawings. Note the trajectory of the hand or foot throughout the stages, and put marks in, here and there throughout, so as to build up the whole structure: this will ensure that the strength of line is not too unbalanced, staccato or distracting from the main message, which is continuity of movement. For the same reason, do not be tempted to get involved with details.

Try this exercise several times to develop an awareness of space-coverage in movement; this in turn will help you to relax into the process of drawing one sequential 'idea'. Also try using Eye-Trust by putting a finger from the other hand on the

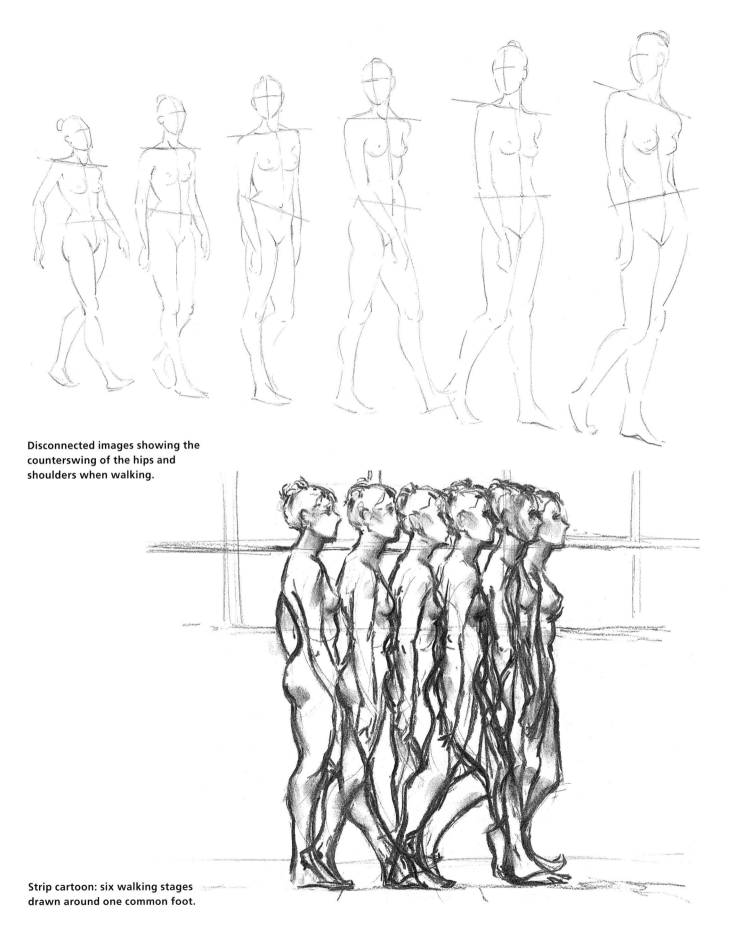

Disconnected images showing the counterswing of the hips and shoulders when walking.

Strip cartoon: six walking stages drawn around one common foot.

destination point of each drawing before you begin to draw it without looking.

What does this drawing convey? Sequence drawing describes movement by conveying a feeling of three-dimensional space filled by an action. A sense of space, agitated by fleeting movement, will be expressed if the lines that comprise the drawing are short and varied in strength. If, however, the lines are long and continuous, a smooth flowing movement, though less active, will be implied; and if the marks are light, the impression can be ghostly, like an apparition or memory. There are many variations on this theme of sequence drawing, and it is exciting to experiment with different marks and media in preparation for drawing directly from the moving subject. By doing this you will be developing an instinctive approach to mark-making which is ideally suited to depicting movement.

Here is a list of other sequence poses that are interesting to draw:

- Approaching a chair, sitting down and walking away: a seven-stage pose (three to approach the chair, one sitting, and three to get up and leave); remember to put two foot-markers on the floor and on the chair back and seat for the supporting, and pushing off with hands.
- Curled up in a ball-like shape on the knees on the floor, with head tucked in, rising to kneeling, and finally with arms outspread in mid-air whilst still kneeling.
- Describing a throwing movement, the weight transferring from the back to the front leg, both feet in common.
- Bending, while standing, with the legs bent and hands touching the floor down to one side, then twisting, raising the arms and swinging them outspread in the opposite direction, both feet in common.
- Climbing up two rungs of a ladder.

**Different tone is used to distinguish three
ball positions of a dancer rehearsing.**
ARTIST: ROSEMARY SHUTTLEWORTH

**Trajectory lines guide the drawing of this
turning, bending, stretching pose.**
ARTIST: CLAIRE REDGROVE

A line that subtly appears and disappears suggests the transient quality of this sequence pose.
ARTIST: ROSEMARY SHUTTLEWORTH

EXERCISE: **BODY ARCS**

This method describes a movement in terms of the trajectories of different parts of the body in relation to each other; it also goes some way towards expressing the relative speeds of parts of the body within one action. For example, when walking, a foot moves more, and faster, in relation to the ground as it is drawn forwards from the back to the front position of a stride than it does while taking the bodyweight, when it only rocks in the same place on the ground. Simultaneously, the exact reverse is true of the relationship between the same foot and head that moves over the weight-bearing 'static' foot and is linked to the follow-through leg. The head, hips, shoulders and hands all have their own relative speed, both to each other and to the ground, and yet the whole body moves as one element to keep every gram of weight perfectly balanced over the centre of gravity, so as to avoid falling over.

While this is a three-dimensional reality in space and time, this exercise is an abstract concept for conveying the spatial event to a two-dimensional surface.

What will you learn? To watch, and draw, the relationship of the key points of a moving body to each other and to the surrounding space. This exercise also helps to further the understanding of a movement as an entity in its own right, which will consequently inform the drawing of single images of moving subjects.

— ACTION: One continuous sequence of movement (to be repeated) that travels through space and uses legs, arms and head
— TIME: Period to be limited by the patience of the model, or as long as is necessary for the artists, whichever is the sooner (depending upon the pose)

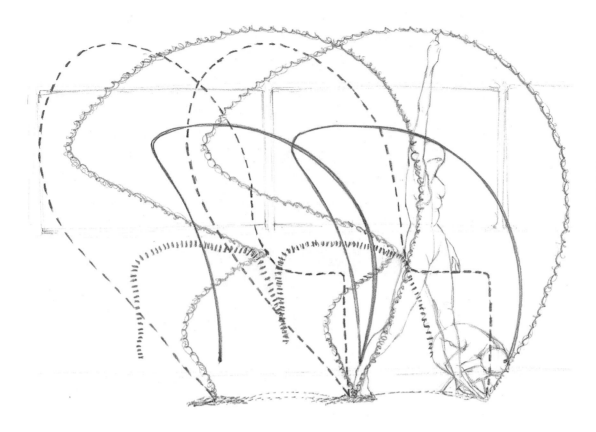

Body Arcs, showing the highest and lowest point of this turning and stretching sequence.

Take the time to devise an exciting, repeating movement that simultaneously covers plenty of space and changes the body shape within the sequence. Try movements that turn, or travel up or downwards, and shapes that twist, bend, expand or contract, for example (it can help to mark the foot positions, but this must not hinder the flow of movement). Then watch the sequence several times, looking for the highest and lowest points of the entire movement, and the distance covered in relation to the height, lightly and briefly marking relevant background information on your paper.

While watching, choose five key points or joints (including the big 'movers') on the model that you will follow individually throughout the repeated sequence. Then, ask your model to hold the starting position of the movement for a minute only (just once) so that you can mark the whole body shape very lightly as a reference from which to start. Make sure that there is ample space on the paper for the *whole* movement, then, without looking at the paper, gently trace with a single line, the trajectory of one body-point while the model moves, following it right through to the end of the process. (A high-reaching body-point is recommended as first choice, to act as an extreme outpost of the whole shape.) Now put a finger from the other hand at the end of the sequence on the paper and, as the model repeats the sequence, follow through with another body-point.

Do this until you have a description of individual body-part movements that you can then see in relation to each other.

What does this method convey? An image that does not resemble a person, but rather the interconnection of several elements in one expression of energy. (If this sounds complex, it is! Imagine, by contrast, following five key points of an inactive, horizontal pose in the time duration, to understand your achievement.) The drawing will show, like leaves floating on a fast-flowing river, the confluence and divergence, often eddying, of the limbs and body away from, and towards each other.

It is fascinating to develop this idea by using more body points or introducing a range of slow, fast or sudden movements, including stamping or clapping. Use Passionate Line and Expressive Tone to make a wide variety of marks to express, not only the directions of movement in the relative time-scale, but also the sound, tension, weight or 'feeling' of the movements in visual or physical terms. For example, a sound may provoke a physical response that elicits a mark in no way visually resembling the hand that made the sound. The mark, however, may perfectly convey the *sound* to another person.

Again, if this sounds complex – it is, in both words and fact; but don't worry, your instinct will guide you in expressing the idea. Remember, the sheet of paper is *your* space to explore.

146

Drawing Sporting Activities

While drawing from a live model is always a more exhilarating process, nevertheless with the aid of modern technology it is possible to record, freeze-frame and copy any moment of an action-sequence. The newspapers also have many excellent images from which to work. It's worth remembering, however, that the photos that are used are often taken at such a long range that the dynamic effects of perspective are diminished, because the greater the distance between viewer and subject, the less is the difference in scale between the near and far parts of the body. Also, because the telephoto lens can record an image beyond the range of the human eye, the information can look strange, because the 'squashed' proportions are not familiar to our brain.

Nevertheless, it can be useful to trace images from photos, because the very act of drawing around strongly foreshortened body and muscle shapes that we don't normally see in static poses, stimulates and familiarizes our brain with the fleeting or extraordinary image.

EXERCISE: **FREEZE FRAME**

The aim of this exercise is to express, with the help of photographic or 'frozen' film images, both direction of movement *and* contrast between the static and active aspects of one dynamic pose. Because people are not usually naked when engaged in sporting activity, it is important to observe and draw the fabric around the body. Although the addition of clothes can interrupt the continuity of the whole bodyline, and the dynamics of the moving body can be hidden beneath fabric that is boned, firm or spongy, fabric with less autonomous support can actually accentuate the underlying form. When clothing is tight, for example, it expresses the tension in certain areas by appearing folded or stretched, often giving clear, extra three-dimensional information around the form. When it is loose or draped, in still conditions, it conveys the idea of gravity with its folds. Also, being lighter than the body, fabric is often more subject to the effects of airflow caused by the fast movement of either the body in space or the wind around it, and can express not just the action but the *direction* of the action. One still image of a clothed athlete can clearly convey the preceding and following moments simply by the direction of the fabric folds.

What will you learn? To decipher the intention and dynamics of the movement and, using Passionate Line, convey an idea of the time-scale before, during and after the action, in one drawing.

— POSE: No model. Choose one particularly dynamic still photographic image from the enactment of a fast movement
— TIME: As no model is involved, this decision is yours: but remember the value of spontaneity and first impressions when depicting movement. Extra time can often be best spent in the *subtraction* of information
— MEDIUM: Soft pencil or charcoal initially, because it smudges and erases easily

Study the photo carefully, using your experience from the previous exercise to help elucidate the progression of the whole movement, of which the image shows only a part. Clues are to be found in the direction of the fabric folds. If they are hanging vertically, then that part of the body is probably at rest, moving upwards or at the midway point of a change of direction; and if the folds are stretched or blowing in the wind, they will express the muscle tension or direction of the movement (or prevailing wind). If the body is twisting, the folds will tell you the story. A ball in the photo, for example, will help to explain the intention of the movement simply by its position in relation to the person. (If the eyes are not on the ball, it is possible that the target, or goal, is in the person's 'sights', thus indicating body direction.)

When we look at any autonomously moving object (not a transported one), we are presented with a choice of focus. As stated before, the subject not only moves in relation to the background, but also moves the limbs, trunk and head in local terms. Do we

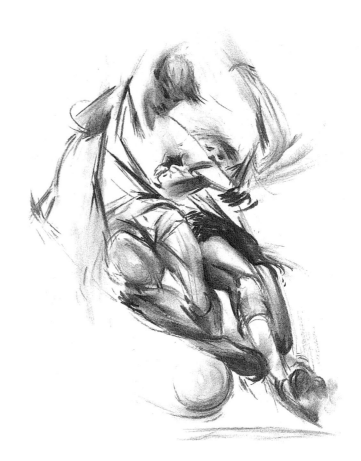

The impact of a tackle in football.

follow the subject with our eyes and see an image that, although moving locally, is 'static' in relation to a 'moving' background? Or do we focus on one waving hand, for example, and look at the static hand against a moving body and background? Do we focus firmly on the tree in the background and witness a blur moving across in front? Photographs of moving people or objects also make this choice. The background information must therefore add to the sense of movement, and may be selected either to mirror the action – for instance, diagonal lines and/or soft blurring marks – or to contrast with it, such as using fixed, sharp-edged surrounding marks and blurry action.

The whole drawing process should initially be quite fast, your response instinctive and your marks as expressive as possible, smudging vigorously where necessary to indicate direction of movement. Start by drawing the most evident, dramatic or longest energy line that runs through the whole body shape, pressing harder, for example, where you feel that the weight impact or tension is strongest, and trailing the line away to describe the 'follow-through' where energy is dispersed or 'expelled' from the body, in the case of a throwing or kicking action. Clump together crossing marks, or those that run in the same direction, thick or thin, or make small individual flicking marks, inside or outside the drawn body, to give the feeling of energy and momentum behind the movement.

Make sure that the information in the drawing expresses the *action*, rather than a portrait of the person, only adding details if they are an intrinsic part of, or parallel to (often literally), that description. Actively erase any superfluous marks that do not serve this end, and accentuate the ones that do. The drawing needs to be an experience of discovery for both artist and viewer, rather than clean, so it is important not to be over-protective or precious about 'beautiful' marks that don't do the job.

What does this method convey? A feeling of dynamism that incorporates the notion of time and speed. 'Long' drawings of passive, static poses often describe the environmental reality of their creation – the studio with its familiar props and methods may involve a refinement of the image that 'fixes' the outline of the 'unbreathing' figure forever, whereas this 'unfixed' image has an ephemeral quality that may belie the time it actually took to create. As long as the basic principles are adhered to, it is possible to spend any amount of time on this type of drawing without the image becoming stale and overburdened with the 'encrustations' of overworking. By continuing to add and subtract marks, using trial and error as your guide, the drawing will stay 'alive'.

Drawing swimmers involves expressing a change of gravity within a surrounding 'space', which is less transparent when aerated.

EXERCISE: **QUICK ON THE DRAW**

Drawing a moving image using Eye-Trust is less of an exercise, more of a way of life for many artists. With a sketchbook constantly to hand, the thrills of drawing people engaged in natural everyday activities, including sport and dance, are yours to enjoy at any time of day (and, because you are not looking at the paper, night). In order not to disturb people by staring at them for long periods, studying your subject should be as natural and inconsequential as normal 'looking around' – except that your hand will be working simultaneously. To this end, the sketchbook must be small (A4 or smaller), discreet (not brightly coloured), cheap (so as not to feel inhibited about using paper) and, most importantly, must have attached to it a mechanical pencil (that can be refilled with plenty of soft 2B leads, and never needs sharpening).

What will you learn? By using Eye-Trust, it is easy to draw moving figures on the train, plane or bus, in a bar, restaurant, in a darkened theatre or at the opera, or simply at home from the television. The more important part of this process *is* the process, not the resultant picture – the drawing, not what is drawn. Habit will have told your eye, brain and hand that normally when you draw people, they stay still. You will soon learn, however, to let go of the frustration you may feel when your subject walks away just as you are getting engrossed, and will come to accept that people moving naturally are not modelling. You, the artist, must 'draw to their dance'.

It is normal for the marks you make to look like random lines and partial drawings, however don't waste energy clinging to the past (the unfinished picture), but come back immediately to the present (drawing the next subject). Remember that the act of drawing *one line* – recognized and prioritized by you to describe the intention of an action, and recorded by your eye, brain and hand in harmony – will have developed your skills. If your subject moves slowly, keep drawing continuously, moving on to the new shape.

— POSE: Anyone, anywhere
— TIME: As decreed by your 'models'

Without looking at the paper – or only very occasionally – work instinctively and as quickly as you can. At any moment your 'model' can actually move out of sight, so it is useful to devise ways of recording the most important aspect first. Use any method that best describes your instinctive choice of statement; for example, for the shape that describes action, begin with marks that express the inter-related extremes of the body, their intention and inclination – whether stretching, bending or curled up – before working on the inner contours of the figure. (Note the general scale and folds of the clothing.)

For a facial movement or grip of the hand, however, start from the place where most energy seems to be concentrated: being careful not to lift the pencil, follow the features outwards, revisiting the centre of your attention, if necessary, to travel outwards

**Balanced verticals and horizontals contrast
with curving energy in this quick drawing.**
ARTIST: JULIE SIMMONS-GREGORY

in another direction. For instance, for a frown, start at the bridge of the nose; for chewing, at the cheek; for a clenched fist, at the centre of the gathered fingers or stretched knuckles; for a pointing finger, at its tip; and so on. It is quite possible to chat with another person while doing this, and in some ways to do so is positively useful, because the part of the brain that may at first want to take control of the moving subject, can be occupied by talking, and thus allow the process to flow more easily under the guidance of your eye.

What does this method convey? Despite having emphasized the importance of the *process*, the actual results can also be regarded as a true record of a particular place, event or meeting, and more importantly, as a vivid reminder of them, in ways that a photograph cannot convey. The surroundings – the 360 degrees of visual information – have been personally filtered by you, and the choices you made were the most pertinent to convey *your* feelings about the situation, like a stream of visual consciousness. So the scene is not just objectively recorded as seen, but is a personal

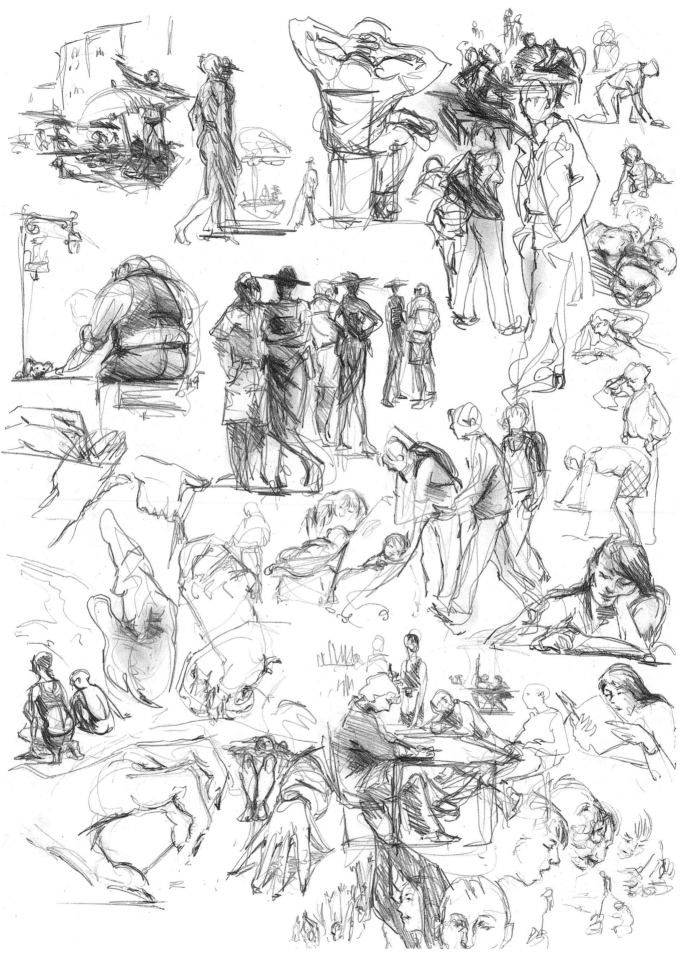

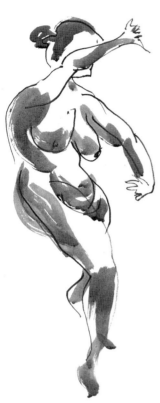

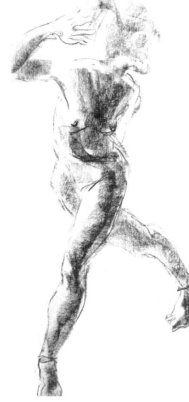

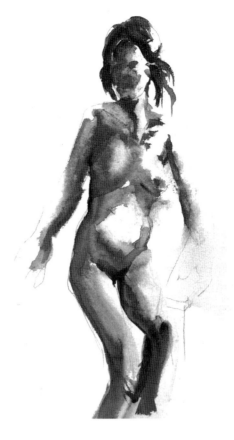

A vigorous line-and-wash drawing.
ARTIST: ANGUS HARRIS

Quick strokes of tone and line capture the spirit of stretch, turn and form.
ARTIST: DOUG GREEN

Lively open-ended ink marks express an earthy exhilaration.
ARTIST: BABS LOCKYER

A contrast of fluidity and volume express this evolving pose.
ARTIST: URSULA BICKERSTETH

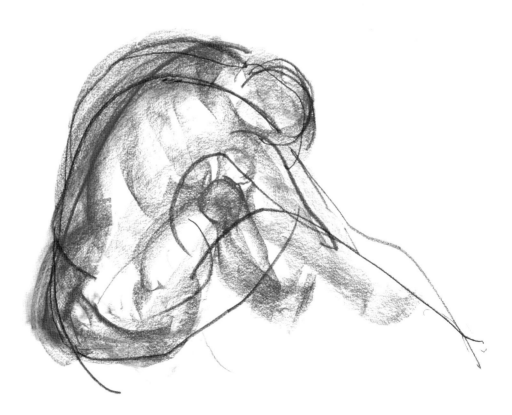

OPPOSITE PAGE:
Double-page example of quick sketches.

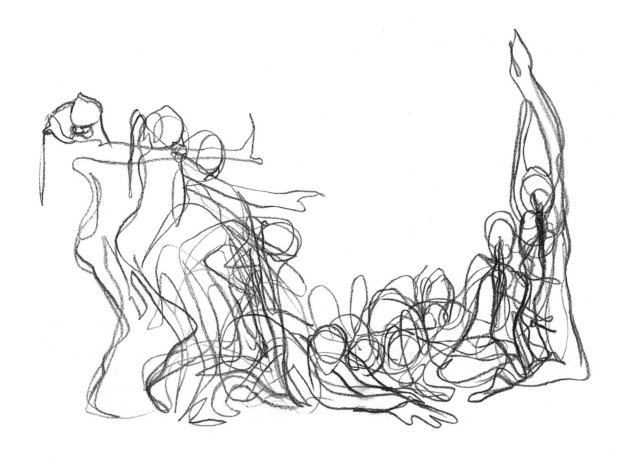

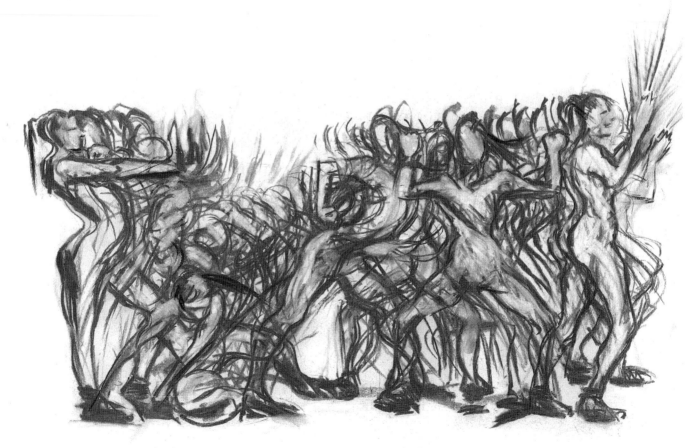

OPPOSITE PAGE:
TOP: **Continuous Eye-Trust drawing of a very slow sequence, which reads from left to right.**

BOTTOM: **Motion Picture drawing of a hip-hop sequence, which reads from right to left.**

impression: the tilt of a person's head, the arrangement of their legs, the curling of their fingers or the bend of the back when walking, are all features that you have subjectively selected as being idiosyncratic to that subject. (Try drawing during a film, then wait a week or longer before looking at the results, and see which aspects and moments you chose to record.)

Drawing from Sequential Movement

Working from film or from still photos using the last two techniques can be good preliminary practice for drawing live movement. If possible, draw from life by paying a dancer or gymnast to model for the drawing session. Alternatively, sit in on dance classes, or choreography or T'ai Chi sessions, for example. When drawing dancers, try to find a wide range of dancing styles and nationalities, as different cultures will make completely different body shapes, often describing different motives.

A major advantage in drawing at rehearsals or martial arts' sessions is that the same movements are repeated, and this gives the artist the opportunity to become familiarized with the body shapes, to choose key images from the sequences, and to build up individual images little by little. Simple lines or marks in one or several directions can alone give a strong sense of dynamism.

EXERCISE: **MOTION PICTURE**
In this exercise, the idea of a moving figure is expressed in staggered images using multiple line drawings that gradually change throughout the sequence of movement.

What will you learn? This process will develop drawing speed, and will deepen an artist's awareness of the everyday displacement of moving objects in relation to their surrounding space.

— POSE: A dance or gymnastic sequence that moves across a minimum space of 5m (16ft) and can be repeated. It can be helpful to put different coloured ribbons around the wrists, ankles, neck and waist of the subject so you can more easily distinguish and follow individual lines of trajectory

This 'busy angel' is the synthesis of a dancer's gentle warm-up sequence!

— TIME: For as long as either the model or the artists find the exercise necessary or supportable

This exercise can be tackled in two ways. If the movement is very slow, draw in a continuous line using Eye-Trust to move from one shape to the next. If, however, the movement is fast, use trajectory lines as before (discussed in Body Arcs, *see* page 145) to first trace the progress of the head, feet and hands with a light line of pencil. Then choose five key images that occur throughout the pose at regular intervals, and note where they occur along the flow-lines that you have drawn. Look ahead to where the next chosen shape will appear. Then put a finger from your other hand on the paper where you anticipate the head will be, and using Eye-Trust, draw the figure in charcoal from the feet upwards. Draw as much of a pre-chosen position as possible in one go; it won't be possible to complete a whole shape, or to work on every shape during the course of one sequence – so relax, and prepare for the next one.

Having lightly line-drawn five images, gently build up the intervening images until you have constructed an 'animated' image of the whole movement. You may need to use an eraser as well to balance the images.

What does this convey? This image yields an impression of movement, similar to watching a slowed-down film of staggered images. A similar impression, but more obscure and more dynamic can be achieved using Rhythm and Curve or Swordplay.

EXERCISE: **A MOVING EXPERIENCE**

This is a very personal and dynamic way of drawing, which expresses the 'feeling' of the pose; it requires no more than an open and relaxed approach for the artist to be rewarded with a sense of liberation.

What will you learn? Although you, the artist, will not be *making* the movements, it is normal to empathize with another moving person to a degree that is dictated by past personal experience. By loosening the grip of that part of your brain that quantifies visual information (in terms of dimension, shape and tone), and by tapping into your 'physical memory', you will develop this aspect of awareness. It will then be possible to express the movements subjectively, using the widest possible range of marks and methods. Your experience and interpretative skills will grow so that both the physical act of drawing and the results on paper will communicate more than a purely visual experience. For example, thrust, weight, gravity, balance,

tension and imbalance are components of dance, which is, in itself, a gesture of expression. Your ability to express those elements will, in turn, be developed by this exercise.

In order to loosen up, and summon up and expand your vocabulary of marks, it is recommended that you spend 5–10min mark-making, and share your results in preparation for this experience.

— POSE: Dance or movement that contains a variety of shapes, speeds and energy changes in the repeated sequence; for example sliding, jumping, turning, hopping, bending and so on
— MEDIUM: Large sheet of paper, thick chunk of charcoal
— TIME: Open-ended, but determined by the needs of the group and the stamina of the model. (Maximum speed on the part of the artists is essential, a finished drawing is not)

As before, watch the sequence several times, and then lightly mark on the paper the space that will be necessary to fit the whole movement, marking the window or ceiling junctions as a guide. As before, choose five shapes from the process that seem to be key moments, either because they end or change a movement. This time, however, try to express the feeling of the movements as you experience them visually – their weight and speed, whether smooth or staccato, even their sounds – by the quality of mark that you use; for example, strengthen the mark to fix or weigh it down, or completely omit it to describe fast movement. In the event of the model moving towards you, compound the images, overlaying them in larger and larger scale. However bizarre and complex the total conglomeration of marks may be,

Instinctive drawing of a fast, dynamic and long sequence.

it will be a direct response to the experience of an approaching figure and the centres of greatest energy.

What does this method convey? An abstract variety of shapes and marks that may, or may not, look like a body, but which will be visually intriguing, however obscure. Nevertheless, much more importantly, movement will be evident as a dynamic expression of the effects of gravity and physical energy. While skill and visual knowledge are useful, this exercise can be attempted by an open and courageous beginner because it calls upon a direct 'gut' reaction to the movement.

EXERCISE: DOPPELGANGERS

This visual statement of movement using tone rather than the two-dimensional and abstract concept of line, draws closer to the language of actual perception – though it is, of course, monochromatic (i.e. one-, and not many-coloured). Because it is comprised of selected, directly recorded information only, the viewer's eye can move smoothly across the whole sequence at speed, being neither hindered by too much information nor fixed by a continuous line. The open-ended and somewhat vague statement is not dissimilar to our actual experience of movement. Lacking the time to record all the information, we are normally obliged to snatch at key tonal changes and peripheral data, 'completing' the whole picture by guesswork later, so that we can still 'follow the action' (a fact that conjurors and card-sharps use to their advantage). Also, in visual reality many tonal edges, as we have seen, are 'lost': so while the other techniques have concentrated on the area, surrounding space, memory, feeling and texture of movement, this method aims to directly express our *visual* experience of movement.

What will you learn? This exercise develops the eye/brain/hand co-ordination of the artist by practising the process of recognition, selection and recording of tonal information very quickly. Speed and efficiency are as vital in this method as they are in the daily use of our 'looking' processes for survival. With practice this method can become a quick and easy way of drawing movement in everyday life.

— POSE: Any sequence of movement (to be repeated) that has a wide variety of body shapes and scale within it, for example stretching, striding, bending. The model should be strongly lit, if possible

— TIME: Depending on the strenuousness of the movements, to be negotiated with the model

— ARTISTS: To be positioned so that the model is back-lit or side-lit (not front-lit)

— MEDIUM: A choice of three methods:

■ a large sheet of paper that may be covered with charcoal and used with an eraser;

■ black paper used with white chalk or pastel;

■ white paper, to be used with a large chunk of charcoal.

In all cases the paper must be fixed firmly to a board to cope with vigorous mark-making.

The main aim is to gather information and express the idea of movement as quickly as possible, in a way that parallels the way we look, and mimics the message that we receive. For this to happen, the eye must rule and the brain must 'disengage'. Drawing in tone alone for the first time may have felt briefly uncomfortable because so many of us were habituated, as children, to primary mark-making in terms of writing and a linear description of the world, rather than in shapes of dark, medium and light. After a short while, though, the concept of copying the visual world in tones that we see, without having to invent a surrounding artificial line, suddenly seems to be the easier option, allowing the image and artist to breathe and develop, or 'become', from the *inside*. In the same way, this method needs only a simple and spontaneous approach that echoes the looking process. Having followed the previous exercises, you will be attuned to the sequence or event as one whole image or shape, and will automatically be aware of the necessary space required. All that remains now is to respond to the action naturally.

Looking as little as possible at the paper, begin, during the first run-through, by drawing one central or striking part of the body first, in soft, open-edged middle tones, right through its progression of movement, using the means most appropriate to your response. This could range from many lightning movements across the paper, to flowing, continuous marks if you are following the figure, not the background. For example, the reason for making sudden movements (physical hand action of the artist) to break up the image (visual two-dimensional marks) may depend on the speed (time) or staccato effect (quality-reception of visual information) of the movement (physical action of the performer).

Each time the action is repeated, build on to the image until the darks and lights have a rhythm of continuity that expresses the life of the action, rather than pinning it into one place. To achieve the communication link between performer and artist – visualized intention, physical action, visual response, physical reaction – there can be no barriers such as fear, or even anticipation; only an openness and alertness to be ready in that moment to transpose the idea, like a relay runner waiting to seize the baton, running.

What does this method convey? Whatever else, this image will express movement as long as the artist can prepare, like a perfectly strung bow, to let go future, past and external considerations in order to 'travel' *with* the performer. Then the act of drawing can mirror the intention that begins in the mind of the performer both before and while he executes the movement, and transcribe it as fast as he performs it.

Dance sequence drawing using charcoal and eraser (Finding the Form).

EXERCISE: **TWO-HANDED PERFORMANCE**

If following and tracing a movement on paper with one hand is energizing, this method, using both hands, allows you to cruise at top speed!

What will you learn? This very physical form of expression encourages the artist to completely let go and become more involved in the action. At times the movements of artist and performer may even be quite literally mirrored. As drawing with both hands is a more symmetrical activity than using one hand alone, the link with whole-body movements is much closer: for instance wide, expansive body shapes will be described with hands apart, while small contracting movements bring both hands together. It is a good idea to limber up in advance by practising with both hands on scrap paper: this welcomes the other hand onto the 'stage', and feels more physically balanced.

— POSE: As before, a repeated sequence of movement (ideally dance), which involves a wide range of shape and speed.

— TIME: Dependent on the needs of the artist and the stamina of the performer

— MEDIUM: Any medium that makes a reliable mark, and a large receptive surface; for example:

- black and white conte sticks (or charcoal and chalk) in the appropriate hands, on middle-tone paper;
- 'Cave-Painting' materials, such as powdered chalk and charcoal, used directly on the fingers (with or without water) with nails or scratching implements, on a very robust cartridge, pastel or watercolour paper;
- two brushes well loaded with black and white ink or paint ready in bowls to right and left appropriate to the light;
- water-soluble graphite that can be drawn in the first 'run-throughs' and spread during the following repeats.

This salsa sequence (reading from right to left) was drawn with both hands using white and black conte.

This exercise is, by design, intended to be a visual and physical experience of mutual commitment to expression of the human body by both dancer and artist. As there are infinite permutations – individual movements, response, interpretation and method – one universal drawing process is completely inappropriate here. Having followed the previous exercises, you will by now have developed an approach idiosyncratic to *your* expression of movement. Also, drawing at speed with both arms requires such a personal and instinctive approach that the enormous diversity of method and mark-making choice should not be prescribed.

Only a few guidelines are worth stating here:

■ Stand up to draw if possible, to give yourself complete freedom to physically echo the movements and swing your arms, especially if using a large sheet of paper (which is recommended).

■ Make sure that your paper is well tethered and supported, and that you are conscious of its edges.

■ Eye-contact with the subject will be necessary all the time that the sequence is in progress so that the visual message can zoom – body movement, eyes, brain, both hands – onto the paper, without interruption or intermediary 'commentary' on the picture.

■ If using black and white, do not hesitate to draw on top of previous marks: the overlapping will add to the feeling of transparency and transition.

What does this method convey? As an event, because it requires an equal physical engagement by artist and performer, it could appear to an onlooker as a two-person performance art. This mutual focus and commitment to one statement of the body's potential by the 'mover' and the 'movie recorder' bring dynamic results and usually describe a great freedom of expression (the antithesis of containment or repression). The images often have an ephemeral abstract quality, ideal for conveying the illusion of transience.

THIS PAGE:
This more abstract Two-Hand interpretation shows the static origins of a dynamic sequence. Charcoal stick and finger-and-charcoal dust were used simultaneously.

OPPOSITE PAGE:
TOP: **A continuous mark combines the outline and the trajectories.**
ARTIST: BILL STOTE

BOTTOM: **Turning 'on the spot' produces a density of marks, whereas jumps make space in the drawing.**

Conclusion

By engaging in these exercises, quite apart from learning more about the capabilities of the muscles and bones of the 'being' to transport its body, you will have explored another rich realm of awareness. The lightning speed with which your eye, brain and body can work to record the moving world is just one of its elements. Sensitivity to body language (from grand gestures to masked messages); judgement of the ratio of speed between people/environment/individual parts of the body; the selection and prioritizing of significant and peripheral movements; and a perfect sense of balance, thrust and fall are only a few more. Using the potential that usually comes, at our conception, with the whole 'body-equipment package', all of these skills are learned or developed, and seem to happen automatically. However, to observe these processes at work in ourselves can be fascinating, or even awe-inspiring; and then to be able to use them for describing human movement on a static sheet of flat paper is a positively exhilarating leap of creative courage.

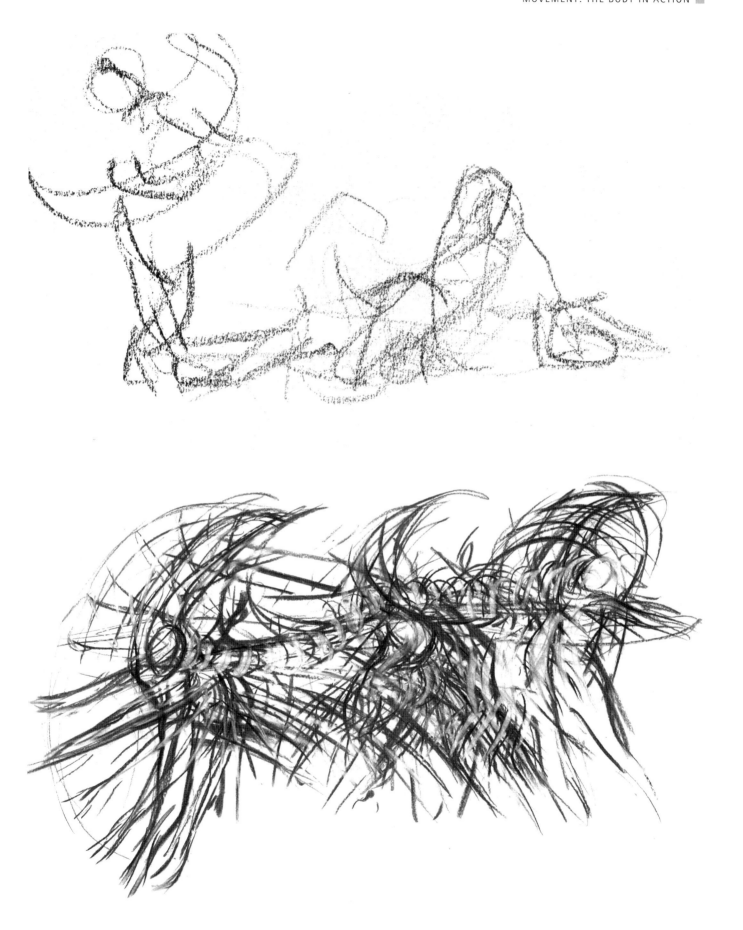

ALTERED IMAGES

In order to be able to express this brilliant machine that we all possess, the human body, we have explored, pondered and studied many of its aspects. This we have done by asking the following questions: How do we look at it? What are its dimensions: how wide, how high? How do we know it's not flat? Is it dark or light? What is it made of? What does it do? Why? What does it feel like? How does it work? What marks can express it? What happens when it moves? How can I draw that?

Now we might ask how we can change the message or mood of the poses that we draw, while still remaining faithful to reality. We can do this principally either by altering the external conditions affecting the model, or 'story', or by changing *our* viewpoint or the facts we select in the retelling of that story. We can do these in many ways, some of which can be broadly grouped as changes of lighting, artist's position, selection, pose structure and imagery. By now, both your developed drawing and model management skills will enable you to decide and negotiate the appropriate pose, time limits and choice of medium for these projects, unless otherwise stated.

Different Lighting to Change the Mood

As people are of primary importance to our survival, so, amongst other forces of nature, is light. Chronobiology (the relationship of time to biology) governs our behaviour from dawn to dusk and through the night to dawn. When there is no light – a state of complete darkness – we cannot identify or be sure of our surroundings,

and tend to feel less secure and more vulnerable to outside influences. It is therefore natural, at night, for the human being to find a safe place, well defended from any potentially hostile elements, and, curling up in protective pose, go to sleep.

In light conditions, by complete contrast, when we can operate at our full potential, and keep surveillance over our surroundings, we immediately feel reassured. For this reason, bright sunshine is often associated with a carefree state of happiness. Despite the fact that artificial lighting is now virtually ubiquitous in modern life, our animal response to the presence and absence of *real* daylight is still keen, dominant and absolutely primal. We instinctively know that these other forms of lighting are not only localized but also controlled by elements far less reliable than the sun. Stimulated by twilight, our senses reprioritize for 'night duty' in preparation for the different conditions of darkness, and in the half light of dawn, they begin to rebalance and re-attune to the ensuing light. These are the principal reasons why the human eye is so subtly aware of the direction, intensity, artificiality and general quality of light, and consequently, why lighting is such a crucial factor when considering the mood or atmosphere of any picture.

EXERCISE: **MOOD LIGHTING**

In this exercise we shall draw the same pose under different lighting conditions: the artist and model maintain the same position throughout, and only the lighting conditions are changed. It is advisable to use a portable lighting method – for example a clip-on spotlight – because this is unobtrusive and easy to change, and to plan the lighting in advance, in order not to break the flow of concentration. The time allowed may be short or long, but it must be the same for each drawing. Sitting or standing poses are generally easier to under-light, and they have a greater number of planes.

With side lighting: Draw the model, side-lit, in tones ranging from black through to white, using any method and medium that proves reliable for you personally for the accurate tonal

LEFT: **Casually nonchalant as a naked pose, this image when wrapped and side-lit resembles an almost awesome icon of pride and defiance.**

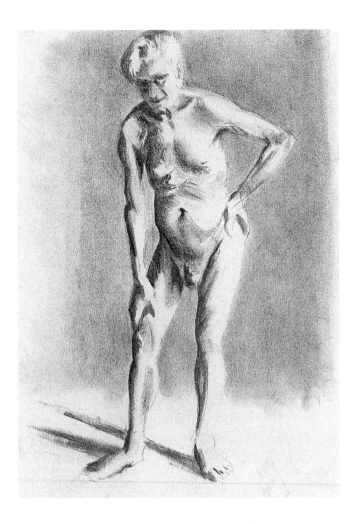

Side-lighting effects on the model.

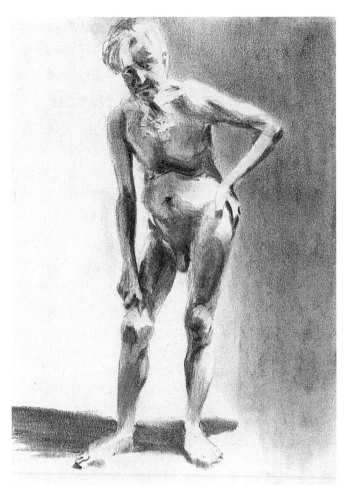

Overhead lighting effects on the model.

description of specific conditions. If the drawing time is short and the overall lighting dark, the methods Find the Form or White on Black may be appropriate. Whatever you choose, it is important to use the same method throughout this exercise, as the lighting changes will be easier to observe with a consistent drawing style.

With top lighting: Draw the model, as before.

With under lighting: Draw the model, as before.

What message or mood is conveyed? Though the lighting may be artificial, its directional aspects will still affect the response of the viewer, simply by their association to natural light. Observe and discuss the effects of lighting changes before reading on. You will notice that they vary from subtle to striking. Generally, raised side-lighting is the most familiar daylight condition: it gives the fullest information on form and is, therefore, a reassuring

statement of the nature of any subject; under lighting, on the other hand, can be so unfamiliar as to be frightening. Overhead lighting, though suggestive of high summer, midday light, can also create some disturbing pools of dark cast shadow around the face and particularly the eyes.

It can also be interesting to experiment with, and observe the changes that occur when the proximity, intensity and type of light is altered. Broken, reflected, flickering or dappled patterns of light upon the image of one person can also have an emotive effect upon another, ranging from distraction and delight to distress or mystery.

Changing the Artist's Viewpoint

Again, primal instincts and a refined awareness of body space make us extremely sensitive to the nearness of 'another', and our

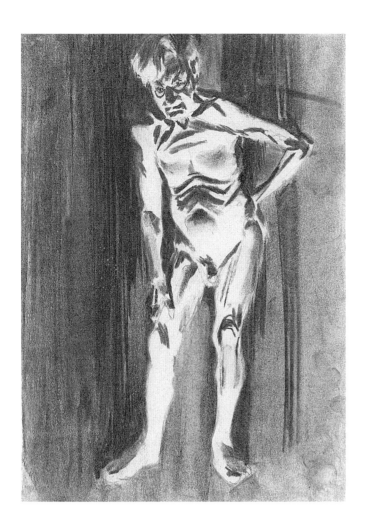

Under-lighting effects on the model.

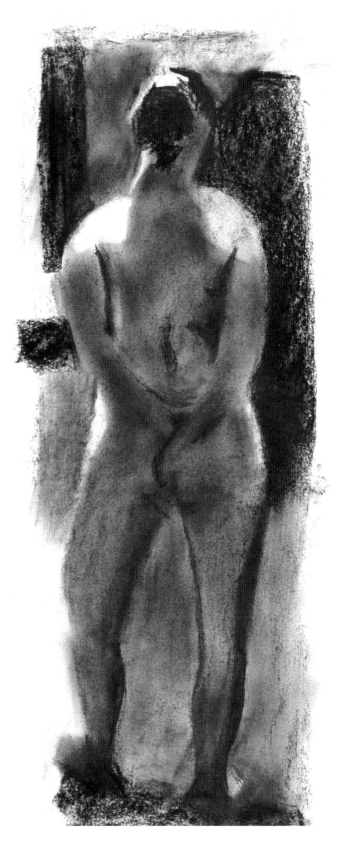

perception of another living animal, both visual and psychological, changes radically when we change our proximity or height in relation to it. This is even true of self-perception, either direct or mirrored. The most obvious changes visually are those of scale and clarity, which in turn give rise to our emotional response to the subject and depend largely on our pre-existing familiarity with it. For example, we may feel disturbed by the very small, unknown, unclear image of a distant moving 'animal', and even frightened by its close proximity if viewed from below. On the other hand, the very large, clear presence of an overseeing protector can be desirable; whilst the small, distant image of the same person can, by contrast, engender a sense of loss.

On a more objective level, you will notice, as before, that the relative scale between the near and far parts of the body that you are drawing is greater when you are positioned close to the model, and less when you are further away. In reality it is mostly this information that indicates the relationship and proximity of the artist to the model.

Overhead back-lighting give this pose a momentous quality. ('We', the onlookers, are in the shadows.)
ARTIST: JO GIBSON

EXERCISE: **A FRESH PERSPECTIVE**

In this exercise we shall draw the same pose from different positions. In order to enjoy the extremes of relative scale, it is exciting to arrange a pose that has some foreshortening. The time taken to do the drawings may be short or long, but it should be consistent. However, on this occasion you have a choice of method: either you go for one that suits your particular area of exploration, whether it be scale, mood or presence, for example; or you wait to discover your subjective reactions to the model from the various viewpoints, and make the choice spontaneously. For example, overwhelmed at the feet of your model, you may choose Passionate Line and fill the paper; alternatively, if you are working from a great distance away and the model looks tiny, you may feel more in control and choose a clear, considered line and feature the surrounding room. Now draw the pose from the following positions:

- ■ Far away, from at least 8m.
- ■ Very close, within a metre (use your dominant eye to avoid confusion).
- ■ Looking down on the model: to achieve this position, stand on a chair or table.
- ■ Looking up: lying down or sitting on the floor, if the model is on a raised surface.

With some experience, the introduction of mirrors can make this project even more fascinating, as the dynamics between artist, model *and* their reflections change in scale and mutual impact.

What message or mood is conveyed? Look at the drawings and discuss with the model your individual reactions: did either of you sense that your personal body space had been invaded? Or feel estranged when distant? Dominant when above? Small when below?

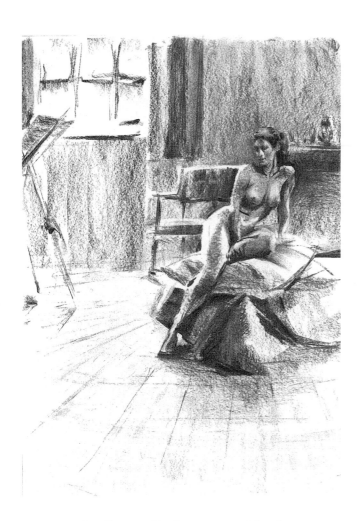

At a distance this elegant pose, obliquely lit, looks understated and languorous.

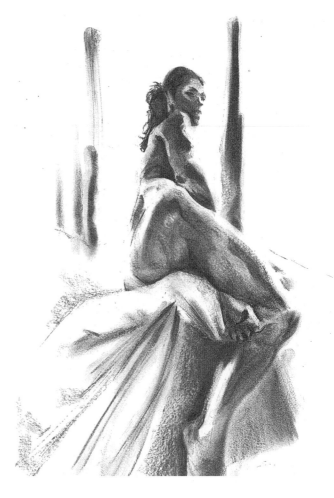

The back lighting and close, low viewpoint give this angular, silhouetted pose an almost threatening feel.

LEFT: **At close range the high viewpoint, by compressing the pose, amplifies its spirally vortex-like qualities.**

ABOVE: **A different close, low viewpoint exposes an open, curving, almost protective aspect of the same pose.**

The triangulation of this pose enhances the scale of the elbow.

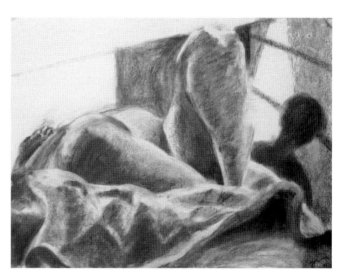

The silhouette in the mirror adds further mystery to this low eye-view drawing.
ARTIST: DIANA KING

Conversely, does the model in your drawings look invaded, tiny, vulnerable, heroic? (An outside opinion is useful here.) There can be no doubt that the experience, for the artist, of drawing the model at different distances and heights can be much more than a purely factual and visual one. An awareness of another person's breathing, visible skin texture, even their warmth, will certainly have its effect upon the drawing of the skilled or sensitive artist. Responses will differ between models and artists, so try this exercise with another model and compare notes.

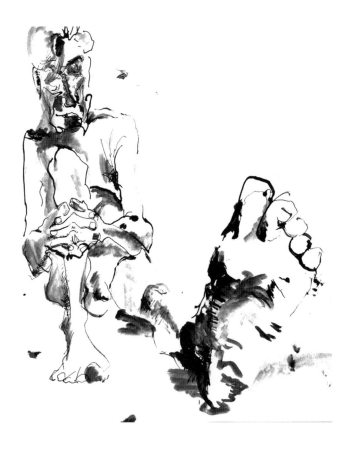

**Fluid, casual ink marks juxtapose
drama and relaxed intimacy.**
ARTIST: KATE VINER

Selection and Composition

The flavour of a drawing of the same pose may also be radically altered by the treatment of the area around the model, the way in which the environment is depicted. Simply by the addition or exclusion of surrounding information – by changing the frame edges – a standing pose, for example, can evoke the idea of distance and space (supremacy, solitude or loneliness), or of confinement (imprisonment, cosiness or protection). Cropping can make an image appear like a vast landscape, a rockface or a cave, for example, or it can express another story, mood or idea in purely abstract terms by its association of shape, tone and texture to other visual elements.

Experiment with varying images before you draw. To view the model more easily in relation to surroundings of different scale and shape, first make a simple view-finder by cutting out two right-angled L-shapes, 8 × 40cm, in plain, neutral grey card. (Later, try other shapes, for instance circular, triangular, oval, polygonal.) Hold them up in front of your eyes to make a

rectangular frame-shape; you can enlarge or reduce this shape by moving it towards and away from your eyes, or closing and opening it. Make both 'landscape' and 'portrait' formats, ranging from very narrow to square, viewing the model with varying degrees of surrounding space, and noting the different 'story' expressing the same 'event'.

Next, close the view-finder right down and, looking at the relative scale, tone and texture of the shapes, crop the image to include some background and some model. Then focus right in and choose a small portion of the model that may express another aspect of the pose or idea, or may simply appeal to you as an interesting composition.

EXERCISE: **IN THE FRAME**

This exercise investigates the relationship of the model to different border shapes; each sketch should take no more than 20–30min.

Using your 'view-finder', move it around to compose the shape within it, paying particular attention not only to the shape of the model, but also to the empty space-shapes between model and frame edges, until they all look interesting. Take the time to consider where you want the eye to travel in the picture space, and where you want it to linger. Empty space can be either visually relaxing or boring for the eye, just as lack of space can be claustrophobic or exciting, depending on the quantity and juxtaposition of objects within it. For example, where model and frame edges are placed very closely, narrowing towards each other, there will be a heightened sense of enclosure and tension, which will therefore draw the attention. Being bold and using large spaces will accentuate the sense of activity in other areas.

Horizontal lines tend to look stable and passive, while vertical lines appear more active. Diagonal lines look dynamic but less stable. Look for shapes that are directive, or point like arrows, and use them to show the viewing eye the way to the crucial moments of your story, while using curves for a more meandering wander or for 'swinging' the attention. Above all, give the eye an interesting journey around the picture space.

Be adventurous, take outrageous risks with your composition, and trust your instinct rather than habit, using symmetry only when it helps to fulfil the story, and not as a safe option. In pencil, make a preliminary sketch that explores the compositional rhythm and balance in order to better understand and fine tune your choice. Then note the placing of the frame edges and the ratio of height to width, and very clearly draw the borders on the paper *first*. Refer continually to the view-finder, and use a broad sketching method to lightly mark in and arrange the placing of the model within the frame-shape beforehand. Finally, draw in the model as a simple, but strong outline drawing. This exercise can later be developed by blocking in various shapes with tone, texture or flat, repeated pattern.

This working drawing shows the exploration of shape, balance and rhythm potential.

BELOW: **The final decision is a personal choice based on many influences, for instance past experience, the pose, model, present mood.**

What message or mood does this convey? Though the working sketches can resemble stained glass or architectural plans, their permutations, by conscious design, can enable the final drawing to subliminally express a predetermined mood. Apart from the significance of the subject, this depends upon the arrangement of shapes, unaided by the emotive input of tone. Though apparently abstract, choices of juxtaposition usually derive, by association, from a personal experience of space, boundary and body edge. For this reason, the outcome will not necessarily have the same effect upon everyone.

EXERCISE: **THE FABLE**

This time draw the model and surroundings lightly in charcoal, with space not to the sides, where the figure may even be cropped, but *above* the figure. This may include anything from consciously planned patterned or plain drapes, to doors, windows, other artists, easels or haphazard junk. View-find and first draw the frame as before. Each sketch should take no longer than 30–60min.

As you are drawing, allow your mind to ponder the mood/story that is evolving from the image, and write down key words or phrases that express it: reflective, heavy, peaceful, belonging, strong, viewed through a door, after work, anticipation, and so on. As you are drawing within the frame, refer to the words you have written and develop their 'story' by softening, strengthening or completely erasing shapes, or changing medium or tones, and in this way, altering the relationship of figure to surroundings.

Using the same pose, try this experiment with differing shapes of background – for instance background to the left, to the right, below the model, panoramic.

What message or mood does this convey? As before, the smallest changes of space/body ratio can dramatically affect the

167

OPPOSITE PAGE:
LEFT: **Drawing extended above the model.**
Mood: alone, tired, enclosed.
Method: vertical marks in heavy charcoal.

TOP RIGHT: **Drawing extended to the top and right.**
Mood: relaxation, optimism, space.
Method: broad tone.

BOTTOM RIGHT: **Drawing extended to the left of the model.**
Mood: light, lively, cosy, confident.
Method: curly ink marks.

THIS PAGE:
RIGHT: **Drawing extended below the model.**
Mood: edgy, tense and anxious.
Method: angular marks made with an italic bamboo pen.

BELOW: **Panoramic format. Comfortable, real, with the**
feel of a Greek vase or storyboard.
Method: full tone.

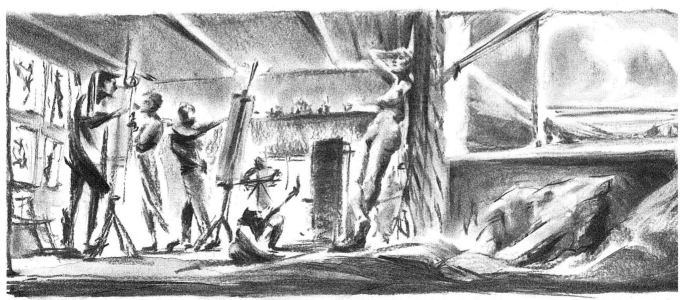

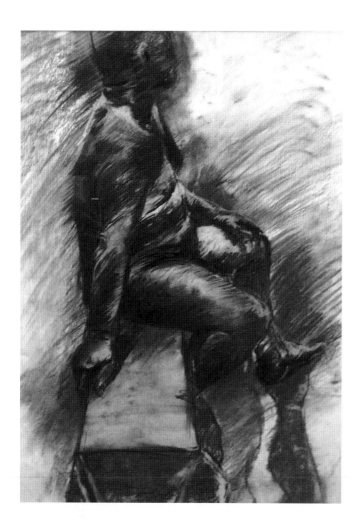

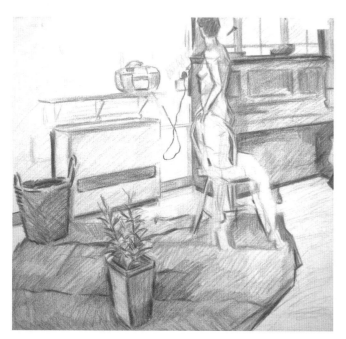

LEFT: The marks, turn of the head, and relationship to the frame give the figure an air of anticipation.
ARTIST: ŠÁRKA DARTON

BELOW: **The dramatic back-lighting, space and bars of both chair and window impose a mood of introspection, loneliness and entrapment.**
ARTIST: CAROLYN DODD

BELOW LEFT: **Integrating with the surroundings the model looks comfortable yet in control.**
ARTIST: CLIVE DE VRIES

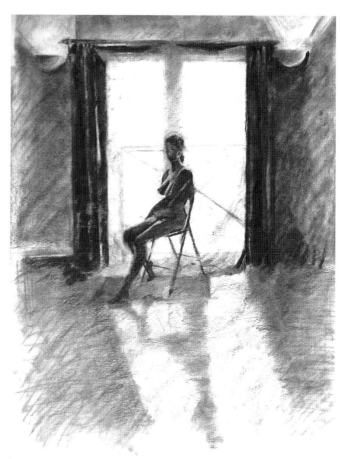

mood of the drawing. Identifying why will add another interpretative skill to your toolbox. Remember, however, that while many circumstances of surroundings may suggest a common mood, the response is still a subjective one.

EXERCISE: **EARLY CROP**

With this exercise, zoom in to a very small area of a pose, either choosing it to express a pre-selected word or idea, or because the balance of shape, tone and texture appeals to you subjectively.

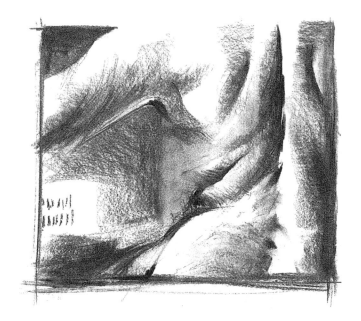

TOP RIGHT: **Cropped, the spine forms a square with the frame, left. The radiator mimics the spine horizontally.**

MIDDLE RIGHT: **With cropping, the strong tone and negative shape suggest the 'arch' form of eroded cliffs in sunlight.**

BOTTOM RIGHT: **Surface texture and folding body shapes create a spiralling rhythm.**

The selected portion may be within the edges of the model's body, or incorporate some background. Then, after establishing strong frame edges and lightly placing the shape first, make a large drawing of it, allowing your imagination to take over in the selection of line, tone and texture – the final drawing need not be recognizable.

What message or mood does this convey? Because our environment has so much bearing on our own well-being and survival, the amount and importance of surroundings in a drawing of another person can simply, and subconsciously, by our identification with them, change the viewer's perception of that person. The lightness, darkness, softness, sharpness and so on of shapes, which may merely be empty space, can create a figure-and-stage relationship so powerful as to highlight, protect, isolate or incorporate the human being in relation to the surrounding world.

The Effect of Wrapping

The following exercises investigate the interaction of form and covering. Though bodies are certainly well known to us (as first-hand owners), we may not be so objectively aware of their 'presence' in terms of their capacity to fill and alter the external environment. As a human being automatically effects a change or displacement factor upon the surrounding air, temperature or water, for example, the following alternative images show the effects by the body upon 'coverings'.

EXERCISE: **WRAPPING**

By completely covering or 'wrapping' a body, with cloth or ribbon, for example, the accent on familiar dominant areas of body-expression is shifted. Head and hands are relegated, subjected to equalizing surface conditions, and recognition of them is less obvious so that we are obliged to identify the person or pose by the referred surface information, as we might recognize a friend by their voice. The nature of a body partially covered, however, makes a statement of contrast about concealment and exposure

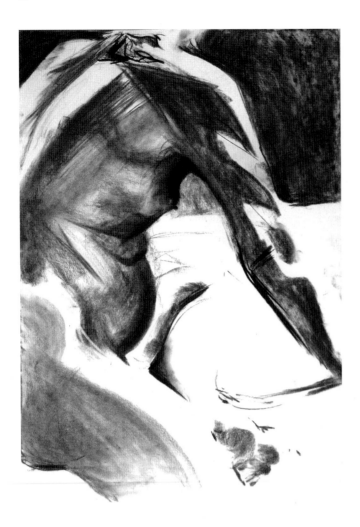

The broad, square spaces contrast with the
spiralling intensity of pressure at the chin.
ARTIST: SUE KELK

Tonal interchange and lost edges add to the impression
of an archway, created between the body, arm and leg.

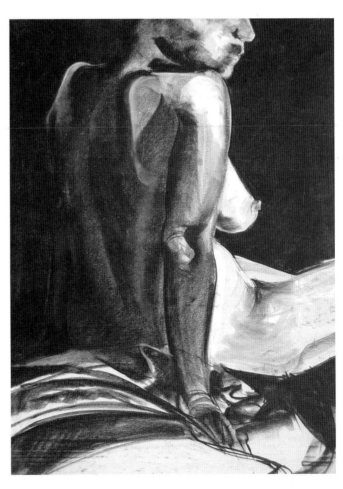

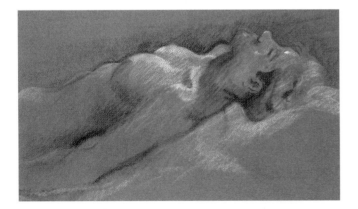

Close cropping allows the attention to rise and fall
along the rippling edge to and from the nose.
ARTIST: JANE GERMAN

Tonal contrast reaches its extreme where the key
negative shape meets the front edge of the body.
ARTIST: LIZANNE JOHNSTONE

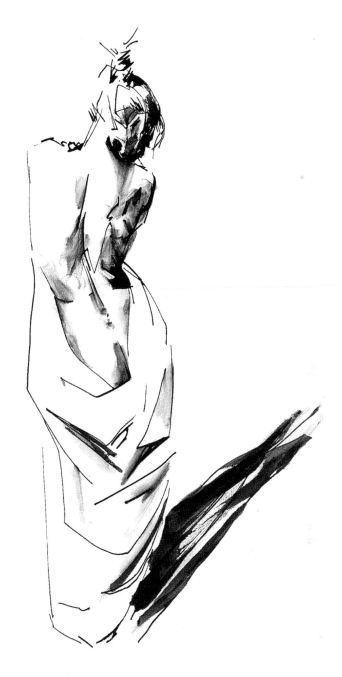

When naked, this pose conveyed 'observation from a superior position'. Wrapped, the same pose reads as 'cowed, trapped'.

RIGHT: **Reflective when naked, this pose acquires an erotic quality when partially wrapped.**

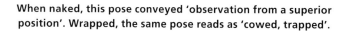

of the human body, which may not only constitute direct sexual signals, but may also represent a wide variety of metaphors for the nature of the human mind, behaviour and morality.

Cloth: By covering the body with different materials – either soft and heavy, or stretchy, or patterned – there are exciting opportunities to observe other aspects of its three-dimensional form. A model making short poses enveloped in a tube of inexpensive cotton jersey, creates a dynamic drawing experience. Creases of fabric accentuate the form and tension of a pose. Your drawing will also be informed by you (separately!) trying on the tube as well, and discussing the 'inside' experience with the model, for

whom the sense of enclosure and weight-tension dynamics caused by the support/restriction of the fabric, will change the modelling experience.

Ribbon (ask your model in advance): Lay black ribbon over, or wrap it randomly around, the limbs and body of the model. By making a line drawing that follows both the body boundaries and the ribbon, new shapes and messages about body form are discovered, as the ribbon explicitly describes the volume and foreshortened areas of the body as truncated cylinders. (At a more prosaic level, this exercise is excellent for enhancing fore-shortening skills.)

A relaxed reclining pose becomes sinister
and corpse-like when wrapped.

Drawing showing construction, ribbon
and some selected body edges.

The visible ribbon and selected body edges.

**This version, showing the construction work,
has had selected Armadillo shapes blocked in.**

What message or mood does this convey? Like other ideas mentioned in this chapter, the effects of covering a body can convey the most extreme messages. Consider how covering, clothing and wrapping can be associated with veiling, decoration, shrouding, protection, hiding, warmth, signalling status/sexual distinctions or availability. By contrast, think how exposure can reveal or express honesty, fragility, vulnerability and so on. Our responses will also be individually affected by group culture and personal experience, so discuss your reactions with other people.

Group Studies

EXERCISE: **MULTI-LOCATION**

This method involves 'peopling' a room with only one person by drawing the model in different places, and therefore different scales. The serial drawing of figures can be intriguingly surreal because it 'defies' the element of time by juxtaposing many figures (who are, in reality, one) involved in a situation that never happened! While time unfolds in the normal way for the model, the sensation for the artist, creating an apparently simultaneous 'event', can feel like puppet-mastery. It is not only a magical experience of discovery but also gives a dramatic insight into the relative scale of figures in space, and is a useful tool for composing multi-figure drawings.

First discuss with the model the multi-poses, no fewer than five, which will take place in different parts of the room, and may suggest an interrelated activity (how many, where, and how long). Then mark the positions. Take a sheet of rough paper and make a small preliminary working sketch of the whole room (including ceiling, floor and significant furniture), which represents a width and height of approximately 4 × 3 hand-spans (little finger to thumb, measured at arm's length). Then assess how big you will need to draw the area size of the

whole room as a stage set, to include all the poses, by asking the model to walk to the positions and hold them for a minute.

Do not draw the model, but clearly note the extremity points of the whole composition, using the Elastic Band, as though you were looking at one pose, for example, from the top of the head on one pose to the lowest toe of another, maybe the nearest, and so on. Then take a large sheet of paper and make an accurate, but light, line drawing, in pencil, of the necessary room area

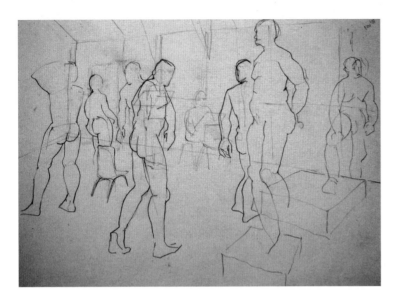

LEFT: **The firm line and muscular model give this multi-location drawing a heroic and Olympian feel.** ARTIST: SUSAN HARPER

BELOW: **With only one model, this busy working drawing gives some idea of the scope of multi-location to collect information.**

when the model is not there. (As it can take up to an hour, this worthwhile process can be done separately.) Start with the largest-scale dimensions first, and note that the floor/wall/ceiling junctions curve to a greater or lesser degree (*see* Perspective and Foreshortening) because they diminish optically further away from the viewer's eye to both the right and left, and up and down. Draw a horizontal line at your eye level, and a vertical line from the point where your eye meets the facing wall at right angles. Use their conjunction as a reference point when angle-finding. Draw useful key reference points such as windows, floor-boards or tiles, and major non-moving structures.

Now you can put your 'actors' on the stage, using the surroundings for reference of scale and positioning. While there are advantages to initially placing all the poses with quick drawings, and building them up together to maintain a balanced approach to detail and drawing intensity, and to spot any inaccuracies in the room-drawing early on, this is by no means proscriptive. To complete one drawing before starting the next can deepen the

involvement with each character. In the case of figures obscuring each other partially or completely, simply overlay the images. It is, of course, possible (and fun) to add different models at a later date by simply drawing from the same position.

What message or mood does this convey? Depending on the placing and poses of the different figures, the finished drawing can, like a play, send out many diverse messages about inter-personal relationships. These range from a mysterious air of estrangement (if, for example, the figures are looking into the distance, apparently oblivious to each other) to a high degree of dynamism when 'joint activities' were pre-planned (and often when they were not!). However, the most startling observation with this method is the fact that the viewer – and even the artist – immediately embarks upon a search around the drawing to make sense of the group story, however evident it may be that the drawing is a composite of the same person. Our acute awareness of each other as interactive human beings, and our ever-present willingness to subconsciously identify with the subject, make this an exciting experiment in both process and outcome, like the unfolding of a gripping story.

EXERCISE: **GROUP INTERACTION**

Drawing more than one model is surprisingly different to drawing one alone twice. The drawing, like any group of people, tends to have its own identity, and is different from the mere sum of its parts. Real, not invented, relationships are the subject here, and questions of comparison, scale, distance, space and dynamics change not only the look of the drawing but also the experience for both artist and model.

The mood and message conveyed will be largely dependent upon the poses, and these are dictated by the way that the models naturally relate to each other. The challenge for two or more models is to find poses of equal comfort/length ratio, and to adjust to each other. The challenge for the artist is to fit all the figures onto the paper by forming the habit of studying the relationship of *all* the models from the start (otherwise there might just as well be one model!). The best approach for this is to initially treat all the models as one whole shape, by using the Elastic Band or Five Star methods. (Only where one model is very dominant in scale, in the foreground, for example, can it sometimes help to draw one and add others to the first.) Also, Armadillo shapes both within and as negative shapes between the bodies are invaluable for comfortably linking bodies together, and achieving a real sense of spatial distance and accurate proportions.

What message or mood does this convey? A drawing featuring more than one model, like the previous exercise, is so affected by the 'relationship' between the models in physical terms, and the comparison of shapes, tone and texture for the aforementioned reasons of identification, that the mood and

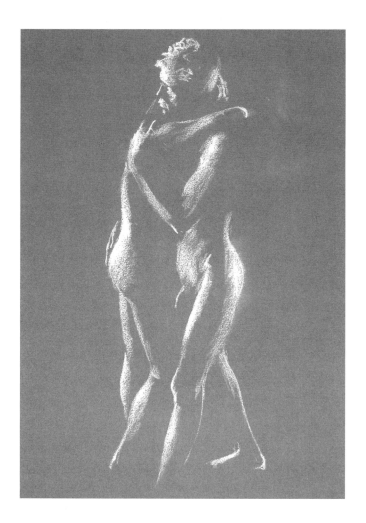

An expressive study of a man and woman in white conte.
ARTIST: ROY PACE

story will be greatly dictated by the specific combination of models. Though viewpoint can alter the emphasis, a group of people automatically create their own dynamic story, offered for recounting or interpretation by you, the 'story-teller'.

Conclusion

By exploring only some of the ways in which the 'feeling' of a drawing may consciously be altered, it is hoped that you will develop and invent more ways of externally affecting and recording the 'truth'. It is possible to witness an event from an absolutely unique viewpoint and still remain the faithful reporter on the scene. It is also very useful to learn to open up, imbibe and express the truth 'out there' as you find it, before using the same skill of verity to express the subjective responses 'in here' (which may distort or 'fictionalize' the visual truth).

As far as the degree of accuracy goes, the debate is as hot as that regarding the necessary amount of anatomical knowledge for life drawing. It can be argued that it is more direct to convey important ideas by drawing symbolic imagery; or that, by ignoring objective realism from the start, it can never become a superficial habit that blocks the inner 'voice'. Properly managed, though, drawing accuracy is a skill that can 'oil the wheels' of both self-expression (however abstract) and communication. Ideally, the motor responses of the brain, eye and hand are always primed, ready for action, to respond to any situation, from reportage to the inner 'mind's eye' of the imagination. To use the analogy of the motor, if the vehicle of the eye/brain/hand mechanism is handled with skill, the automatic and smooth co-ordination will leave the driver free to decide the route.

However, to some, skill and subsequent freedom can also be a challenge. Possible drawbacks to the idea of first acquiring high-level drawing skills can, unfortunately, be that the timid person or perfectionist may *never* feel ready to use the means to express the ends, and will hide behind the notion of developing skill first as a reason not to make the final creative leap. Objective drawing skill does take time and effort to develop. Remember, though, that too long a time spent *only* recording can become a habit-forming and knee-jerk process, a mechanical 'faxing' of visual information, which, though safe, can stifle the imagination. Back to the driving analogy, this is like continually polishing the car, or mindlessly, but beautifully, driving it round and round a disused airfield (to loud applause), fearful of, even forgetting, the world of choice outside.

Indeed, the stated purpose of many people when choosing to learn to draw may be, at the outset, 'to acquire sufficient skill to create a photographic likeness of a person'. However, having achieved this skill the pleasure is often short-lived for various reasons: either quite simply because the goal *is* achieved; or because of the realization that a photograph can already do this; or because the underlying need for self-expression was there all along, but hidden; or finally – and this is a phenomenon that often occurs – that the desire for self-expression grows stronger during the process of skill acquisition. One thing, however, is certain: well equipped with all the preceding skills, you now have the vehicle, the skill to drive it, and the open road ahead!

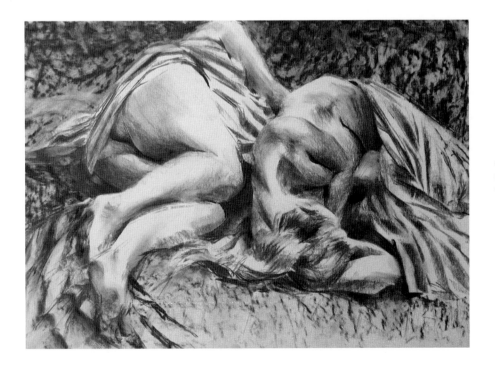

A figure-of-eight rhythm and striped cloth link these two models.

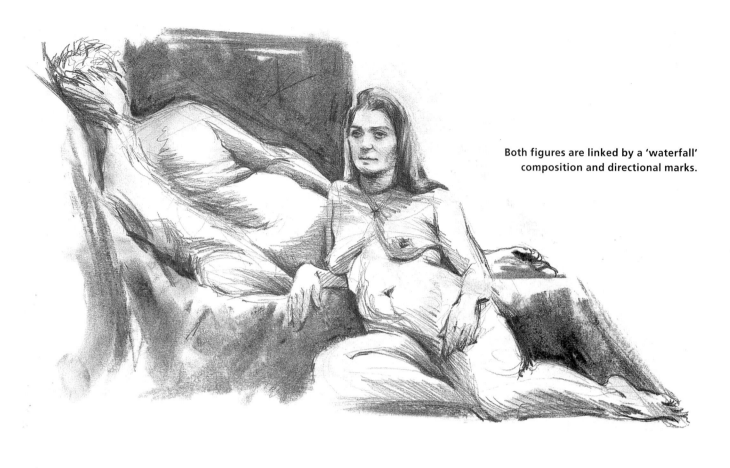

Both figures are linked by a 'waterfall' composition and directional marks.

Lost edges and a low viewpoint give this open, relaxed double pose the suggestion of a sunlit landscape.

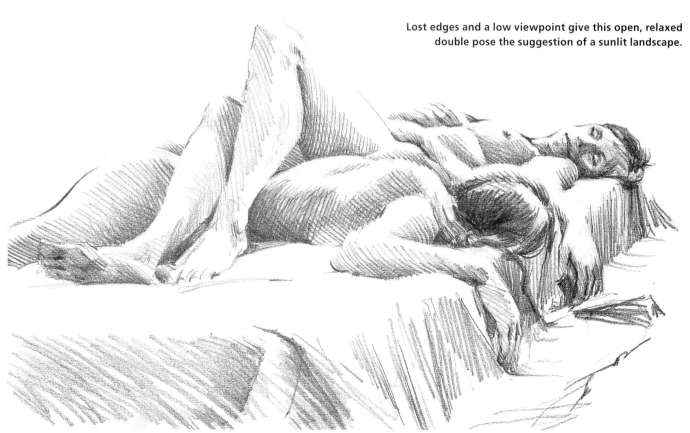

PERSONAL RESPONSE AND SELF-EXPRESSION

The skill of accurate drawing is quantifiable, with proportions and tones that are either right or wrong, and generally, development can be directly equated to the amount of concentration and practice applied. Personal expression, however, requires only the additional desire to do it, and – knowing that your statement will be unique – the courage. This means that, if personal interpretation is the aim, *only you* will know if it has been achieved, because every decision will be informed by your experience alone. (This is the wide, long, 'open road' of the driving analogy, and you may need a little time to adjust to all the choices before deciding where you want to go.)

A Journey to Self-Expression

The transition from simply copying what is 'out there', and imagining and copying what is inside the mind, requires that the channels of expression and visualization are opened, and that feelings are invited 'onto the stage'. While we all have feelings and imagination, we differ greatly in our handling of them: some people, from choice or necessity, find it easy to access, read and show them, and do so comfortably, others find it less easy. The following exercises are specially designed to find and open the pathways, and ease the transition to self-expression.

LEFT: **Sliced linear marks and strong tonal contrasts convey the model's contained tension.**

EXERCISE: **THE INNER SCREEN**

— POSE: Any, but not symmetrical
— TIME: 5min pose, 5min drawing time, 5min correcting time

The aim of this exercise is to learn the skill of drawing an image that is stored inside the head, in the visual memory. It is therefore a particularly good exercise for the artist who draws like a 'fax' machine, rather than studying the integrity of the whole body. Ask your model to hold a pose, and memorize it and its placing. (If working in a group, it is useful to take it in turns to be the 'reporter' who draws the pose directly and accurately at this point.) Look at the pose for 5min, not drawing, and try to remember the configuration of the body as seen from your viewpoint. Ask the model to go out of sight while you draw the pose as well as you can. Then ask the model to return to the pose (helped by the 'reporter'). Correct your drawing, if necessary, in a crayon of different colour.

How well did you do? How did you remember? Did you use visualized or internally 'heard' words – such as 'sitting with hands on lap, folded left over right' – or did you re-see the pose? Did you imagine what the pose felt like for the model, or did you imagine yourself drawing it? All these methods can work for different people, and tend to come through the 'inner screen'.

Do this exercise at least five times, gradually reducing the time limit to 1min for each process (in some respects holding the image is easier when the process is quicker). Then, if working in a group, move round one place when the model returns after the first drawing, to correct your neighbour's drawing, with a different colour pencil. Be honest, but look carefully for the 'key' to any problem areas. With the next drawing, repeat, moving the other way. By mutually putting your work 'out there' for comment and correction, you can develop sensitivity, objectivity and courage, in a 'safe' place.

EXERCISE: **PERSONAL RESPONSE TO THE MODEL**

By now you will already know what aspects of life drawing are especially important to you. In terms of our broad definition of beauty, affected as it is by fashion or culture, there are, of course, some preferences (for a particular build or hair colouring for example) that may be shared. Beyond this, however, there are certain models or poses that may trigger reactions in certain artists (or viewers of the drawings): these are specific to that person's personality, caused by the sum total of their experiences of other people.

This unique view of life evokes responses that are not only wide, but subtle in their variation. Our awareness of other human beings is so delicately tuned that our memory store of life experience is extremely well stocked. On first sight, even though we do not know the model we are drawing, we immediately refer to a 'general description' file within that subconscious store and may start to form an opinion constructed by mere visual association.

In this project you are invited to choose, invent or develop any drawing technique to express your response to three different models but each with a similar pose.

— POSE: A standard, comfortable pose that can typify each model, for instance sitting
— TIME: Not less than 30min

This project can be conducted over several weeks or longer (as you may not have three models immediately available in a rota); its only requirement is that a similar pose is held by each model. To encourage an adventurous approach and allay the tendency to trip down old, familiar, tried-and-trusted drawing routes, it can help to write down words that express your feelings about each model. Refer to examples of many past methods and techniques, and visualize the kinds of mark that feel appropriate.

Because individual responses will, of course, be subjective, there is no standard answer to this project, which is more about your description than preference. There are many variables. For example, most descriptive words can evoke more than one response: thus one artist may feel that a model is 'airy and relaxed', while another thinks they are 'vague and sloppy' (which, in turn, may feel comfortable or disturbing). Likewise, one person's 'strong' is another's 'aggressive', similarly elegant/thin, dynamic/tense, fragile/weak, and so on.

Also, although life models might unclothe their bodies, they do not necessarily disclose all aspects of their character in the visual terms of body language. At this stage of the project, no one else should know your reactions. It is advisable to use a method that can be erased and reworked as you explore your real or subtle feelings, which don't always surface immediately.

After the project is completed, if working in a group, arrange a free discussion session with the drawings displayed in groups of model. (If working on your own, invite your friends and family to give their responses.) Begin by asking other members of the group what feelings the drawings convey to them, then share your own responses. Your message may not be interpreted as *you* felt it, because the viewer, in turn, will have their own personal reaction to your drawing, which comes from a completely different source of experience. Bear in mind that the aim of the exercise

Medium and method: understated white and black conte and charcoal stroked onto mid-tone paper.

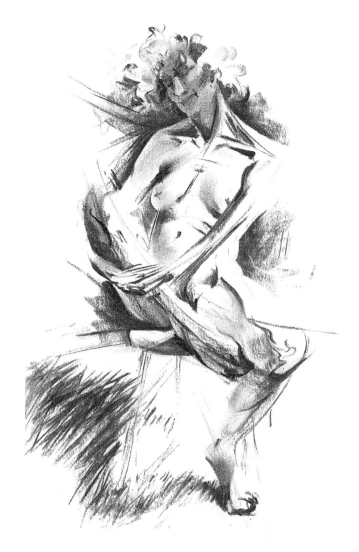

Medium and method:
a fine but strong, tensile pen line.

Medium and method: a combination of
strong, energetic and soft charcoal marks.

is to successfully express your feelings, regardless of any consensus of opinion that judges whether you have or have not communicated them – and remember, there is no right or wrong.

EXERCISE: **RESPONDING TO THE MOOD OF THE POSE**

Here you can study the emotive quality that different poses can express, and your response to them as a person, and then explore, as an artist, spontaneous ways of drawing them. It is an advantage to have for this exercise a model who is naturally expressive, because the pose is intended to convey a proposed mood. (In a group you can take it in turns to choose 'mood words'.)

It is extremely important that both artists and model physically engage in the following pre-drawing process. Remember an instance, in your own life, of the feeling suggested by the 'mood-word', as an inner sensation. Either visualize the memory of yourself at that time, and re-enact that pose; or see what body shape comes naturally when you remember or imagine the feeling, and visualize yourself now; or visualize another person from your memory in that mood. Which comes naturally? Try the other methods of visualization later, with other words. Note how much body language you share in common with others, though remember that while every body configuration that we make may have its function, our personal way of assuming it is idiosyncratic. For this reason, the final pose must be the decision of the model.

(The following mood words and pose descriptions are only guidelines.)

— MATERIALS: A full range of mark-making tools laid out and ready to hand

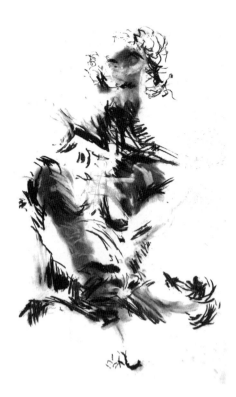

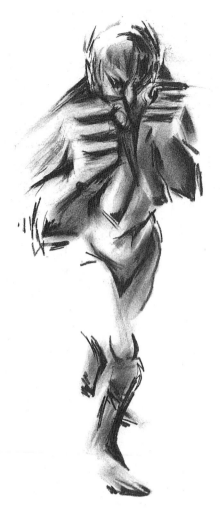

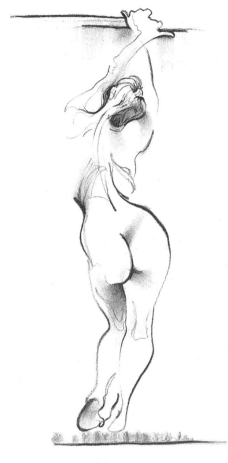

ABOVE: **An informal pose: lively marks emanating from the 'inside', rather than the surface, edge.**

RIGHT: **An aggressive stance: sharp, strong marks.**

FAR RIGHT: **Languorous sensuality: sinuous line.**

— TIME: 6min for each pose (2min for experiencing, 1min for preparing, 3min for drawing)

Pose 1: Passive – e.g. horizontal, rounded, relaxed
Pose 2: Dynamic – e.g. diagonal, stretched
Pose 3: Mysterious – e.g. curled up, face partially hidden
Pose 4: Aggressive – e.g. sharp shaped
Pose 5: Joyful – e.g. open shaped, looking upward

The aim of this project, like the last, is to recognize your responses and expand your abilities to express them through choice of method and mark-making techniques. This time, however, the pose, not the model, is the focus of attention. It is therefore possible, before each drawing, for the artist to gain first-hand experience by taking up the same pose as the model to physically identify with it (you may need cushions for the reclining poses). Hold the pose for at least 2min, and note the feel and look of it

from the inside. Close your eyes for a while, and sense the mood, shape, weight and tension of it. Then, using the medium and marks that *feel* right, draw very quickly so as not to lose sight of that feeling. (The essence of the pose may not be visible from all parts of the room when working in a group, so repeat or extend the number of poses.)

Because this exercise involves a high degree of identification and personal engagement with both model and pose, it enriches the process of self-expression and produces visual results that are often tangibly expressive.

EXERCISE: **READING BODY LANGUAGE**
This exercise is useful and fun, and calls upon the acquired skills of the past exercise. If possible, employ an actor or dancer who is trained to communicate mood through body language (many life models are able to perform this task, but do check first). A

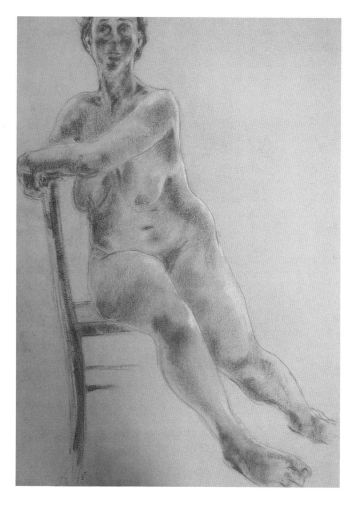

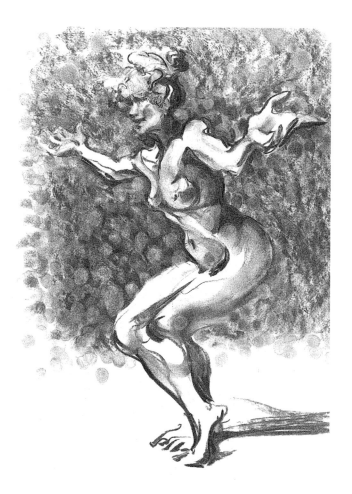

**Sensitive handling, a complex lighting situation
and a low viewpoint give this 'draping' pose
vulnerability and majesty combined.**
ARTIST: WENDY GEORGE

**Witty, extrovert: short, curving
marks and fingerprints.**

wide mixture of short excerpts of music (4–7min long), maybe repeated, can also be included as a powerful tool to trigger mood-response. Music that does not radically change in mood, and which has an abstract quality – that is, without an overtly figurative image or words – is ideal for developing the imagination of both model and artists.

— POSE(S): To convey an idea, a mood or a situation (that may be stimulated by music), to be decided by the model without initially telling the artists
— TIME: To be stipulated by the model, possibly without notice

The aim of this project is firstly, to try to read the message of the pose and the model's facial expression by opening up your awareness of their body language, and to spontaneously write,

on a separate piece of paper, key words that come to mind. Where the model uses music for self-expression, several poses or even continuous movement may be necessary. Then use the marks, methods and materials that will best express the idea that you are receiving, in order to communicate it to others.

Don't worry if the message is unclear to you – and remember that most poses have a particular viewpoint that will convey the most, or the least information – but start to draw. As you are drawing you will find that your imagination develops, however subtly, an idea of a message or storyline that the pose conveys. If using music, actively incorporate, through the marks you make, a visualization of the different sounds. As the sensation becomes clearer, rework the drawing to communicate the feeling.

When several poses are completed, put them, grouped by pose, on the floor or wall. Discuss each artist's drawing in turn, first ask-

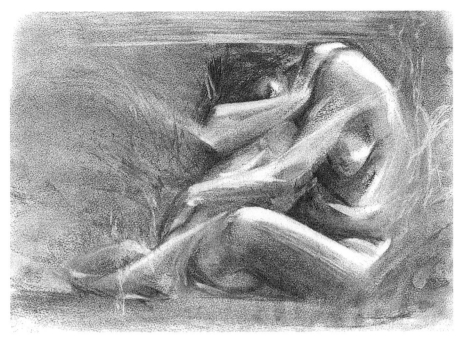

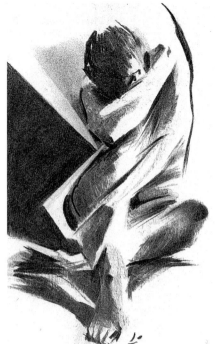

ABOVE: **Suspicion: unclear form with sporadic flashes of light.**

RIGHT: **Fear: a nearly identical pose from a different viewpoint gives a more direct and intense message of self-defence.**

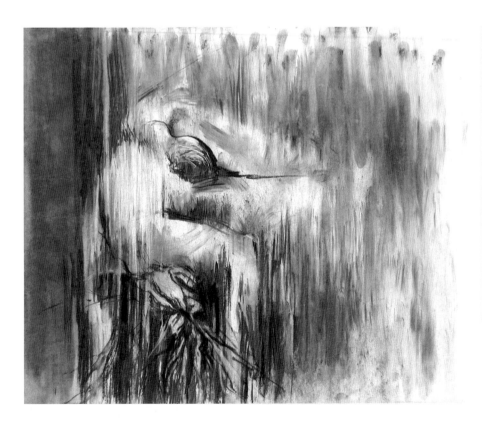

Music of liberation and joy was described with an explosion of light ink brushmarks.

Anguish and despair were suggested by music and interpreted with oppressive, downward marks.

artist's drawings have been discussed – and only then – finally ask the model what *they* intended to convey. It is notable that people in the same area of the room will often pick up a particular subtle variation of the mood, because different parts of the body fulfil different roles in the expression of one whole composite message.

EXERCISE: **HIGH FIVE**

At the beginning of the book we sought the skill to draw accurately *all* the available information. The skill here is to be simple and honest, not complex or slick. Your mark-making vocabulary will be wide by now, and well primed for this galvanizing exercise, which develops your ability to distil the essence of the pose by making only a few marks. As prioritization is a key skill for *any* chosen method, however detailed, this experience is invaluable.

— POSES: Any thirteen poses, the model to devise a completely different subsequent pose while modelling to avoid any time gaps between poses
— TIME: 10min for the first pose, reducing the time by 1min with each pose, until the tenth pose is 1min and the last three are only 30sec
— MATERIALS: All, ready to hand

The aim of this exercise is to describe your response to the pose with only five selected marks. It may be that any number of *types* of mark between one and five express one pose. You, the artist, however, must be able to travel at lightning speed through the whole visual encyclopaedia of marks in your memory and imagination, through all possible depths of tone, all patterns, all textures, to select *five essential marks*.

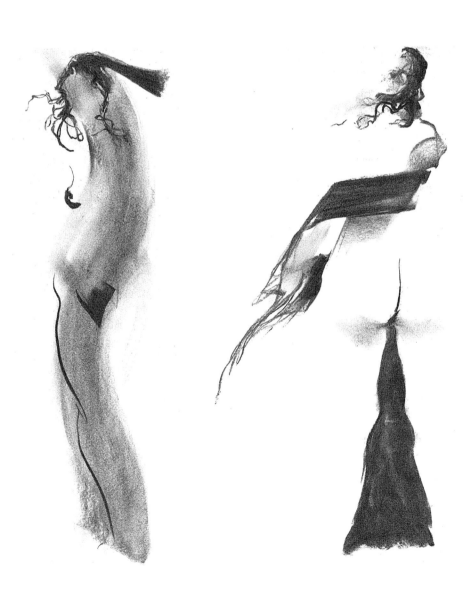

A totem-like image for a classic pose.

A scarf, a breeze and a sturdy pose.

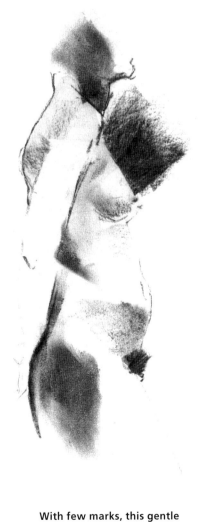

With few marks, this gentle sketch makes a restrained but essential statement.
ARTIST: DOUG GREEN

187

For the first few drawings it is better to put down, very spontaneously and without thought or inhibition, any number and any *kind* of mark, and spend the remaining time consciously selecting, erasing, working, reworking and altering the image to its minimal distillation of only five marks. Then, progressively reducing the time spent on each pose, make your statements more forthright and pre-determined, until on the tenth pose you allow yourself just 1min, and finally just 30sec per pose, when instinct will be driving your drawing. The drawing may not resemble the pose in figurative terms, but it must represent it in *your* terms. If working in a group, remember to put all same-pose drawings together to compare ideas.

This exercise, though apparently simple to the layman, represents a culmination of many skills. It displays:

■ outward visual awareness, of the model and pose;
■ inner visual awareness: having the imagination to describe the response;
■ memory, of the available encyclopaedia/vocabulary;
■ dynamic decision-making, in choosing ideas and methods;
■ physical speed in applying your skills;
■ humility, when you change unsuitable marks, however pretty;
■ courage, in daring to be different, and 'tell it like it is' for *you.*

These skills of selection and accentuation will have developed a personal style and statement that is visually interesting when, in other drawing situations, many more marks may be used.

The Artist's Personal Style

Though many of us, with fire in our eyes, may embark upon a life-drawing experience aiming to draw, for example, 'like Leonardo da Vinci', or 'as well as Mary', or 'as realistically as a photograph', the experience of physical engagement in the process begins to blur our perceptions of achievement, and to alter our original goals. The 'doing' gradually becomes as important as the 'done', and one day we realize that, yes, we *could* copy other people's drawings or photographs, but we no longer *want* to. The germ of an idea begins to grow that no one has ever drawn quite like this, nor seen what we have seen. Like the statement of a precious eye-witness, our own story and viewpoint are unique and of value. The words of external criteria such as 'compared to', 'like a photo', 'good and bad', begin to have less impact now than 'authenticity', 'discovery' and 'enjoyment'.

If you have followed the exercises in this book you will, by now, in both technical and expressive skills, have reached the culmination/reason for any creative act: the desire to make something that is new and unique. (It is true to say that the first marks we ever made were also unique – but to use the driving analogy, so was the crunch of gears.) Now that you can drive smoothly and automatically, alone on the open road, you can decide where to go and concentrate on enjoying the view. So where *do* you want to go? What interests you, or excites you most about people? To what degree do you want your style and approach to be openly affected and influenced by different models, poses and mood (either yours or the model's)? Or would you prefer consistently to infuse all situations and subjects with your personal 'language', whether fixed or developing? Do you feel, as a Method actor might, when playing another character, that you need to identify with the model and 'live' the pose; or, acting purely as a vehicle, are you happy to let the visual information pass through your eye, brain and hand to be recorded on paper as objective fact? Or do you want the visual information to arrive transmuted, with your stamp on it, or to use it as a trigger, or departure point, for the exploration and composition of shape, tone and texture?

Ongoing Projects

These projects, though final in the book, are ones that can continue for all your drawing days. They are invaluable because they will help you to answer the above questions, and will stimulate the very reasons (whether conscious or not) for drawing anything in the first place: to look, study, learn, copy and make something new of our own. Enjoyable and key skills for developing originality and creativity are imagination, choice, selection, and the ability to make decisions, while remaining flexible to personal changes. It is easy, however, to pursue a thought, reach a conclusion, and then lose it in the noises of the world (*and* other thoughts) while the list of choices seems to grow ever longer, and life itself shorter! Relax: these continuing projects will provide a sanctuary of clarity.

EXERCISE: **DESTINATION LOGBOOK**

So where are you now, and where do you want to go? To answer these questions, you will need an A4 or A5 hardback book, unruled and inexpensive; and a mechanical pencil with 2B leads, attached permanently either to you or the book.

Once in your hands, this humble book will cease to be simply paper and card: because you are an artist, it can become any 'world' of your creation – a logbook, scrapbook, notebook, sketchbook, or diary that combines words, pictures, dates, 'buzz' information, and a splurge of visual ideas that represent only you. It's for dream plans, projected images, the map that keeps you on the right track but is always open to question and flexible to change. It's for noting influences, inspirations of any

related kind – exhibitions, theatre, holidays, television, landscape, cuttings, music, food, clothes, packaging, tickets and so on. It's a place for escape, conversations, philosophy, just thinking ... And no thought, image or feeling is too stupid, funny, pretentious, childish, unrelated, banal or obscure to be entered.

The empty white spaces in the book are there to rattle round in, jump and dance in, dream and imagine in, for a regular habit of discovery, a familiar personal reference library, when you want to remember who you were, remind yourself where you are and visualize where you want to go. In here you can scribble, neatly note, draw anywhere (using Eye-Trust), scrawl, visualize, play, sprawl all over the page if you want. This book is for you, and no one else, so it doesn't have to be sensible or beautiful, only honest. Then it can act as a mirror, honest adviser, loyal travelling companion, trusty confidant, and it will also take care of your imaginative health by ensuring that your visual system is continually nourished and stimulated (to avoid blockages). It's a best friend.

EXERCISE: 'HOMAGE TO...'

Take your 'best friend' on frequent outings to the library to study the masters of life drawing, 'heroes' whom you respect. Identify and copy drawing techniques that you admire. This will teach you, physically, how the marks were made, not by magic, but by the variation of pressure, inclination and selection of mark – choices made by a person just like, and *not* like, you. Drink in the experience and absorb into your style only what *feels* right. (You may need to work with other materials, but keep the drawings or photos of them in the logbook.)

EXERCISE: **SNIP-SNAP HAPPY – FINDING YOUR BEARINGS**

Once a month, on the same date (or day of the week), for two hours, take a large sheet of paper, a glue-stick, and a pile of magazines and newspapers, and cut out any images or words that interest you, for any reason, and collage them onto the

A project of the past, celebrated in the present and affecting the future; a sample page of a destination logbook.

189

paper. Now try to identify the common theme that links your choices, and note them in your logbook. (The identification process will be easier next month, when you can compare and note changes or continuity.) Take a photo of the collage, date it, and put it in the book. This is a rewarding and very important project because it will also help you to stay focused and in charge of your own journey. (Be aware that fashion produces popular styles and compositional formulae. Follow these safe 'rules' if you really want to, but at least do so consciously.)

In the same way that a simmering pot is always bubbling and developing flavour in the background, use these methods to direct your attention in the life-drawing sessions towards any of the myriad aspects of the human being that can be studied or expressed. Though drawing may be a process that continually and naturally evolves, it is nevertheless important and pleasurable to keep a conscious eye on your changing preferences by planning personal projects ('adventures') for study. The human being offers so many areas for exploration – structure, mechanics, body language, movement, inter-personal dynamics, surface texture, tone and weight, quite apart from the development of your own style – that the pot need never burn dry!

Conclusion

This book aims to encourage you to take the time to explore many ways towards accurate drawing, and to feel a sense of personal discovery. By offering a 'taste' of distinctly different approaches, media, marks and preoccupations it is hoped that, by selecting certain aspects, you will naturally begin to create your own cocktail of flavours, or personal style. It is only by being open to experimentation that you can find your way to discovering or annealing your personal language of mark-making, one that truly expresses your nature. It is not difficult, and requires only that you continually make, and observe *your* preferences. These may form a band that is narrow, clear and focused, or spread wide enough to encompass and respond to every occasion with a different mark. The building blocks of your awareness of other human beings are gathered from every moment of your existence till now: what happens tomorrow will add to, and could change, that awareness. Though events may be shared with others, remember that your reactions and, therefore, whole experience and story are unique in the whole of time: past, present and future.

Life drawing is becoming increasingly popular. Perhaps we human beings having spent hundreds of years concentrating on the performance of the brain, which currently holds us at the top of the 'animal tree', now feel that conditions are safe and that it is time for us to 'reconnect' with our bodies. At this stage of human evolution, though, a life class may still seem strange

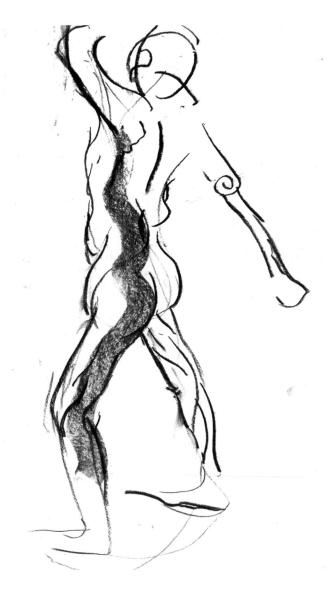

A spontaneous drawing with life force.
ARTIST: FIONA WASHBURN

to some non-practitioners, like a day spent at the zoo gaping in fascination at ... our naked selves. However, despite the fact that many of us practitioners may still feel awestruck and privileged to be able to draw another human being, we *all* know that drawing other people is a study of never-ending fascination, which not only tells us more about the look of our own bodies, but also the human condition. As a celebration of the commonalities and differences between our individual lives in history, life drawing records a tacit, fleeting link between one being and another, artist and model, and therefore affirms both existences. Where landscape and still life can only illustrate an extraneous part of our experience, life drawing, by comparison, is the study of life itself.

INDEX

Exercises appear under their full capitalized titles, with the page numbers on which they begin, for example 'Armadillo *ex.52*'.

When an exercise is used as part of a *later* exercise, the later page number is also given.

When artwork *elsewhere* illustrates a method from an exercise, the page number of the illustration is shown, for example '*ill.175*'.

The 'trouble-shooting' section shows how common problems can be corrected or avoided.